TAMING THE FRONTIER

TAMING THE FRONTIER:

ART AND WOMEN IN THE CANADIAN WEST 1880-1920

VIRGINIA G. BERRY

BAYEUX

THEWINNIPEGARTGALLERY
Involving People in the Visual Arts

TAMING THE FRONTIER:
ART AND WOMEN IN THE CANADIAN WEST 1880-1920
Copyright © 2005 Margaret Berry and Julia Berry Melnyk

A co-publication of:

Bayeux Arts, Inc.
119 Stratton Crescent SW
Calgary, AB, Canada T3H 1T7
www.bayeux.com

The Winnipeg Art Gallery
300 Memorial Boulevard
Winnipeg, MB, Canada R3C 1V1
www.wag.mb.ca

Cover Art: Lucille Casey McArthur, *Portrait of a Boy,* 1891-98 oil.
 Courtesy of The Winnipeg Art Gallery.

Back Cover Photo: Ernest Mayer

Library and Archives Canada Cataloguing in Publication
Berry, Virginia G.
 Taming the frontier : art and women in the Canadian West 1880-1920 / Virginia G. Berry.
 Co-published by the Winnipeg Art Gallery.
 ISBN 1-896209-55-6
1. Feminism and art--Canada, Western--History.
2. Women artists--Canada, Western--History. I. Winnipeg Art Gallery II. Title.
N6546.W47B47 2005 704'.082'09712 C2005-904469

First Printing: July 2005
Printed in Canada

 *Books published by Bayeux Arts are available at special quantity discounts to use as premiums and
 sales promotions, or for use in corporate training programs. For more information, please write to
 Special Sales, Bayeux Arts, Inc., 119 Stratton Crescent SW, Calgary, Canada T3H 1T7.*

Bayeux Arts gratefully acknowledges the financial support of the Canada Council for the
Arts, the Alberta Foundation for the Arts, and the Government of Canada through the Book
Publishing Industry Development Program.

CONTENTS

AUTHOR'S ACKNOWLEDGEMENTS (2002)

I wish to acknowledge assistance from the Canada Council, the Archives of Manitoba (Elizabeth Blight and Barrie Hyman), the Provincial Library of Manitoba, the Lyceum Club and Women's Art Association of Canada, the Toronto Metropolitan Library and the National Gallery of Canada and the following individuals who helped me in various ways over many years: Hope Smith and the late Ruth McLintock.

Virginia G. Berry

EDITOR'S ACKNOWLEDGEMENTS (2005)

Dr. Berry died in 2003 before she was able to complete the planned revisions to her manuscript. She only had time to revise the first four chapters before her death. These were extensive revisions that almost doubled the amount of material in those chapters. They have been incorporated in the book, as well as further refinements and additions based on readers' comments that she had hoped to address, but which fell to me to respond to. I regret that I have been unable to meet the high standard set by Dr. Berry in her revisions to the first four chapters. The manuscript should be considered incomplete because Dr. Berry was unable to finish her revisions of the whole manuscript.

The posthumous publication of unfinished manuscripts is always problematic and even controversial. However, it is my belief that the original research contained here is worthy of publication so that readers and researchers may find inspiration for further study. Dr. Berry's research into the role of women and women artists of the period may have been inspired in part by a statement made by Angela E. Davis in an article in Manitoba History (No. 4 Autumn 1982) titled "Laying the

Ground: The Establishment of an Artistic Milieu in Winnipeg 1890-1913" in which she stated: "Perhaps because so many of the early artists and art promoters were women that their activities have been ignored by art critics and art historians." The lack of material on these activities and key personalities is evident in Davis' statements that "…there is little information on the Association [Women's Art Association] after 1896" or that "a group broke away to become the Western Art Association, but whether this was to be free of the National Association is not recorded." Dr. Berry's research and writing on these subjects has now filled the gaps in our knowledge and appreciation of the role of women in the development of art at the turn of the century in western Canada.

I wish to thank Margaret Berry for her proofreading and Julia Berry Melnyk for her valuable assistance throughout the editorial process, including the preparation of the index. I want to extend a special thanks to Pat Bovey, former Director of the Winnipeg Art Gallery, for her gracious and insightful introduction. Eva Rempel, Deputy Director of the Winnipeg Art Gallery, was an enthusiastic supporter of this book and played a major part in its publication. Lisa Quirion, Collections Manager of the Winnipeg Art Gallery, provided the cover illustration. Elizabeth Blight of the Archives of Manitoba was most helpful in securing a variety of illustrations for this book. I am grateful to them all in making this publication possible.

Every effort has been made to obtain permission from copyright holders to publish illustrations. However I was not successful in every case and would appreciate information leading to proper acknowledgement in the future.

George Melnyk
University of Calgary

INTRODUCTION

THE SCHOLAR AND HER BOOK

"History is where one is." Virginia Berry took up that mantra with great passion and effect, researching and recoding the art history of Manitoba, finding new material and, indeed, creating history through her own many accomplishments.

Dr. Berry's contributions to the life of Winnipeg and Manitoba were many, particularly in the visual arts and art history during her long association with The Winnipeg Art Gallery (WAG). Born in North Manchester, Indiana in 1915, she did her BA at Mount Holyoke, and her MA and PhD at the University of Chicago. On arriving in Winnipeg, she first taught at St. John's College in her field of training, which was medieval history. Given the times, however, Virginia's formal academic career ended when she commenced her next career, that of motherhood. Yet, her academic interests continued and she switched her attention to the art history of Manitoba. The multi-disciplinary aspect of medieval scholarship served her well in her engagement in Manitoba art history, as she approached this field with the same inter-disciplinary attention, discipline and detail. Her academic achievements were recognized by St. John's College of the University of Manitoba when she became a Fellow in 1986.

It was in the late 1940s that she joined with a number of highly educated and committed women to found The Winnipeg Art Gallery's Women's Committee. Each of the women had impressive professional and academic backgrounds and today most would have been in the work force. Societal conventions of the 1940s and 1950s certainly benefited The Winnipeg Art Gallery. Virginia was a key leader and constant champion of the committee and served in almost every capacity, including a term as President from 1959 to 1961. She was well aware that strong vibrant arts activity was a critical element in any healthy community.

Each aspect of the WAG was positively enhanced and touched by her work. A member of the Board of Governors from 1957 to 1983, save two years when she was out of the country, she served a number of terms as a Vice President. She was a long time member of the Works of Art Committee, and served on the Board's Membership, Nominating, Publicity, Site, Building, Education, Programs, Long-range Planning, and Policy Review committees. She played a very key role in the work of the Building Committee, culminating in the nationally acclaimed signature building, designed by Gustavo da Rosa, which opened on Memorial Boulevard, September 25, 1971.

With her scholarly background and deep knowledge of art and art history, Virginia Berry was particularly interested in the strength of the WAG's exhibitions, programs and its continuing contributions to the furtherance of Canadian art history, especially that of the west. It was natural that she was on the committee for the first Winnipeg Show in 1955, the WAG's annual, national contemporary juried exhibition. This and the Montreal Juried Exhibition were the two most important contemporary exhibitions in Canada in the 1950s and 1960s, giving young and established artists the opportunity of exhibiting work with their national colleagues. In all her work she encouraged and supported Winnipeg's artists, emerging and experienced. When she died in 2003, she was an active member of the WAG's Archives Committee, the Advisory Committee of the Volunteer Committee and the editorial committee for

the Focus Series publications of the WAG's decorative arts collection.

The contribution of her scholarship, however, was perhaps her most unique gift. No one has done more for the history of Manitoba art than Virginia Berry. Her engagement in Manitoba art started shortly after her arrival in Winnipeg and became her full time consuming interest in the 1960s when she turned her attention to The Winnipeg Art Gallery's upcoming Manitoba Centennial Exhibition. She was the prime researcher for the 1970 exhibition "150 Years of Art in Manitoba." Combing archives, galleries and private collections for information, connections and images, she found names of artists then unknown and works never seen before.

After the success of that project she continued her researches in the Manitoba Archives and the National Archives of Canada. Her findings led her to guest curate two exhibitions for the WAG documenting the region's art history: "A Boundless Horizon : Visual Records of Exploration and Settlement in the Manitoba Region 1624-1874" on view in 1983, and "Vistas of Promise : Manitoba 1874-1919" shown in 1987-1988. Her research for these exhibitions and publications was exhaustive and these accomplishments earned her the Order of Canada, an Honorary Degree from the University of Winnipeg and, the year before her death, the Queen's Golden Jubilee Medal.

Research into other untold aspects of Manitoba art history were her next preoccupation. She now focused on the Winnipeg Branch (WB) of the Women's Art Association of Canada (WAAC) and affiliated organizations, culminating in this posthumous publication. A period until now little documented, it was a critically important time of transition from the itinerant fur trade and western exploration artists to the establishment of the post World War I urban visual arts centre.

This book fills a very important gap in the knowledge and scholarship in Canadian art. Its thoroughness is impressive and the material is new. Chronicling the roots of 20th century art in Winnipeg and western Canada, it was drawn solely from primary

and original sources. In government and gallery archives across Canada, the British Library and other related institutions, Dr. Berry comprehensively examined news clippings, personal papers, correspondence, published materials and any extant minute books of the associations. The period column Town Topics, by E. Cora Hind, was a major source, one she read, enjoyed and recorded to the fullest detail, noting every exhibition entry, artist and work of art. She researched exhibitions and exhibition reviews and traced the prevailing climates and art school curricula in the US, England, Paris and eastern Canada. As a result this book is a truly skilful comprehensive portrayal of a fascinating and changing scene, incorporating descriptions of exhibitions, work of individual artists, advancements in art education, trends in painting, handicrafts, china painting and lectures, societal interests and connections with artists and organizations in New York, Toronto, Montreal and London. Dr. Berry documents the sales, marketing opportunities, budgets and financial results of each of the WB's endeavours, as well as the aesthetic interests and modes of expression of the day.

Dr. Berry clearly examines the local and national context in which women artists and art supporters worked, and assesses their accomplishments and contributions at a time of great economic development and population growth in Winnipeg. Members of the Women's Art Association of Canada and the Western Art Association contributed to the creation of major new institutions that furthered art and art education. In the process of describing these achievements, Viriginia Berry provides valuable biographical information on such leading figures as Mary Dignam, Mary Ewart and Mary Riter Hamilton. It is intriguing to see with whom these women studied, prominent artists like James Abbott McNeill Whistler in Paris and William Merritt Chase in New York. Interesting too is the import of the ideology of John Ruskin and William Morris and the influences of the educational attitudes of South Kensington. The relationships Dr. Berry traces between Manitoba and eastern artists is likewise significant, in particular,

F. McGillivray Knowles, Frederic Bell-Smith and Marmaduke Matthews. She also effectively sets the stage for subsequent links with women artists from further west, Sophie Pemberton and Emily Carr, both of Victoria, who, like Manitoba's Mrs. T.T.W. Bready, went to France to study.

In addition to situating Winnipeg in this larger sphere, Dr. Berry rightly considers the impacts of economic and international events, which affected the arts, including political relations with the east, the First World War and the 1919 Winnipeg General Strike. Candidly noting Winnipeg's perennial problem of isolation from other parts of Canada, she assiduously assesses the local situation throughout the period, the roles of the annual Agricultural Fair and the Industrial Bureau, the founding of the Manitoba Society of Artists, the Women's Exchange and the development of the Saskatchewan Women's Art Association.

Her account also sheds new light on the community impetus for an art gallery and school of art. "The art community seems to have been of two minds. While all wanted a building devoted to art, there was no consensus whether it should be a gallery or a school... Some indeed envisioned a combination of both, like Chicago's Art Institute or Pittsburgh's Carnegie Institute." Having been turned down by City Council, The Winnipeg Art Gallery was finally founded by citizen leaders in the Industrial Bureau in 1912, making it the first civic art gallery in Canada. The Winnipeg School of Art opened in 1913. Aspiring to become 'Chicago of the North', Winnipeg's economic development and population growth were significant. An important and thriving railway centre, the building of major institutions such as the Winnipeg Carnegie Library, two technical high schools, and the planning for the new Legislature energized and transformed the community.

Dr. Berry concludes that while the activities of these women were significant, by the time they disbanded, many had become redundant, being assumed by the new organizations: "the association appears to be the victim of the very progress for which the members worked devotedly." Yet the women

were visionaries. The early inclusion of First Nations art in the region's concerns, and the recognition and successful inclusion of multicultural dimensions in artistic activities are impressive aspects of the women's involvement in art. As well, their international interests imbued Winnipeg with an internationalism much earlier than other western cities, and the breadth of media these artists employed certainly laid the foundations for the scope of artistic work in the years to come. The prominence of china painting, for instance, generated an interest in ceramics, building a base for the later very significant national and international contribution of Winnipeg's contemporary ceramic artists. The exhibitions, teaching and lectures likewise established the benchmark for decades to come, providing a breadth of interest for the developing School of Art and Winnipeg Art Gallery. The women definitely opened the doors for Winnipeg's establishment as the vibrant arts centre it has become. Virginia Berry rightly emphasizes that "the legacy of these women was an enhanced appreciation of the visual arts in Manitoba. Without them it would have been slower in coming; after the club disbanded, the capacity remained."

Virginia Berry gave energetically and substantively to this project, even though she was already in her eighties when she wrote the first draft. Enriching the wider community and field of art history with a fuller understanding of the development and vibrancy of the visual arts in Manitoba, her work becomes a truly solid foundation for all who continue the rich exploration of western art. She has provided us with invaluable material and insights which will become a benchmark for future scholarship in this field. Virginia Berry, like the women about whom she writes, was a pioneer and has unquestionably "enhanced the appreciation of the visual arts in Manitoba."

Patricia Bovey

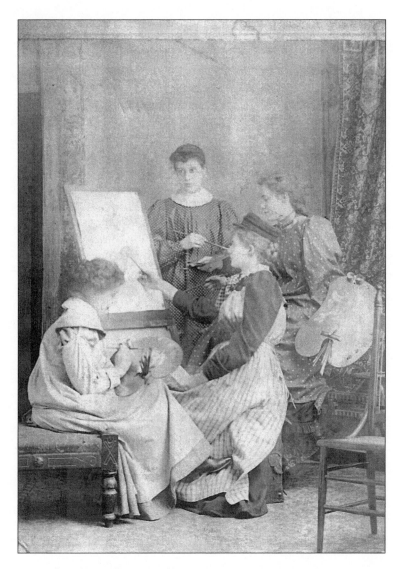

*Mary Dignam, seated centre, with students at the Associated
Artists School of Art and Design, Toronto, 1886.*

CHAPTER ONE

MARY DIGNAM AND THE FOUNDING OF THE WOMAN'S ART ASSOCIATION OF CANADA

In February 1894 "several ladies prominent in art circles" formed the Winnipeg branch of the Woman's Art Association of Canada.[1] This group was to become a significant force in developing the practice and appreciation of the visual arts in Winnipeg during the next two decades. The very existence of an art organization for women, dynamic enough to set up a western branch in the 1890s, raises intriguing questions about the Woman's Art Association (WAAC). What was the nature of the art community from which it came? How did it evolve? What sort of milieu did it find in Winnipeg?

The first key to the WAAC is its founder. Mary Ella Dignam, nee Williams, (1857-1938) was a Toronto painter and educator, who became deeply interested in promoting women's rights in the arts.[2] In order to understand her motivation it is useful to look at the art community which formed Dignam. In the early years of European settlement, art-making was primarily topographical. Explorers and settlers recorded the country's appearance, its inhabitants and their customs; native birds, animals, and flowers; and their own experiences in camps, homesteads, and towns. Portrait painters worked in larger

centres, while other artists portrayed religious subjects, especially in Quebec. The few who put down roots were scattered across the vast country and usually worked in isolation.

By the mid-nineteenth century, however, a cohesive art community began to develop as the promise of cheap land and other opportunities in Canada attracted an increasing flow of immigrants. Among them were a few artists from Great Britain, continental Europe, and the United States, who brought new ideas, as well as numerical strength to those already in residence.

In the following decades supportive art institutions, modelled on those in other countries, were gradually established—the Art Association of Montreal (1860), the Society of Canadian Artists (Montreal, 1867), the Ontario Society of Artists (1872). These were followed by the Central Ontario School of Art and Design (1876), the Royal Canadian Academy of Art (1880), the National Gallery (1882), and the Toronto Art Students League (1886). Although limited at first, they provided opportunities for instruction, venues for the exhibition and sale of works, and places where artists could associate with kindred spirits.

London, Ontario where Mary Dignam spent her formative years as an artist, is an example of these pioneering days. In the mid-fifties, four English artists of similar age and with some years of professional experience made London their home. At first none was able to establish himself as a full-time artist. Charles Chapman (1827-87) began a book bindery.[3] John Robert Peel (n.d., fl.1855-?) started as a marble cutter at a monument works and then became the owner.[4]

James Griffiths (1825-96) was employed as a civil servant, and his brother John Howard Griffiths (1826-98) farmed and then had a photographic studio.[5] Peel and Chapman have left no information about their life and training in England. The Griffiths, however, had spent some years as apprentices and then decorators at the well-known firm of Minton's China Works. John had also studied with Edward Villiers Rippengille, who showed at the Royal Academy from 1813-1857.

To supplement their incomes and fill a gap in local art education, Peel and Chapman gave lessons at their studios. Peel also taught drawing at the Old Mechanics' Institute, while Chapman instructed students at the Hellmuth Ladies' College. All four artists continued to draw and paint, specializing in landscape, still life, and floral subjects. Their chief exhibition space was the art section of the Upper Canada Provincial Exhibition, which was sometimes held in London. In addition to providing an audience, the Exhibition had a competitive side with prizes awarded for excellence. It also gave artists from the region an opportunity to meet, form friendships, and exchange professional information. James Griffiths is credited with convincing the administration of the Exhibition to admit china painting to the fine art section.

In the late sixties William Lee Judson (1842-1928) introduced a more continental style to London.[6] When he was a boy of ten he had emigrated from England to Brooklyn, New York. He studied first with his father and then with John Beaufain Irving (1826-77), a painter of portraits and genre subjects, who had studied in Germany for many years. This was followed by work in Paris with William Adolphe Bouguereau (1825-1906) and Jules Lefebvre (1836-1911), well-known artists of solid reputation and members of the select Académie des Beaux Arts. In London Judson devoted himself to painting, teaching, and filling commissions, mostly for portraits.

Seeing a demand for more art instruction in London, Peel, Chapman, and the Griffiths joined forces in 1870 to found The Western School of Art and Design, which combined the study of the fine and decorative arts. John Griffiths was Principal. The curriculum included drawing, painting in water colours and oils, modelling, industrial design, china decoration, etc. The founders hoped that their students would combine proficiency in art with improved design for industrial products. The work of the London artists was recognized when James Griffiths was elected to the Ontario Society of Artists (OSA) in 1873, its second year. Chapman became a member in 1874.

This period of artistic growth occurred in Mary Williams'

youth. She was the only child of Byron Williams Esq. and Margaret Fergusson, the third generation of a United Empire Loyalist family to be born in Canada. In her mid-teens Mary went from her home near Port Burwell for secondary schooling, most likely as a boarder at Hellmuth Ladies' College. The girl, who had drawn and made pictures from childhood, found the atmosphere in London stimulating. She studied with Judson, who followed the French method of teaching—copying pictures, drawing from casts, and painting landscapes. He also used the colouristic and genre techniques learned from Irving.

John Peel's gifted son, Paul Peel (1860-92) was a fellow student.[7] While Paul Peel developed into a famous figure and genre painter during the next decade, he exerted a lasting influence on Mary. She often mentioned their early association when describing her career.[8] His advanced studies at the Pennsylvania Academy of Art (1877-80), the Royal Academy in London (1880) and the Académie Julian in Paris (1881-86) surely encouraged her to adopt an artistic career. In addition to work with Judson, Mary studied in the British Arts and Crafts tradition at the Western School of Art and Design. From her later career we can see that china painting classes with John Griffiths made a deep impression, and so did the design section of the school, with its goal of improving the quality of crafts and manufactures.

In the meantime Mary Williams had decided to embark on the domestic career customary for women of her time. On March 2, 1880 she was married to John Sifton Dignam, a London china merchant whose background resembled hers. His grandfather, John Sifton, was one of the original settlers in London Township.[9] The marriage of this well-connected pair, however, was not at all conventional. Mary, who had become an independent and strong-willed woman, had no intention of giving up the art interests, which meant so much to her and which had been encouraged during the previous six years. Somehow she won John over to an unusual arrangement. After the birth of a daughter, Frances, in 1881, Mary had several years in which to pursue her ambitions, while her sister-in-law

(another Mary Dignam) looked after the household. Dignam is believed to have financed her activities by conducting European art tours for women and to have sent some of this income to her family.[10]

Mary went first to New York and enrolled in the women's section of an interesting new school—The New York Art Students League (NYASL). The League was based on the European studio tradition with emphasis on drawing, outdoor sketching and painting, and life studies. Except for weekly critiques by experienced artists, the classes were unsupervised. William Merritt Chase (1849-1916) was Dignam's principal critic. He had come to the NYASL after six years in Europe, mainly at the Königliche Akademie in Munich. Although still young, he was known for realistic genre scenes and portraits. As a change of pace Dignam painted flower subjects at the studio of Mrs. Julia McEntee Dillon (1834-1918), who had studied with her cousin Jervis McEntee, a member of the Hudson River School.[11]

At this point Europe beckoned, especially Paris, the mecca of nineteenth century Canadian artists and for Dignam, associated with Judson and Peel. She made it her centre with additional work in Holland, Italy, and other parts of France. Her two teachers, Louis-Joseph Raphael Colleu (1850-1916) and Luc Olivier-Merson (1846-1920), were both exponents of academic realism. Colleu had studied with Bouguereau and Cabanel. He was known for his genre, portrait, and nude paintings, and was a successful mural painter. Merson, with many of the same interests, specialized in historic subjects. Five years in Italy (1869-74), during which he won the Prix de Rome, brought him under the influence of the Italian Primitives. He developed an archaic style often seen in paintings and designs for tapestries, stained glass, and murals.

During these years Dignam returned periodically to visit her family. She also kept in touch with the Ontario art world by showing her new work regularly at the Western Art Fair. In the summers from 1880-85 Peel also returned to London and exhibited. Mary gained recognition consistently but did

not receive top prizes. In 1885, for example, she was placed third in a difficult competition in which Peel, now OSA and ARCA, won first prize and Frederic Marlett Bell-Smith RCA, OSA (1845-1923) was second.[12]

After some portrait painting in her early years, Dignam now began to concentrate mainly on flower studies and landscapes done in the plein air method so popular in New York and France. In 1893 she explained her method in the following way:

> I paint no studio pictures, for all my work is done out-of-doors, and painted from direct contact with nature. I am much too fond of landscape to sacrifice it to the figures which go with it… my pictures must be true of the landscape environment.[13]

In 1886 the years of concentrated study and travel came to an end. The Dignams moved to Toronto, where John established himself as a coke merchant. Mary opened a studio and began to acquaint herself with the local art scene. Except for occasional absences, often in the summer, Toronto became her home. The tension between a career and family remained; the birth of a son, William, in 1887 did not interrupt her professional life.

After her student years in London, New York, and Paris, Mary Dignam was disappointed to find that Canadian women had very limited access to instruction and careers in art.[14] Art education was at a low ebb. The original Central Ontario School of Art, founded by the Ontario Society of Artists in 1876 and later associated with the provincial Education Department, had been closed that year. In its place the department had set up the Toronto Art School, which was more utilitarian and bureaucratic than its predecessor. It lasted for only four years. Concurrently, the OSA made unsuccessful attempts to found a rival school. Less ambitious was the Toronto Arts Students League (TASL) based on the NYASL, which was begun in 1886 by artists connected with engraving and lithography.

For its first years, however, membership was confined to

men only.[15] This may have followed NYASL practice, which had separate sections for men and women. In Toronto there was no provision for a woman's group.

Furthermore, the OSA and the RCA offered limited opportunities to women. Dignam had exhibited with the RCA since 1883 and with the OSA since 1884. While she valued the exposure these shows gave her work, she probably took it as a matter of course for an artist of her experience. Her feelings sharpened when she discovered how hard it was to be elected a member of the societies and what a minor role women members played. She found this situation unfair and attributed it to male discrimination. The membership rosters were revealing. The OSA waited until its third year before electing Esther K. Westmacott, who specialized in oil painting. In total seven women joined in the 1870s in contrast to sixty-five men. This proportion of women to men continued: six women and thirty-two men in the 1880s, five women and twenty-eight men in the 1890s.[16]

The Royal Academy was even more selective. The only woman to become a charter member was Charlotte Schreiber (1834-1922), who had studied portrait and figure painting in London, England before coming to Canada in 1875. She did not, however, enjoy the same privileges as her male colleagues. Women, the constitution stated, "shall not be required to attend business meetings nor will their names be placed upon the list of rotation for Council." Some years later this clause was removed, but as Newton MacTavish wrote in 1925, "all along there seems to have been a determination to deter women from taking an active part in the affairs of the Academy."[17] This he ascribed to politics, saying that it was unlikely for any woman to secure enough votes for election although a number were considered better painters than some Academicians. After Schreiber, no woman was elected a full member before Marion Long in 1933. Only three women were made Associates in the eighties and seven in the nineties.[18] Since more than half were already OSA members, the number of women belonging to the two societies was very small. Dignam was a frequent candidate

for membership in both, but her work fell short of the exacting standards expected of female members. It is also likely that her manner of claiming opportunities for women artists was unpopular.

Looking back some years later, Dignam described her view of women's status in the Toronto art community in this way: "When I began work for art in Canada, women had no recognition or place."[19] As a result Mary Dignam resolved to improve and create opportunities for female artists. This decision proved to be a turning point in her life, which had previously been focused on her own work.

Like many before her, Dignam decided to give art lessons. She joined the Associated School of Art and Design, which had been founded by Esther K. Westmacott, the first woman member of the OSA and the daughter of Stewart Westmacott, an English portrait and landscape painter and art teacher.[20] Her school was inspired by such English institutions as London's Female School of Design. It undertook the task of teaching useful arts to young women so that they could earn a living: interior decoration, fabric and wallpaper design, and handicrafts.[21] The arts and crafts atmosphere of the Associated School must have reminded Dignam of her student days at the Western School of Art and Design. She was the Associated School's first teacher of drawing and painting. Three years later the school was struggling. When Westmacott retired because of poor health, Dignam became the head. She changed the school's orientation from the decorative to the fine arts, a move which proved to be popular.

Dignam's second teaching post was at Moulton Ladies' College, formerly Woodstock College of Woodstock, Ontario. In 1888 the Toronto Baptist College and Woodstock College merged to become McMaster University and Moulton became its art department in 1890 on Dignam's initiative.[22] Lucius O'Brien OSA (1832-99), the president of the RCA from 1880-90 and a famous painter in both watercolours and oils, was nominally in charge of Moulton's art department for the first year. Dignam, however, is looked upon as the working founder of the department, who guided its fortunes from 1888-1902.

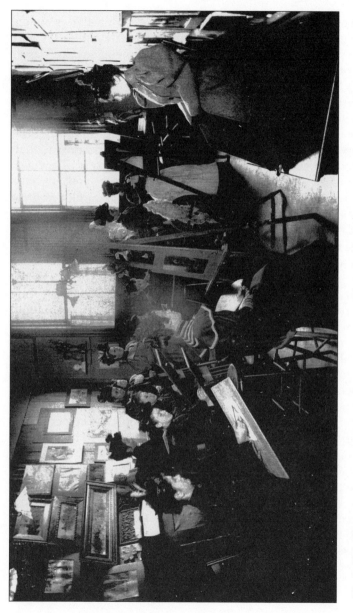

Sketch Club: Women's Art Association of Canada, Canada Life Building, Toronto, January 5th, 1895. Mary Dignam, seated centre.

Moulton offered a classic curriculum of drawing, painting, copying, china painting, etc. Unlike many girls' schools, where art was undertaken as an accomplishment, these classes encouraged students who wished to go on to advanced work.

While finding her way as a teacher, she took an innovative step. In 1887 she organized a club for advanced students and professionals. Like the TASL, the Woman's Art Club (WAC) owed much to NYASL, where Dignam had studied.[23] The group acquired a room in which members could pursue their work, with an emphasis on drawing from models. They also held meetings, sponsored lectures on art subjects, and exhibited their work. The WAC filled a genuine need and enjoyed great success. Five years later it was incorporated as the Woman's Art Association of Canada (WAAC), a self-governing institution, which was not under the auspices of established art institutions. The Association had two general aims: to promote and encourage more general interest in art in Canada, and to foster the mutual help and co-operation of women who were either serious artists or lovers of art. Their motto was Labore et Constantin (Toil and Perseverance). Dignam then began to recruit ancillary groups, starting with London, her old home. In 1894 she asked Mary Phillips, an established Montreal artist and fellow exhibitor in OSA and RCA shows, to organize a branch.[24] A western outpost, Winnipeg, followed soon after.

In founding the WAC and WAAC Mary Dignam had found her profession. She was an enthusiast, deeply concerned about the status of women artists and the place of art in her country. Her energy and gift for organization led to positive action at a time when such enterprise was unique. Although Dignam worked diligently as an artist throughout her life and exhibited frequently, she was never more than a painter of medium talent. Instead, her great contribution to art was the initiation and development of active interest groups for women, which nurtured their members' careers and improved the level of art in Canada.

CHAPTER TWO

ART IN WINNIPEG BEFORE 1894

The fast-growing village of Winnipeg, whose population was 241 in 1871, had become a city of 34,954 in 1894, the eighth largest in Canada.[1] Its isolated position on the western frontier, cut off from eastern Canada by many miles of the pre-Cambrian Shield, had been ameliorated by the transcontinental railroad, a line south to St. Paul, and rising settlement further West. Winnipeg then established itself as the main railroad and distribution centre of western Canada, dominating the agrarian economy of the area and equipped with a variety of local industries. It was also the seat of Manitoba's government, judiciary and educational system. From the beginning the city, whose citizens came from varied backgrounds, had a rather cosmopolitan flavour. Pride in economic growth was accompanied by the desire for cultural and educational achievements as Manitobans aspired to have amenities similar to those in their former homes. Also they wanted to show that the new province was much more than a raw, materialistic place. These goals were difficult to achieve because the effort of establishing new homes and occupations absorbed the main energy of early settlers.

As in Ontario, Manitoba's chief art event was the

Agricultural Fair. The first years were hard. Optimistically founded as early as 1871, it lasted for only two years. When revived in 1876, however, there were a surprising 1225 entries from Winnipeg and the surrounding country in all classes, but the Fine Arts section was unimpressive. The *Manitoba Free Press* dismissed local art as being in its infancy and compared it unfavourably with the attainable success in agriculture: "…if we cannot yet produce paintings to rank with those of the old masters…we can raise four pound and a half ounce potatoes and thirty-six pound turnips."[2] The next ten years saw an annual Fair, except for 1882. This stability was accompanied by art entries of improved quality, submitted by a growing number of professionals and amateur artists, attracted to Winnipeg as a growing centre. Among them were architects, surveyors and teachers.

When economic depression followed the good times, the Fair stopped again, but the concept persisted. Four years later a civic by-law created the Winnipeg Industrial and Agricultural Association (WI), an institution which held annual exhibitions from 1891 to 1915, when the First World War caused its suspension. A committee led by Lauchlan A. Hamilton, the land commissioner of the Canadian Pacific Railway and a keen amateur artist, did much to improve the quality of the art section. In addition to upgrading the facilities, tightening regulations, and increasing the prize monies, the art committee brought in established Canadian artists as judges. In 1892 Marmaduke Mathews (1837-1913), a well-known Ontario painter and member of the RCA and OSA, judged the entries. He was also available to talk to local artists about their work. 1893 brought a new feature: the OSA mounted an exhibition on loan of one hundred and fifty-six paintings. For many Winnipeggers this provided a first exposure to a large range of contemporary Canadian art. F. McGillivray Knowles (1859-1932), OSA and ARCA, accompanied the exhibition and probably judged the local entries. From this time, outside judges and loan exhibits came frequently, some of the latter borrowed from Montreal, New York, and Europe, as well as Toronto

and Winnipeg collections. The quality of the art section still fluctuated, mirroring the condition of the local community, but the WI remained an important venue throughout, because it gave local artists in Winnipeg access to the work being done in distant art centres.

As yet Winnipeg had no school of art. There was a movement in 1881 to initiate one because "schools for the teaching of drawing, sketching, and painting are being established in the chief towns of Canada…Toronto, London, Kingston, Ottawa and Montreal have now efficient art schools which are producing the best results."[3] A Mr. Legg, said to have been involved in founding the Ottawa school, felt that the impending visit of the Governor-General, the Marquis of Lorne, would furnish an impetus to the plan, because of his well-known art interests. Although the art school did not materialize, the project resulted in a significant step. The Department of Education decided to initiate public school classes for industrial and ornamental drawing, and for painting in watercolour and oils.[4] The programme was not fully implemented for some time. By 1892 the Winnipeg schools used the Prang system for the first three grades; this American system revolved around the study of colours and shapes, trained students in observation and taught map making. Two years later the Prang curriculum had been extended to grade six. Convents and other private schools for girls already taught drawing, painting, and ornamental penmanship.[5] Since some artists also gave lessons in their studios, the result was a small network of art education.

In March 1886 a new initiative led to the formation of the Winnipeg Art Society (WAS) for the advancement of painting and drawing. The executive committee included R.E. Young, the Provincial Land Surveyor of Manitoba and a keen amateur photographer; W.M. Huston, an artist associated with Soper's art and picture framing business; W.C. Kievel, a sign writer and painter; and Dr. J.A. McArthur, an art amateur, who was married to one of the most prominent artists in Winnipeg. While living in Montreal, Lucille Casey McArthur (1844-1902)[6]

13

had studied painting with William Raphael (1833-1914), a member of the Society of Canadian Artists and RCA, who was a portrait and genre artist trained at the Berlin Academy. She also learned china painting from Edward Lycett (1833-1910), who had emigrated to New York City in 1861 after working at Copeland and Garrett in Staffordshire. He is considered the pioneer of china painting in the United States. McArthur exhibited many works at the WI after her arrival in 1885, and she gave lessons in her studio.

Women, among them certainly Lucille McArthur, indicated at once that they wanted to belong to the WAS. At a special meeting, the members yielded to this pressure and arranged for shared studio accommodation, allotting two days a week for ladies, two for gentlemen and the rest for mixed groups. Twenty-five women joined, bringing membership nearly to fifty, and a committee of five women was appointed to co-operate with the executive committee in managing affairs.[7]

In May the WAS held an exhibition of work by members and their pupils to which teachers from city schools and colleges and their students were specially invited. Between the hours of two and ten about three hundred people came. This was considered "very satisfactory" and "a success for a first effort."[8] The WAS was also instrumental in securing new quarters and an increased prize list for the Fine Arts section at the WI.[9] These improvements and the concentrated work carried on in the WAS studio resulted in a larger section than usual at the WI. The show made a good impression. "On these walls," wrote a *Free Press* reporter, "rests the most complete answer to the opinion held by many easterners that the Northwest has but little refinement and is entirely inhabited by money grubbers."[10]

After the first enthusiasm wore off, the Winnipeg Art Society began to decline. On January 31, 1887, the members decided to dissolve it and organize a new group, the Manitoba Art Association (MAA), which was open to all who were interested in joining. The founding meeting was well attended, "especially by the ladies."[11] Continuity with the WAS was furnished by

several officers (McArthur, Huston and Kievel). An addition was John Soper. He allowed the club to use two large rooms over his art shop as studios, where classes were held for three days each week. For some years the MAA continued to exist as a nucleus for artists of both sexes, even though it did not have a high profile.

Opportunities for marketing art were rare. At first artists attracted attention through newspaper stories and advertisements; occasionally they placed paintings in prominent store windows. Selling pictures as a commercial enterprise evolved slowly from framing operations. In 1875, for example, Bishop and Shelton's Pioneer Furniture Company described themselves as cabinetmakers and framers. By 1880 they were displaying oil paintings, chromos, and holiday goods along with parlour furniture on the second floor of the store. Over the years they featured prints, especially steel engravings of works by famous international artists.[12] A high point came in 1891 when Bishop's arranged an ambitious show and sale of local works, designed to "encourage and stimulate art", since Winnipeg lacked "art centres or Art Expositions established solely to collect works of merit and offer them for sale."[13] The large number of contributions was a revelation to visitors. Outstanding exhibitors were Victor Long[14], Winnipeg's chief portrait artist and a painter of landscape and genre subjects, who had studied in French and German academies; and Margaret Hackland Sutherland (Mrs. Angus), who was active from 1888 to 1912 and was known specially for china painting and watercolour landscapes. She was currently upgrading her skills at the NYASL.

Although the show was well attended, sales evidently lagged. Works not purchased or not called for by their owners at the end of the exhibition were sold at auction. Shortly afterwards Bishop's experienced a shaky financial period. In 1892, however, they advertised a sale of oils and watercolours by Marmaduke Mathews and Thomas Mower Martin as the first of their annual shows of work by Canadian artists. Again the remainder was sold at auction.[15] Several months later

Bishop Furniture Company went bankrupt and was bought by J. H. Cook, who had had experience in the framing and gilding departments of the Toronto Gallery of Art and the Fine Art Emporium.[16] Although he continued to carry some pictures, Cook's emphasis was on furniture and framing, thereby avoiding Bishop's premature efforts to establish an art dealership.

Bishop's competitor, John G. Soper of the Pioneer Art Gallery founded in 1881 was more specialty art-oriented.[17] In addition to framing, carving and gilding, he offered a select range of artists' supplies: Whatman drawing paper, watercolour paints from Reeves Sons and Winsor and Newton, and a variety of brushes (camel, sable, badger and bristle).[18] He also rented out studios for copying.[19] His stock of pictures included steel engravings and paintings in oils and watercolours by known artists such as Frederick Arthur Verner OSA (1836-1928). Verner was famous for his depictions of First Nations people, the landscape of the Northwest, and buffalos. In 1890 Soper also sold at auction Paul Peel's *The Fish Market* for the then sizable sum of one hundred dollars.[20] As a dealer in pictures and artists' supplies, Soper boasted that he had the best and only art gallery in the Northwest.[21] His interest in art went beyond the sales room, when he encouraged local artists by lending studio space to their organizations and by serving as secretary-treasurer for the MAA.[22]

The first substantial art exhibition featuring the work of one artist was presented by Lucille McArthur in 1888, not at Bishop's or Soper's, but in the Federal Bank Building. For more than two years she had been travelling and studying art in Amsterdam, Munich, Rome and Paris. Like the Dignam family in a similar situation, John McArthur's unmarried sister, Isabel, had looked after the household. Lucille spent a large part of the time working at the Académie Julian, and she had succeeded in having two of her paintings hung at the Paris Salon.

For a week McArthur exhibited the Salon pictures and more than a hundred landscapes, genre subjects, still life and life studies, the latter hung in a curtained space. As an added

feature the artist was on hand to discuss her work. Attendance was large, reaching five hundred by mid-week.[23]

What was McArthur's work like in 1888? No pieces from that period are available today. The Salon paintings cannot be traced, but they were surely done in the academic style of the time at a competent level. McArthur combined realistic handling with romantic subjects and backgrounds. In *Telling the Bees* a girl brings the message of a death in the family by draping the hives. The theme is underlined by the intrusion of black on the soft colours of the pretty garden scene. *Woman in White*, set in a remote spot near evening, has darker colours and stronger forms. In both the figures are well handled. McArthur's work stood out in Winnipeg and won recognition further afield when she exhibited at the Minnesota State Fair and the Fine Arts Pavilion at the World's Fair in Chicago.

After three years of teaching and painting at home, she left in 1891 to pursue a more extended period of study. Her later work is broader and more confident and shows some influence of Impressionism in its use of colour. *Portrait of a Boy* compares well with work by such Canadian painters as George Reid.[24]

CHAPTER THREE

THE WINNIPEG BRANCH OF THE WAAC 1894-96

Such was the nature of Winnipeg's evolving art climate in 1894. Some progress in establishing an art community had been made, but much remained to be accomplished. The Fine Arts Section of the Fair had become well-established as the chief exhibition. Original art, reproductions, and artists' materials were sold by Bishop's Furniture Company and Soper's Art Gallery, which sometimes showed and marketed local work. There was no school of art, but some art subjects were taught at various artists' studios and in public and private schools. The short-lived WAS and the MAA had shown that there was a group of artists interested in working together. Since many were women, conditions for introducing a branch of the WAAC seemed favourable.

Local impetus for the WAAC group came from Maud Moore, a young woman, who was only known for her successful entries in the 1893 Winnipeg Exhibition and for her recent study with Mary Dignam.[1] From her initiative in creating a local branch, it may be inferred that she had leadership qualities, determination to progress as an artist, and enthusiasm for the WAAC program.

Dignam was careful to select women of ability to start

19

branches. Paintings exhibited in the east by western women were also said to have influenced Dignam to sponsor the branch.[2] The most prestigious was Lucille McArthur's *Gateway*, which was selected for the special RCA competition in 1893. After stops in Toronto and Montreal, the show had proceeded to Chicago, where it represented Canadian art at the World's Fair (Columbian Exposition).[3] Among other Manitoba artists, known in Toronto, may have been Elizabeth Taylor, who had studied in Paris in 1891 and was a friend and contemporary of Ernest Thompson Seton, well-known for his writings and depictions of natural subjects in Manitoba.[4] As well, there was Mrs. T.T.W. Bready, who had joined Lucille McArthur in Europe for further training during the past three years.[5] Carlotta Beattie of Portage La Prairie, a town west of Winnipeg, was a student of and assistant to F.M. Bell-Smith at Alma College in Saint Thomas, Ontario.[6] In 1893 she had won a silver medal at Toronto's art examination for ladies' colleges.[7]

Although these women were not in Winnipeg in early 1894 to launch the WAAC, a core group of about twenty professional artists and art teachers, students, and art lovers indicated their interest in forming a Winnipeg branch. They were attracted by the Association's goals of encouraging and promoting general interest in art in Canada; they especially welcomed the idea of fostering mutual help and co-operation among women artists and art lovers through exhibitions, art lectures and a studio where women could work together and have the freedom of drawing from models. Women in Winnipeg had not experienced as much exclusion from a male-oriented field as their colleagues in the East. They had been admitted to the WAS and the MAA, but on an auxiliary level, while men served as officers. The WAAC enabled them to have an independent group which was closely associated with like-minded women in Toronto, Montreal, London, and Hamilton.

As specified by the WAAC constitution, the branch (hereafter to be known as WB) had two kinds of members: active (professional artists and serious students, who were acceptable to the group) and honorary (women interested in art

and supportive of the group's projects). Fees were one dollar per year for honorary members and probably two dollars for active members. The latter was set as low as possible to remain accessible and still cover the expense of rental and basic equipment for a studio.

Some of the active members, in addition to Maud Moore, were Miss F.E. Van Etten, Miss Forrest, and Lillian K. Ponton B.A. The list of honorary members was led by Mary Elizabeth Aikins, wife of former Lt. Governor and Senator James Cox Aikins; Lile (Elizabeth) Drewry, wife of the owner of the flourishing Drewry's Brewery and city and provincial official Edward L. Drewry; and Mrs. J.H. Munson, wife of a prominent lawyer. Margaret Sutherland, a professional artist who had just re-opened her own studio after three years at the New York Art Students League, chose honorary status in order to support the Association, while carrying on her professional responsibilities.[8] For the most part the members belonged to the upper middle class. They had the inclination, the leisure, and the means to acquaint themselves, their families and the public with art matters. Maud Moore, the catalyst in organizing the WB, was elected president; other officers were Mrs. McBride, Miss Gertrude Drewry, Miss Van Etten, Miss E. MacFarlane, and Miss Stevens.[9] A priority was the recruitment of members with the expectation that more women would join when the club was fully organized.

The WB's first and eagerly anticipated achievement was to set up a studio in a well-lit room at The Manitoba, Winnipeg's best hotel. While fees looked after basic costs, each participant furnished her own materials. Sometimes referred to as a school, the studio group filled a niche between women studying with art teachers, and full-time professionals; they worked together on a co-operative basis. Things got off to a good start with approximately ten or twelve attending sketch and life classes at two-week intervals. Work with casts was also included and the studio was available to members outside of class hours.[10]

Two of the honorary members illustrate how the WB filled the needs of women artists at different stages in their

development. Mary Riter Hamilton (c.1873-1954) gained support, inspiration, and exhibition opportunities at the start of a long, distinguished career. When still a child, Mary Hamilton moved with her family from Teeswater, Ontario to Clearwater, Manitoba.[11] Her mother, Charity Zimmerman, was of United Empire Loyalist stock and her father, John Riter was a farmer and sawmill operator, who apparently looked for opportunities in the newly-opened West after his mill burned down. Because of Mary's tendency to gloss over events in her youth, except for references to the rigours of pioneer life, we know little about this period other than her early persistent interest in making art.[12] In 1889 she married Charles Hamilton, a merchant in Port Arthur. His premature death in 1893 left Hamilton a widow at the young age of twenty, well enough off to live independently. Mary's decisions about the future show her to be self-reliant, mature and determined to become an artist. In 1894 she chose to live in Winnipeg, near her family in Clearwater, but able to enjoy the advantages of city life. She also decided to become a professional artist and teacher of china painting. Hamilton was not rash enough to attempt this without any preparation. Obviously, her early talent had led to some, now unknown, art instruction and encouragement.

Mary seems to have devoted part of the interval between Charles' death and the move to Winnipeg in 1894, to improving her skills. Later she linked the move (misdated 1896) with a week's instruction from George Agnew Reid RCA, OSA and his wife Mary Hiester Reid ARCA, OSA.[13] Both had studied in Philadelphia and Paris before establishing a studio in Toronto in the late eighties. George had become one of Canada's leading genre painters, while Mary's specialty was still life. It is impossible to tell whether these lessons were in china painting or not. The experience brought her into contact with professionals of considerable training and achievement, who encouraged her to persevere in her aspirations.

China painting was not entirely new to Winnipeg. Lucille McArthur and Margaret Sutherland had listed it among their

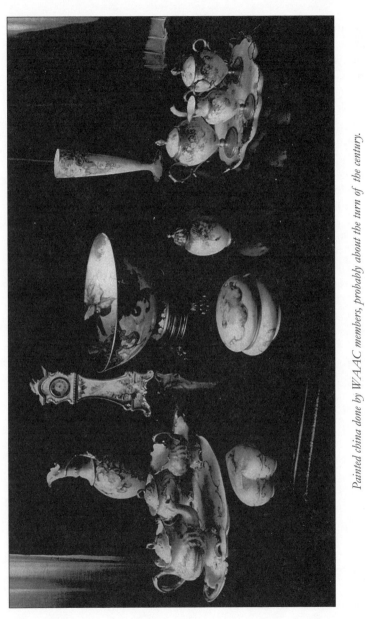

Painted china done by WAAC members, probably about the turn of the century.

Date and source unknown

teaching areas, and some pieces were shown at the Fair. The lack of a kiln, however, had curtailed efforts. Sending breakable objects away for firing was risky. In the summer of 1894 the *Nor'Wester* newspaper encouraged a dealer in art materials to fix this gap.[14]

Not long after, a kiln was brought in, either by the dealer or by Hamilton, who must have known how essential this technology was to her success. With the kiln in place, she was in a position to tap a hitherto unfulfilled interest in a very popular field. She acquired a house in a good section of the city and opened a studio, where, it was announced, she would teach the art of china painting at which she was very clever.[15] Such a venture must have seemed enterprising for a young woman barely in her twenties.

Another honorary member was Mrs. T.T.W. Bready, who was older and more experienced than Hamilton. Although at different stages, they shared the desire to be artists and were to draw strength from the WB. Mrs. Bready, whose husband was an executive in the grain trade, came to Winnipeg from Thedford, Ontario in the mid-eighties. After some previous study, she was keen to progress further. She showed paintings at the Fair (1886); listed herself as an artist in the City Directory; and joined the WAA, whose rooms she used for conducting classes. The major art event of 1888 was Lucille McArthur's display of her European works. Impressed by the artist's work and knowledge, Bready became one of McArthur's pupils. She developed well during the next three years. The next step was further work in Europe. Bready's situation gave her more independence than most married women had then. She had no children to look after; her husband apparently sympathized with her ambitions; and they had the means to subsidize extended studies. In 1891 she joined McArthur, who had recently resumed her work in Paris. For the next three years the Académie Julian was their centre. In 1892 they also painted in Germany, sketched in the more exotic country of Algiers, and worked in northern France during the summer. Bready broke this routine with a group of students and teachers in Wisconsin in 1893. In her final year in

Paris, she took trips to such artists' meccas as Rome, Florence, Naples, Venice and Switzerland.[16] All in all, it had been a rich and enviable experience.

Together with examples of her own work, Bready brought back a collection of pictures and other objects, which she installed in the Breadys' apartment at The Manitoba Hotel. Unlike Lucille McArthur in 1888, Bready neither held an exhibition nor returned to teaching. Quite soon, however, she joined the WB, where she was to find companionship, recognition and an opportunity to exhibit. In return, Bready inspired WB members with her accomplished work. She also was a role model, who showed that it was possible for women to study in prestigious studios abroad.

When the WB adjourned in June, a course of lectures was being planned. Members could feel that their organization had begun successfully, despite the novelty of its appeal. The studio furnished a valuable resource to women artists, and the WB looked forward to an expanding program. Following the WAAC calendar, the annual meeting took place in September. Maud Moore remained president with Lile Drewry, Mrs. Munson, Gertrude Drewry (Lile's daughter), and Lillian Ponton as the other officers. The new season started slowly; during the summer enthusiasm seems to have waned. The WB still needed members. While the honorary category had increased somewhat, the active group stayed much as before. Income from fees was so low that the studio program was in jeopardy. It was thus impossible to comply when Mary Dignam asked the WB to mount a show of pieces from WAAC affiliates, including local work. They could not afford the freight costs from the East to their isolated location, even though the Montreal and Toronto clubs offered to pay half the expenses.[17]

By January the situation of the WB had improved enough for the WB to arrange an exhibition of paintings and sketches for February 5 to 7 at The Manitoba Hotel. Both active and honorary members worked hard to ensure success for this first major undertaking, the first exhibition organized by a women's group in Winnipeg. The event was also seen as a turning-point

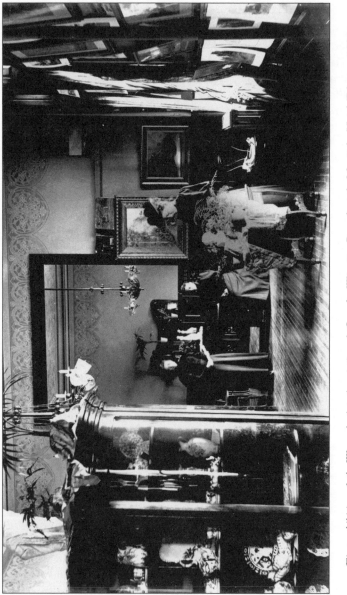

First exhibition of the Women's Art Association of Canada, Winnipeg Branch at the Manitoba Hotel, February 1895.

Source: Manitoba Archives, Events 7/4 (N7518) (Published with permission)

in the club's existence. "Upon the patronage which the exhibition receives from the public," said the *Free Press*, "will depend the continuance or dispersal of the society, and the latter misfortune it is earnestly hoped will be prevented."[18]

The Hanging Committee (Mrs. Bready, Mrs. Munson, Mary Hamilton, Maud Moore, and Agnes Culver) had the difficult task of selecting as well as displaying the works. Most of the three hundred submissions came from WAAC branches in Toronto, Montreal and London in Canada and from the New York Watercolor Society. The committee chose forty-two oils, fifty-six watercolours, eleven ink and pencil drawings, and a group of hand-painted china pieces.[19] They also prepared a catalogue. The mostly unframed pictures covered the walls quite densely as was the custom; ceramics were arranged in a china cabinet and on a mantelpiece. Using palms, ferns, flowers and drapery, Elizabeth (Mrs. J.C.) Aikins, Mrs. Lile Drewry, and Mrs. Henderson had created an attractive atmosphere in the rooms. Casts of the *Venus de Milo*, *The Greek Slave*, and two of Donatello's *Boy*, added a further dimension. The same committee looked after the opening and other social events during the exhibition. Admission was set at twenty-five cents, which included the catalogue.

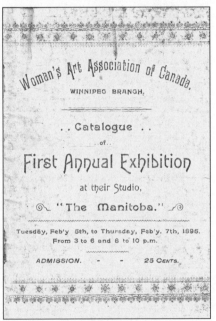

Woman's Art Association of Canada,
WINNIPEG BRANCH.

.. Catalogue ..
..of..
First Annual Exhibition
at their Studio,
"The Manitoba."

Tuesday, Feb'y 5th, to Thursday, Feb'y 7th, 1895.
From 3 to 6 and 8 to 10 p.m.

ADMISSION. - - 25 Cents.

On the opening night, attendance was "larger than the most sanguine had anticipated."[20] After Agnes Schultz, wife

of the Lt. Governor, opened the exhibition on behalf of her ailing husband, the audience spent time examining the works, while vocal and instrumental music was performed nearby. Committee members, identified by badges of red and white ribbons, the club's colours, circulated among the crowd, answering questions and providing information.

The show resembled the art section of the Fair in size and subject matter. Landscapes and still life done in a realistic style were combined with a number of sketches, some figure work, and occasionally with more impressionistic renderings. Prominent among the eastern exhibitors were Mary Dignam, Mary Phillips (a founder and vice-president of the Montreal branch), Emma Lampert (president of the Arts Club of Rochester, New York), Rhonda Holmes Nicholson (a medallist at the World's Fair in Chicago), and Clara Osler, who was living in Paris.[21]

The titles give us some of the atmosphere of the show. Dignam's four oils ranged from *Candlestick* and *Tree Trunk* to *A Scene in Muskoka* and *Waiting for Papa*, set in France. She also showed an intriguing drawing of well-worn boats. In the watercolour section Mary Phillips had two Montreal harbour scenes, a sketch of a woman sewing in an attic and two titled *An Old Salt* and *Roses*. Other favourites in this class were Lampert's colourful *Landing Oranges at Capri*, Nicholson's *Colored Children*, *Old Furniture* and *Fisherman and Boat*, and Osler's *Head*.

Naturally people were interested in the Winnipeg artists. This was the first time that Mrs. Bready, the veteran of the WB, had shown her European pictures in public, and they lived up to expectations. Two oil landscapes, one with a cottage, the other with poplars, captured the grey light of the French countryside. Her third entry was a still life of some cooking utensils set in front of a tiled wall in a country kitchen. *Placid Water* and *In the Woods* demonstrated Margaret Sutherland's ability as a painter of North American landscapes. The younger artists did well too. Maud Moore contributed attractive flower subjects (*Apple Blossoms* and *Violets*) and a still life of Spanish onions and a vinegar bottle, described as vigorous and well-finished. Lillian

Women's Art Association, Winnipeg Branch, first art exhibition, 1895.
Source: Archives of Manitoba, Events 7/2 (N7516) (Published with permission)

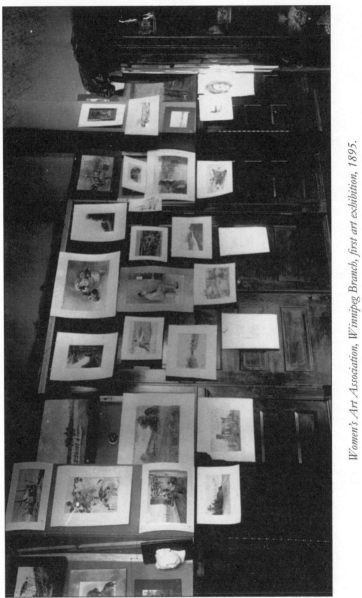

Women's Art Association, Winnipeg Branch, first art exhibition, 1895.

Source: Archives of Manitoba, Events 7/1 (N7515) (Published with permission)

Ponton's skillful ink drawing was titled *A Path in Mount Royal Park*. The ceramic section featuring Mary Hamilton's work was an attractive part of the exhibit, which also included pieces by Agnes Culver, Mrs. Raymond, and Mrs. Munson.[22] Hamilton showed a collection of Doulton, the well-regarded English firm, a coffee set, and a much-admired violet vase. She also hung some "artistic" (meaning impressionistic?) watercolours not listed in the catalogue.

Other added features were loans from local collectors; paintings by Mary Hiester Reid (Mrs. James Tees), an unidentified painting of an Italian girl holding a injured dove (Mrs. Bready), and a photogravure copy of the sketchbook made by the late Johanna Berg of Düsseldorf.[23] Attendance was excellent. Many enjoyed the exhibit as a major cultural and social event, and artists took the opportunity to absorb new ideas. The quality of the show and the efficiency of the project established the WB as a serious organization of women. Their professional status was underlined by the fact that many pictures were for sale and a note in the catalogue indicated that orders for Hamilton's ceramics could be left at the desk.

Financial results were also positive. The club cleared more than $20 from a gross amount of $69.35, which included commission on sales. The WB spent most of this profit immediately to purchase casts for the studio and subscribe to art magazines. Another important result was the addition of new members.

Buoyed by the successful outcome, Maud Moore expressed confidence in the club's future. She also paid tribute to Mary Dignam, saying that the exhibition would never have taken place without her cheerful encouragement.[24]

After the excitement and feeling of accomplishment generated by the show, the active members returned to consistent studio work on Tuesdays and Thursdays, and sketching on Saturdays. They also felt secure enough to reach out to a kindred organization of men, which had been founded in March. The Art and Literary Society, with H. Hartzheim as president, was a discussion group meeting at The Manitoba

Hotel. Since they planned outdoor sketching in the spring, the WB invited them to join the club's Saturday sessions in the interval.[25]

The season closed with an "at house" display of members' work done in the studio during the winter. Hoping to broaden their base, the WB advertised this event as free to all people interested in art. Next they turned to outdoor sketching.[26] In July the Fair provided another showcase for their work. Maud Moore and Lillian Van Etten both showed oils, watercolours, and drawing. Their still life studies and life sketches were singled out as greatly improved over former entries from them and the progress was attributed to consistent work in the WB studio.[27]

At the annual meeting in October the officers of the previous year were re-elected: Maud Moore (president), Mrs. Drewry and Mrs. Munson (vice-presidents), Gertrude Drewry (secretary), and Lillian Ponton (treasurer). The executive committee was made up of Maud Moore, Miss Forrest, Lillian Ponton, Gertrude Drewry and Mary Hamilton. This slate gave continuity to the WB and showed Moore's dedication to the club despite its varying fortunes. It also testifies to her success in leading a group of amateurs and professionals of different ages and backgrounds.

The main business of the meeting concerned changes in the WAAC constitution, which spelled out the nature of the branches more clearly than before. One item of particular interest stated that a branch must have a minimum of eight active members. If this was impossible to achieve, a strict procedure had to be followed. Minute books, any cash remaining after liabilities were paid, and real and personal property must be sent to the central association. This property would be held for two years and returned if the branch was reorganized during that time. Other areas also received attention. No officers should be paid; funds should be used exclusively for renting and furnishing rooms, employing models, and covering expenses connected with exhibitions. The names of the officers of the head association should appear together with the names of the

local officers on all publications. WB ratified all the regulations but one. Their experience made them feel that the requirement of a minimum of eight active members would be difficult for small places, possibly including themselves, to follow.[28] It was passed, however, by a majority of the WAAC.

The active members resumed studio classes and, following the WB policy of increasing interest in their program, welcomed visitors to the sessions. In November the group held another "at house", which was attended by the members of the Art and Literary Society and other friends. An hour of sketching, where members posed in turn, was combined with a social period. The WB planned to repeat this event every six weeks.[29] They also decided to add classes in the popular art of china painting. Mary Hamilton agreed to act as critic one morning a week if at least eight people enrolled.

Early in November the WB began preparations for the second WAAC exhibition. While the personnel of the working committees was virtually the same, a few changes in the operation occurred. The Selection and Hanging Committee (Bready, Moore, Forrest, Ponton and Gertrude Drewry) stipulated that entries should be original and not shown in Winnipeg before. Following the WAAC's growing interest in crafts and commercial art, they added categories of wood-carving, modelling, illustration, and design. The popular ceramic section now had a committee of its own: Hamilton, Culver, Paterson, Corbet, and Byrnes. The catalogue, compiled by Moore, Ponton, and Gertrude Drewry, was to be sold for five cents and to include paid advertisements. The Social Committee (Munson, Lile Drewry, Henderson, Aikins, and Culver) decorated the rooms and arranged the opening and other social events. Some hardworking members served on more than one committee.[30]

Advance publicity presented the show as another exhibition opportunity for local artists, a means of educating public taste, and a treat for Winnipeggers whose interest had made the February show successful.[31] A large gathering, including many prominent people, attended the opening. Among them

were the Lt. Governor James C. Patterson, Lt. Governor of the North West Territories Charles H. Macintosh, and the Commissioner of the Hudson's Bay Company and Mrs. Chipman. WB members were on hand to give information and an orchestra played in the background.

This exhibition was larger than the first with expansion in the black and white and ceramic areas. It was also considered of better quality. There was a larger proportion of local pieces displaying the improved skills of WB members, and finer pieces by outside exhibitors, who recognized the value of exhibiting in Winnipeg after the success of the first show.[32] However, there had been no response to the request for crafts.

Mary Dignam was the most prolific exhibitor of oil paintings with three flower pieces and three landscapes. Two favourites were *Last Days of Summer*, which portrayed a little girl waiting at a gate, and *In the Sunshine*, an impressionistic landscape. Charlotte Schreiber, RCA, OSA, the only woman charter member of the Royal Canadian Academy, sent *Dog* and *Head*. Oddly, neither her reputation nor her work was mentioned in the press. Mrs. Bready continued to be the local star, attracting special attention with an effective Algerian scene, *In the Rue Kasbah*, and an atmospheric rendering of *Cottages in Picardy*. Others singled out were Ethel Moore with *Artist's Outfit* and *Still Life*, Maud Moore with *Wild Roses, Sketch* and *Old Mill*, and Lillian Ponton with *Still Life, Sketch* and *Poppies*.

The increase in black and white work stemmed from contemporary emphasis on drawing, sketching, and commercial design. The WB's Miss Forrest showed a set of several drawings with such titles as *In a Hurry, Student*, and *Resting*, while Lillian Ponton provided still life subjects. Toronto artist Emily Elliot was praised for the relaxed poses of her ten wash drawings. Commercial art was a new feature. Among headings for newspaper submitted by the Toronto club were several designs for the Journal (S.H. Palin), one for a sporting column (Mabel Cawthera) and one for music (Mary H. Reid). Designs for a teapot and a glass were sent by Miss Conn of Montreal.[33]

The ceramic section had expanded from a modest offering

to one which included a collection from Toronto and the work of no less than thirteen Winnipeg women. Mary Hamilton was the principal local exhibitor; she was also the only artist to insert an advertisement in the catalogue.[34] Since no specific pieces are listed in the brochure or mentioned in the press, it is impossible to describe this part of the show. The numbers involved caused a problem for reporters who were faced with a relatively unfamiliar area.[35] "One must go and see to believe we have young ladies among us capable of doing such magnificent work" was one reporter's way of covering the challenging subject.[36]

After the opening night, attendance was disappointing. Supportive as usual, the newspapers recommended the show warmly. "Citizens who profess to be interested in art should certainly come", advised *The Tribune*, "It [the show] will bring pleasure to themselves and increase activity in the Association."[37]

By the close, these and other efforts had improved the situation, and the exhibition appears to have been successful. While not feeling the euphoria which marked the close of the first exhibition, the club seems to have settled into a satisfactory pattern, after the excitement and uncertainty they felt at the beginning. Indeed the pace of events was quickening. Within a week they had started plans for a WAAC show of ceramic art in mid-February. This demanding schedule was normal for eastern clubs and it indicated that Winnipeg had taken on the responsibilities of a mature branch.

The WB broadened its participation in women's activities in 1896, when it joined the Manitoba Council of Women (hereafter MCW), an organization founded in Winnipeg at the same time as the WB). This non-sectarian, non-partisan federation of women's groups was part of the National Council of Women of Canada (NCW), founded in 1893 as an offspring of the International Council begun in 1885. Lady Aberdeen, the wife of John Gordon, the Earl of Aberdeen and Governor-General of Canada (1893-98), was the president and active leader of both the international and national councils.[38] She also took an

interest in the provincial councils.

Ishbel Aberdeen's work with the councils arose from her involvement since youth in the educational and social problems of women and children. Her efficiency as an executive, ability as a public speaker, and influential position opened the way for many women of diverse interests to work together. Among them was Mary Dignam, who responded enthusiastically to the concept of the Council and found it akin to the WAAC's aims in the art field. Dignam became a charter member of the Ontario Council and she headed the NCW's art section. Soon Lady Aberdeen added to her duties the position of chief patroness of the WAAC. Acquainted with the arts from childhood and herself a competent watercolourist, she sympathized with the WAAC's efforts to foster women artists and to widen the practice and appreciation of art in Canada.

Thus it was natural for the WB to follow Dignam's example (and probably her urging) by joining the MCW. As their delegates to the group they chose several members: Maud Moore, Lillian Ponton, Gertrude Drewry, and Miss Forrest.[39] Belonging to the Council acquainted the WB with the day-to-day work of women's groups and introduced them to women from various backgrounds. In turn, their reports on WAAC activities reached a wider audience than previously. The other groups in the umbrella organization were ladies' societies in churches, the Children's Home, the Free Kindergarten, the Hospital Aid Society, the YWCA, branches of the WCTU (Woman's Christian Temperance Union), and the Lady Aberdeen Society, which collected and distributed reading material and seed packets to prairie pioneers.

At first the WB was somewhat of an anomaly in this company. The second MCW annual report noted that all member organizations but one were engaged in strictly Christian or philanthropic work.[40] Because of the Council's inclusive philosophy, however, this was not insuperable. The WB made a place for itself; and, because of her gifts as a committee woman, Maud Moore was chosen in 1897 as one of three delegates to the NCW meeting in Montreal.[41]

In addition to pooling information about its members' work, the MCW acted as a pressure group. Its first major effort centred on the introduction of technical training for boys and girls in the public schools. General interest in the topic had been heightened by an excellent paper given by Mrs. George Bryce in November 1894, and it was further encouraged by Ishbel Aberdeen, whose sponsorship of handicraft was well-known from the time her husband was Lord Lieutenant of Ireland and she promoted Irish work. The next year was spent lobbying the Minister of Education, studies of technical education in different places, and various negotiations. This resulted in only partial success. Manual training was to be introduced for boys and domestic science for girls.[42] The MCW continued to monitor the situation, and, of course, it was a cause that appealed to the WB.

Another example of community involvement was the WB's relation to the Fair. As a result of the successful WAAC exhibitions, they were asked to help compile the arts sections of the catalogue sent to intending exhibitors. The WB revised the prize list for the fine arts and made large additions to the china painting department. In addition to raising standards for entries, this revision gave specific information about the kinds of china painting, which was previously vaguely worded, which would inspire the best local painters. Categories specified were: raised paste and jewel work techniques; Doulton, Dresden, Delft, and Wedgwood styles; miniature; landscape; and monochrome. Suggested forms included tray, jardinière, rose jar, bon-bon dish, cocoa set and tea set.[43]

The ceramics exhibition in February was remarkable for concentrating on a single medium and one which usually was seen as an adjunct to the fine arts. The WAAC policy stated the one of three annual shows be devoted to ceramics and it was an attractive project for Winnipeg. Enthusiasm for china painting had blossomed during the past two years. The introduction of necessary technology had coincided with the arrival of Mary Hamilton, a specialist, who showed enterprise in promoting her work. Students ranged from women with some art training,

like Agnes Culver, to neophytes. May Corbet was an additional teacher.[44] In addition women had been inspired by viewing a variety of china painting in the first WAAC shows.

Attendance was encouraged by references to the club's record of giving first-class exhibitions and making them enjoyable. The committee's plan to serve tea each afternoon and present music in the evening aroused agreeable anticipation. "[The tea] together with the excellent work on view will make a pleasant break in the monotony of social inactivity of the Lenten season" was the assessment of *The Free Press*.[45] The exhibition, which was relatively small, included work by ten Toronto and fourteen Winnipeg women because a collection promised by the Montreal Branch failed to arrive.

The pieces were installed in rooms at The Manitoba Hotel, decorated in the now characteristic WB style. Plates were hung on the walls and other objects arranged on tables or in cabinets. Mary Hamilton, Miss Byrnes, and May Corbet were allotted individual cabinets. As an extra feature, H. Hartzheim of the Art and Literary Society had loaned two watercolours by the German artist, Jules Bretz.

Although no catalogue of the show survives, it probably contained a list of the exhibitors, but not a list of the numerous pieces on view, which *The Free Press* lumped together as "hundreds of bits of china tastefully decorated."[46] Some pieces, however, stood out. In the Toronto collection, there was a large urn decorated with flowers by Miss Coven, Mrs. Hannaford's Marie Antoinette tray, Miss Roberts' dainty five o'clock tea set, Miss Mason's pretty plates, and an unattributed bonbon dish with jewel work.

Photographs in the WAAC archives give an idea of how these or similar pieces looked. Although they are in black and white and not shown close up, floral compositions, often of roses, are skillfully adapted to round, tapering and flat forms. These are varied with the figures of cupids and small scenes, while conventional designs appear on the borders of trays and plates. Information about the Winnipeg entries is less specific. Mary Hamilton again demonstrated her expertise by showing

numerous pieces done in many techniques. She was especially commended for a group of plates. People praised Hamilton's outstanding pupil, Agnes Culver, for a vase, clock, and tray with a marine scene and Miss Byrnes' very pretty jardinière. May Corbet made a favourable impression with an artistic collection of Crown Derby, Worcester, Doulton, Belleek, and Lacroix styles. The other contributors were primarily Hamilton's students.[47]

Each day two WB members received visitors and two others served tea. General interest in ceramics also made the show popular. Viewers admired the attractively decorated pieces and appreciated them as potential accoutrements for their own homes. The exhibits also encouraged some to take up china painting as an art and as a do-it-yourself project. So many people came to see the show and enjoy the social occasion, that the project was another success for the WB.

No doubt stimulated by the exhibition, the active members revisited the idea of holding china painting classes. Now, however, there were two potential critics available, since May Corbet had volunteered her services. The club solved the dilemma by asking Mary Hamilton to act for the first three months, beginning immediately, and May Corbet to take over in the fall. At about the same time another art opportunity presented itself when the WAAC invited the WB to send entries in various media to an upcoming show in Toronto.[48]

Art lectures by professional men were part of the WAAC educational program, which the WB had not undertaken, despite good intentions. In early March, however, they arranged a series of four public lectures beginning on March 14 with "The Ministry of Art." This was to be given by James D. O'Meara, Professor of Theology at St. John's College and a Canon of St. John's Cathedral. Uncertain about the appeal of an art talk, which was a novelty in Winnipeg, the committee prepared a backup plan in case only a few tickets were sold: to meet in a smaller room and to produce the remaining lectures for members only rather than the general public.[49] They also added vocal and piano music to the program as extra attractions

and invited the Rev. Dr. George Bryce to chair the event. Rev. Dr. Bryce was a founding clergyman of Knox Presbyterian Church, a professor at Manitoba College and the University of Manitoba, and a recognized historian. Although the lecture was planned by a women's group, the main roles were allotted to men well-known in the community, as was the custom.

After an opening address by Dr. Bryce, Canon O'Meara delivered a wide-ranging and inspirational speech. He described artists not only as workmen who adorn sanctuaries, but as God's ministers who keep our ideal side alive. Also he felt that people need, appreciate, and are uplifted by experiencing art. Amenities like parks, bands, and picture galleries provide special pleasures. O'Meara applied these general concepts to life in contemporary Winnipeg. He urged the city government to devote more attention and resources to the teaching of art and the founding of an art gallery. And he specially commended the WB for their successful art projects. The gathering extended a vote of thanks to the speaker and underlined his remarks about the need for public help to establish an art school. It was proposed that the city government furnish the club with a rent-free room in City Hall. On this enthusiastic note the meeting adjourned with the next lecture scheduled in two weeks.[50]

The request for free space must have been related to the WB's financial problems. Despite its successful program, the club was not generating adequate income. Except for the substantial profit from the first exhibition, which was quickly spent, the WB depended primarily on fees from a small group, whose members fluctuated between twenty and thirty. A crisis came at the end of March when the club was not able to pay the studio rent. After a special committee failed to resolve the situation, they had to close the WB. Members covered the debts with voluntary contributions, and the records were sent to the WAAC.[51]

Certainly the collapse caused deep regret in both Toronto and Winnipeg. After sanguine expectations, Mary Dignam had lost part of the women's organization, which she visualized as national in scope. Maud Moore and the other WB members

had to face the fact that their hard work and enthusiasm had failed to attract enough women to ensure success.

It is hard to reconcile this outcome with the WB's successful program. Many Winnipeggers, however, may have found the art club and its goals an unnecessary frill. Despite repeated public appeals to women interested in art, the WB also may have seemed the pastime of a social group, which it would be difficult or impossible to join. Others probably considered the activities unsuitable for women. Certainly, the same attitudes existed in other places where the WAAC was located, but in Winnipeg they were accentuated by the city's character in the mid-1890s. Exceptional growth in population had not yet been matched by significant cultural development. The twenty years since its founding had not been time enough to establish a supportive art community like those in the East.[52] In 1891 London, Ontario at 31,979 was the closest city in size to Winnipeg at 25,639. In the 1894-95 season the London branch had one hundred members, forty of them in the active category, a figure three to four times that of the WB and far exceeding the twenty percent gap between all the residents of the two cities. This reflects London's status as a settled community with schools which had trained artists for more than a generation (e.g. Paul Peel and Mary Dignam in the 1870s) and raised general interest in art. Toronto, Hamilton, and Montreal, of course, had older traditions. In addition, Winnipeg's distant location deprived the club of easy association and encouragement from nearby colleagues.

Even so the women of the WB had succeeded in advancing visual art in Winnipeg through studio classes and open-house shows. They had carried out Mary Dignam's aim of enabling young women artists to help each other develop skills. The WAAC exhibitions had provided the wider opportunities of exhibiting in a national context and observing otherwise inaccessible work. The club also accommodated the needs of professionals like Mary Hamilton and Mrs. Bready.

People outside the organization benefited through the three WAAC shows, which supplemented the annual ones at

the Fair and played a special part in promoting ceramics. The club also formed alliances with other groups: the Fair, the Art and Literary Society, and the Manitoba Council of Women. It had been an enterprising, productive time and the effect of these achievements did not entirely disappear. Although the dissolution of the WB left a regrettable gap, this was the end of a chapter, not of the full story, of the WAAC in Winnipeg. Like the Fair, which had been revived after an interval, the Association would return when conditions were more favourable.

CHAPTER FOUR

ART DEVELOPMENTS IN WINNIPEG 1896-1903

In the decade spanning the turn of the century, Winnipeg continued its rapid growth and development. Advancing from a population of 37,983 in 1896 to 56,741 in 1901, it became the sixth largest city in Canada. Also more people were settling there permanently; by 1901 just over half the citizens of Canadian origin had been born in Manitoba. At the same time the general ethnic mix was changing with Scandinavians, Germans, middle Europeans and Jews increasing as British immigration became dominant.[1] The grain trade, transportation and wholesale industries remained central to the thriving economy. The earlier isolation that had once characterized Winnipeg was being eroded in many areas.

The art section of the annual fair, now named the Winnipeg International Exhibition (WIE), retained its high profile. In addition to presenting the work of artists, the art section directors usually included exhibits of contemporary Canadian art arranged by the OSA and RCA. Following a second visit from the artist F. McGillivray Knowles in 1896, other well-established artists such as Thomas Mower Martin (1838-1924), Frederic M. Bell-Smith, Robert F. Gagen (1848-1926), and Charles Macdonald Manly (1855-1924) acted as curators of the

shows and judged local entries. At the same time the travelling exhibits enlarged Manitobans' acquaintance with the Canadian art scene.

Charitable events provided another opportunity for viewing art. In December 1897, a committee of male collectors and artists borrowed paintings from Montreal dealers and collectors, from OSA and RCA artists (L.R. O'Brien, G.A. Reid, F.M. Knowles, F.S. Challener, R.F. Gagen), and from local sources for an exhibition and sale in aid of the General Hospital. Among the sponsors were L.A. Hamilton, who had succeeded in raising the standards of the art section of the WIE; architect-artist Walter Chesterton; H.A. Jukes, surveyor and topographical artist; Fred Phillips, a serious amateur; and the collectors James Tees and Dr. H.H. Chown. In June 1900 the Children's Aid Society was the beneficiary of a similar exhibition.

Visiting artists also mounted shows and sales. Winnipeg was a convenient stop en route to the Rocky Mountains, where artists recorded the striking landscape under the auspices of the Canadian Pacific Railway. Thus Frederic Bell-Smith showed his summer's work and pieces by fellow-artists at the Clarendon Hotel in 1899. The next year, also at the Clarendon, Otto Wix, a German miniaturist and landscape artist, exhibited recent paintings from the Rockies and the Lac du Bonnet region in Manitoba. Apparently successful, he repeated the event in 1901.

Art dealers widened their scope by improving general stock and occasionally holding special shows. John Soper showed steel engravings by such favourite members of the British Royal Academy as William P. Frith, James Ward, and Sir Edwin Landseer; and the popular French illustrator, Gustave Doré. This gave art lovers a connection with certain aspects of the international art market without major expense or effort. He also had oils and watercolours from various sources, including an 1898 group of western watercolours and paintings by T. Mower Martin, who had gone from the exhibition at the WIE to paint in the Rockies and the west coast.

Soper's business, however, was declining. In 1902 he went bankrupt.² Soper returned to business again and in 1905 he unsuccessfully fought a charge brought by the Morality Inspector of displaying disgusting pictures in his window that had "a tendency to corrupt youthful morals."³ These were described as "fourteen coloured prints showing more or less (usually less) display of limb by attractive females."⁴ Soon afterwards Soper gave up his gallery and went to homestead in Swift Current.

George W. Cranston then became Winnipeg's chief art dealer. Among the local artists whose work he exhibited were D. Macdonald, a member of the Scottish Academy, who had emigrated to rural Manitoba; W. Frank Lynn, the city's pioneer artist, who had studied at the Royal Academy in London; and Hester Baird, who specialized in china painting.⁵ In 1899 he featured a small collection of watercolours by the marine painter, William St. Thomas Smith RCA. Although Mower Martin had previously patronized Soper's, he and Marmaduke Mathews chose Cranston's in 1901 for a "grand display of watercolours and oils", which was followed by an auction of unsold works.⁶

Because of its prosperity and modest art initiatives, Winnipeg had become a potential market for eastern dealers. In 1899 Soper provided display space for the representative of Scott and Sons, an enterprising Montreal dealer. Scott had cultivated the Toronto market by organizing an exhibition in 1890 with successful results.⁷ The representative, J. Sydney Roe, provided superior stock to the international material previously offered in Winnipeg. In addition to English watercolours, he had Dutch examples from the Hague School, which was currently very popular in eastern Canada and Scotland for its realistic landscapes and genre subjects. He also brought proof etchings, line engravings, and a few Oriental rugs. Roe threw a sidelight on pictures often seen in well-appointed Winnipeg houses, when he said that cheap pictures or illustrations cut from the *London Graphic* spoil the effect of the most lavishly decorated rooms. A *Tribune* reporter considered this a valid

description of some of the city's best-furnished dwellings.[8]

The Foreign and Canadian Art Company of Toronto, represented by H. Block, showed its wares at Cranston's in 1902.[9] With turn-of-the-century hype, the artists were described enthusiastically as "men who have won their way to the front ranks of art."[10] Among the British, French, American and Canadian artists were Henry John Stannard (1870-1857), George Amis Aldridge (1872-1941), Homer Watson, and F.M. Bell-Smith. This collection of paintings by well-trained artists from various countries widened horizons and gave pleasure to viewers. In *Town Topics* E. Cora Hind singled out *An Arabian Courier in Algiers*, *Two Cardinals* and *Noon Day Rest* among the genre subjects and praised the landscapes, pastoral scenes and marine views.[11]

The Block exhibition ended with an auction, which had gradually become an accepted feature of exhibitions. Their stimulating atmosphere and the buyers' hope of securing a bargain helped to spread interest in owning art. Paintings and art objects were also featured at certain home auctions, and art dealers reduced stock or went into liquidation through auction sales. The most prominent auctioneer, Alfred Henry Pulford, had been trained in his father's furniture business in Winnipeg and in the American mid-West (1888-1893).[12] Observing a growing interest in art, he began to initiate art events directly, handling the insolvent stock of J. Hood and Co. of Montreal: steel engravings, original etchings, watercolour facsimiles, photographs, etc.[13] He followed this by auctioning a group of works by Bell-Smith.

In early 1903 the Toronto dealer Block bypassed the galleries by going directly to Pulford's with over one hundred oils and watercolours considered to be of better quality than the 1902 collection. Held on a bitter February day, the sale attracted few bidders and prices were low.[14] A more exotic and longer running event concerned a travelling collection of art and crafts from Austria, ranging from oils and watercolours, etchings and lithographs, to furniture, china, silver, gold, and other objects. It was sponsored locally by the Austro-Hungarian

Association of Manitoba and shown first in a freight car at the CPR. This material from a major centre of advanced art and design drew hundreds of people, eliciting more interest, it is said, than in any other city visited in Canada. Afterwards, a Winnipeg syndicate offered the collection for sale at Cranston's and another location before having the remainder auctioned at Pulford's.[15]

While the art market was developing, there was also progress in art education. Lessons in painting, drawing and china painting were offered by an increasing number of artists. Despite the gains in secondary education, there still was no school for aspiring professionals. Art continued as an important subject in private schools for young women: St. John's, Havergal, and St. Mary's in Winnipeg; St. Michael's in Brandon; and the convents of St. Norbert and Ste. Anne des Chênes. The nuns, who often had considerable attainments, passed on a style rooted in ecclesiastical tradition. At the time, instruction in most public schools was minimal.

The Protestant public school system in Winnipeg displayed some progress. By 1896 teachers attempted to spread the Prang system outside Winnipeg, although local school boards were disposed to resist this subject "which the youth of the country can get along very well without."[16] Yet four years later, drawing was well taught in Brandon and a few rural schools, and was somewhat established in the southeastern section of the province.[17] Chief among those who introduced art to provincial schools was Lily Aitchison, who had a diploma from The South Kensington Schools in London.

Boys in Winnipeg's elementary schools received further opportunities for art-making in 1901 when the MacDonald Lloyd system of manual training was introduced. This was a further step in establishing technical education first advocated by the Council of Women in the 1890s. Described as "teaching boys to use their hands and eyes", this British program, related to the Arts and Crafts movement, had been transplanted successfully to some eastern Canadian and American schools. Thus, when Sir William MacDonald offered to finance the course for a

trial period of three years, Daniel McIntyre, Superintendent of Public Schools, embraced the opportunity.[18] Staff came from England: W.J. Warters, an experienced manual training teacher and four English and Swedish assistants.[19] The results of their efforts were exhibited after the first year of instruction, when students from twelve schools showed drawings, watercolours, plans, and models.[20] The Manual Training course quickly made a place for itself, which lasted for much longer than originally intended.

During this period of modest gains in Winnipeg's art community, it is interesting to follow the careers of two emerging women artists who later had distinguished careers. We have already seen Mary Riter Hamilton's debut as a china painter and teacher. From 1896 to 1901 she persevered in her desire to become an accomplished professional. Now well-established as a teacher of china painting and watercolours, Hamilton exhibited consistently at the WIE, winning prizes and favourable press notices. Her entries gradually shifted from china painting to watercolours of flowers and still life. On several occasions she also held studio shows and sales of her work and that of her students. Feeling the need for further instruction, she went to Chicago in 1897 to study.[21] Two summers later she did some landscape painting with E. Wyly Grier (1862-1957), OSA and RCA, who had studied at the Slade School in London, the Académie Julian in Paris, and in Rome.[22] Recognizing her determination and talent, he encouraged her to continue her education.

By this time Europe was Hamilton's goal. This aspiration can be attributed to the advice of artists like Grier and the Reids, the work seen in WAAC exhibitions, and the example of Winnipeg women like Bready and McArthur. It was a challenging plan for a young woman, who was dependent on her own resources instead of having the support of a co-operative husband or the camaraderie of student friends. A means of realizing her ambition came through Agnes Culver, a pupil and WAAC colleague, whose daughter Jean needed a companion, while studying music in Berlin for a year. Hamilton

grasped the opportunity.[23] Whether she realized it or not, this was the end of her china painting period, her early efforts to master other media, and the nurture she had received from the WAAC program and its members. The winter in Berlin as the pupil of landscape genre artist, Franz Scarbina (1849-1910) gave her the confidence to go on to Paris and to fulfil her latent talents.

Another ambitious young woman, Caroline Helen Wilkinson Armington (1875-1939) arrived with her artist husband, Frank Milton Armington (1876-1941). They had met as teenagers in classes in Toronto conducted by the well-known portrait painter, John W.L. Forster (1850-1938) OSA, ARCA. Caroline's efforts to become an artist, however, met with family resistance. The Wilkinsons wanted their daughter to learn more useful and feminine skills. While Frank studied with Forster for seven years, Caroline spent some of that time teaching and training as a nurse. The two young artists maintained their common interest in art and grew increasingly fond of each other.

In 1899 the Armingtons arranged for Frank to continue his studies in Paris, accompanied by his mother and sister. Caroline went along as far as New York and stalwartly faced separation from Frank and the contrast between their opportunities. In the meantime Caroline used her nursing abilities to advance her career. While working in New York that summer she explored galleries and museums. After returning to Toronto she accumulated enough money to join the Armingtons in Paris. There is no record of her studying at that time, but Frank introduced her to the Paris world of museums, exhibitions and his fellow artists. Frank attended the Académie Julian, where his tutors were two members of the Académie des Beaux Arts: J.J. Benjamin Constant (1846-1902), a successful portrait painter and painter of Arabian horses; and Jean-Paul Laurens (1838-1920) whose speciality was historical subjects done in a realistic style. A few months after her arrival, Caroline and Frank were married and returned to Canada.

Adventurously, they decided to settle in the fast-developing

West. After a short stay in Sault Ste. Marie, they arrived in Winnipeg in July 1901, perhaps because Frank's father had a tent business there.[24] Since opportunities for young artists were meagre, Frank worked at the *Tribune* newspaper for a period. He also taught art lessons and painted portraits on commission. In 1902 he became art master at Havergal, a new private school for girls. Caroline also functioned as a professional artist, arranging her domestic duties so that she could give lessons. In 1902 she had ten students, a mixed group of girls, boys and women, most of whom came once a week. In 1903 this activity occupied two afternoons a week.[25]

Although life in the developing art community of Winnipeg was far different from that in Paris or even Toronto, it enabled the Armingtons to start professional careers and, after some time, to assess plans for the future.

CHAPTER FIVE

THE RETURN OF
THE WOMEN'S ART ASSOCIATION

Winnipeggers heard an unusual piece of arts news early in 1903. The WAAC offered the city the opportunity to participate in an interesting exhibition of contemporary watercolours, which had been chosen by artists in The Hague and Edinburgh. After showings in Toronto and Montreal, the exhibition would be made available to Winnipeg. This was a new departure for the WAAC, whose earlier projects had shown work by members and associates.[1] The redoubtable Mary Dignam had initiated this change through her personal acquaintance with artists in both countries, originally as a student, and then as an enthusiastic supporter. After being on view in Toronto for six or seven weeks, the exhibition had gone to Montreal under the sponsorship of Sir William Van Horne, a prominent figure in commerce and industry. At first the likelihood of finding high-profile sponsors and suitable gallery space in Winnipeg seemed poor. But eventually the format used for charity exhibitions was used. As befitted a WAAC project the sponsors were women, members of the Winnipeg branch of the Council of Women. This organization had been founded recently as an umbrella for women's groups throughout Canada. Dignam

was a founding member, who welcomed the concept of a national group to unite and further the various interests of Canadian women much as the WAAC did in art. Of course, she took a major part in the art section. Isabel McArthur was the Winnipeg Council's convener for fine and industrial arts. Her brother, Dr. John McArthur, and her late sister-in-law, the artist Lucille Casey McArthur, had been leading members of the Winnipeg art community since the 1880s.[2]

The committee secured space at the Masonic Temple and earmarked the proceeds of the show for the Children's Aid Shelter and the Free Kindergarten. Thus Winnipeggers had the opportunity to see quality art and contribute to a worthwhile cause at the same time. Which aspect was more important to Winnipeggers is uncertain, although the charity aspect was dismissed as incidental.[3] Fortuitously, a large and impressive group drawn from the Winnipeg establishment agreed to act as patrons.[4] The Toronto WAAC, however, remained the primary sponsors. It was their exhibit, after all. According to Dignam, the exhibition demonstrated the fact that contemporary watercolour painting had been brought to such perfection of modelling, colour and finish that it was equal to oils.[5] She planned to participate fully in the event, from the installation to the conclusion.

The much-heralded exhibition opened on February 23. For twenty-five cents one could see about seventy watercolours and pastels, together with a collection of cartoons. The subjects appealed to various tastes; they included domestic scenes, informal portraits, and many kinds of landscapes and city scenes. Attendance was very good and it was claimed that many "freely expressed astonishment at the excellence of the exhibition."[6] The Dutch artists, Jacob Maris, Jozef Israels, Bernardus Johannes Blommers, Pieter Groenewegen, and Willy Sluyters [a.k.a. Willy Sluiter] were particularly favoured, while the Scots, Alexander McBride, R.B. Nisbet, Thomas Scott and James Kay attracted many admirers. When crowds of viewers continued to come, Mary Dignam extended the exhibition for two days.[7] Another mark of success was the

sale of pictures at prices from $25 to $350. These included Groenewegen's *The Milking Time*, Ryp's *Birch Trees*, McBride's *Spring*, and Sluyters' *On the Beach*, *Sunday in Katwijk*, and *Student's Paris*.[8] These purchases were notable because they occurred very soon after Block's show and auction of similar material. The sales ensured that the exhibition was a financial as well as an artistic success. From receipts of $448, more than half ($251.05) found its way to the Children's Aid Shelter and the Free Kindergarten. Transportation of the pictures and Mary Dignam's travel expenses accounted for more than half of the show's expenditures. She had thoughtfully avoided further costs while in Winnipeg by staying with her husband's cousins, the prominent Sifton family.[9] Sir Clifford Sifton was a major figure in Manitoba politics, who served in the federal government of Wilfred Laurier as minister of the interior.

This watercolour exhibition resulted in the founding, for the second time, of a Winnipeg branch of the WAAC. The earlier failure must have presented a challenge to Dignam and the local art community. It was the Council of Women that set the wheels in motion. They called an open meeting at which Mary Dignam was to describe the WAAC and its aims. Because of her reputation as a dynamic speaker, she drew a large audience. The Association had not stood still. While the basic philosophy of the WAAC had remained constant, the present group was less centred on members' studio work than before. It had become more generally oriented. With infectious enthusiasm Dignam described the goals of developing artistic taste and fostering art in Canada. To implement these aims WAAC had developed various projects: leagues to foster a better art environment in public schools; loan exhibitions of art and handicraft to bring Canada's present position in art to public notice; exhibitions of women's work to show their attainments as artists and craftsmen; the WAAC's design competitions to improve the appearance of manufactured items and commercial illustrations and to promote the training of home talent as a contributor to national prosperity. Such activities were meant to register a protest against contemporary

commercialism and they were done in the spirit of the arts and crafts tradition of Ruskin and Morris. The promotion and appreciation of handicrafts, although established in central Canada, was unknown in the Canadian west. Dignam drew attention to work by French women in Quebec, as well as that by the First Nations, Doukhobors, and Galicians [Ukrainians]. A representative display of crafts in the meeting room revealed how attractive this material could be. The *Free Press* reported that it was "a very complete and interesting collection."[10] In the same article a review of the displayed handicrafts described the pieces as "beautiful in weave and in colors...artistic greens, blues, pinks, terracottas, etc. wrought with quaint designs."[11] Here was a newly found appreciation for the decorative arts.

Dignam's inspiring talk resulted in a unanimous decision to form a Winnipeg branch at once. Members were enrolled, officers elected and patronesses chosen with a speed which suggests advance preparation. The artist Mrs. Bready was elected president and Isabel McArthur was elected vice-president.[12] The branch began on a wave of enthusiasm, and various activities were proposed for the new organization. Mary Dignam suggested an exhibition for May.[13] Journalist Cora Hind favoured a study of reference books on art and design in order to create a comprehensive list for the Carnegie Library, which was a new and impressive amenity for Winnipeg.[14] The WAAC, however, chose to develop slowly. Neither it nor the public was ready for another major project in such a short interval. At a meeting in April the new committee came to several decisions before adjourning until September. It agreed to affiliate with the Council of Women; to form a sketch group led by Margaret Sutherland, the talented etcher Caroline Armington, and Mrs. McBean; to establish a committee which would make a careful inquiry into western handicrafts, especially Indian bead and silk work, Galician pottery and embroidery, Doukhobor drawn work, and Nestorian [Middle Eastern] rug making.[15]

Over the summer Dignam made ambitious plans to enhance the status of the new branch. She had arranged an exhibition of Dutch pictures and domestic handicrafts, with its

Canadian opening in Winnipeg.[16] After considerable discussion and correspondence, the local group declined that honour. Finances were the basic problem. If it hosted the opening, Winnipeg would be liable for freight charges from Holland; after a Toronto showing the cost would be from that point only. After discussion the schedule was rearranged to accommodate a February showing in Winnipeg. The branch graciously agreed to cover Mary Dignam's expenses when she accompanied the exhibit.[17] From that point plans progressed rapidly. Again the Masonic Temple was the exhibition site but no charities were involved in the project this time. Encouraged by the previous event, the WAAC hoped that the exhibit would succeed as an independent artistic event. In addition to looking after the general running of the show, the show's committee decided to create an atmosphere of genteel sociability by providing tea and music during the event.

In notifying the public, the press termed the works "foreign pictures", a designation which conjured up images of European studios and collections, a romantic rather than a pejorative term. Visitors praised the watercolours lavishly, deeming them to be of better quality than those of the previous year. A number of the works were going on to the World's Fair in St. Louis.[18] Among the favourites were Blommers' *Fresh Shrimps*, Sluyters' *The First Pair of Wooden Shoes*, and de Jong's *The Foundry*, which was a striking dark interior scene with a furnace in full blast while metal was being cast. The industrial subject stood in sharp contrast to the more pastoral works, which played with light and shade. Another section of the exhibit consisted of Canadian handicrafts, featuring Quebec homespun dress fabrics and portières [curtains hung over a doorway] in art shades. For the opening of the show Mary Dignam displayed her characteristic flair for public relations. She wore a cream-coloured gown of homespun, "trimmed with real lace", and reported that Lady Aberdeen and other members of the English aristocracy had ordered similar fabrics because of their interest in Canadian home industries.[19]

Attendance was good. Mary Dignam added another

function to her curatorial duties by giving explanatory tours, pointing out the feeling of repose in many watercolours and the different qualities which made individual artists famous. Among her audiences were members of the WAAC and the Normal School, which was in the process of granting its first certificates in drawing.[20] Continued interest in the exhibition warranted a two-day extension. At the conclusion the WAAC members were "well pleased with the exhibition."[21] They had provided an outstanding art event for their city and had proved that there was an audience attracted solely by an interest in art. On the practical side, they had succeeded in covering substantial expenses.[22] *Town Topics* pointed out the significance of these efforts in the art community, suggesting that the WAAC was owed a "debt of gratitude" for filling the place of a permanent art gallery and it hoped that the success of the WAAC show might encourage the city to set aside a room for the display of art in the Carnegie Library.[23]

The WAAC, however, was not alone in addressing the needs of the local art situation. The Manitoba Society of Artists, modeled on the Ontario Society of Artists, was founded at the end of 1903. Its officers were indicative of a new, lively generation of artists and collectors who were coming to the fore: Hay Stead, artist and cartoonist (president); Frank Armington, portrait and landscape artist, trained in Canada and Paris (vice president); Edgar Ransom of Ransom's Engraving Co. (secretary-treasurer); and George Wilson, amateur artist and dealer in paper products.[24] The MSA wished to improve Manitoba's artistic climate by establishing a provincial art institute, an art school, and a municipal art gallery.[25] Its first activity was an exhibit of work by local artists.[26] The relationship between the MSA and the WAAC, which had some members in common, was cordial. Both welcomed an increase in the number of art events and the greater interest generated by two distinct programs.

During her visit Mary Dignam worked to strengthen the local WAAC; she urged the executive committee to hold regular meetings and to enlarge members' knowledge by providing

an art study course like the one used in Toronto.[27] A large audience at the annual meeting responded enthusiastically to the program she outlined: exhibits of arts and crafts, encouraging young students, self-cultivation through a reading club, and fostering native handicraft. She felt that Winnipeg and Montreal should be the WAAC centres for these activities. So new standing committees on handicrafts and reading club were set up.[28] The members elected a strong slate of officers that included Mrs. Bain as president and Miss McArthur, Mrs. W.H. Culver, and Mrs. J.S. Aikins as vice-presidents. After the business meeting members viewed a display of handicrafts, which had been arranged in order to increase acquaintance with this virtually unknown field. Linen and cotton fabrics, woven by Scandinavian women to make embroidered aprons and blouses, were of special interest.

After the sustained effort connected with the exhibition and the stimulating events at the annual meeting, the WAAC returned to a quieter mode. Research, initiated the year before, into local handicrafts continued. The Association appointed a member of the Toronto group to act as Winnipeg's representative at WAAC meetings, so that the branch would be more closely linked to the central body.[29] In order to fulfil their educational development mandate, the club sponsored its first lecture in April, 1904. Gerald S. Hayward, a British-trained miniature painter working in the city, spoke on the development of this art form from medieval manuscripts to the present day; and he showed some of his paintings as illustrations of modern technologies in the field.[30] As before, larger projects like exhibitions proved more difficult and caused much discussion. Ultimately the WAAC declined Mary Dignam's suggestion of a show at the Fair in July, because many members would be away.[31] They agreed, however, to mount a handicraft exhibition for the national conference of the Council of Women, which was to meet in Winnipeg in the fall.

The exhibition and sale took place at the YWCA. Much of the material had been assembled in Montreal: French Canadian furniture, carpets, tablecloths, lace, embroidery and textiles.[32]

Permanent exhibition 1907-15, WAAC Headquarters, Jarvis St. Toronto: Shows Indian baskets and beadwork; bolts of French Canadian homespun, bedspreads, throws etc., chairs; Eastern European embroideries; lace; woven rag rugs.

Source: Women's Art Association of Canada Archives

Among work obtained in the west were Russian and Swedish textiles, Irish lace and a valuable collection of First Nations artifacts from Rat Portage (now Kenora).[33] Mrs. Alice Peck, president of the Montreal WAAC, accompanied the exhibit as curator. At the opening session of the CCW conference, she also gave a paper about handicrafts and the WAAC's sponsorship of them, stressing both the economic benefit many people derived from cottage industries and the aesthetic pleasure afforded by hand-made objects.[34] Of special importance, she felt, was the encouragement of domestic crafts, which were in danger of disappearing in the machine age. While fostering handicrafts was comparatively new in Canada when compared to the United States, Ireland, and England, it promised to be a fertile field. She closed with an appeal for the hearty co-operation of all delegates in supporting the ideals of the WAAC.[35]

The exhibition was popular, and sales were brisk. French Canadian artifacts were in such demand that the committee had to telegraph for more textiles and thirty-five additional corner seats, rockers and straight chairs. That so many found these hitherto unknown products attractive was unexpected. This growing appreciation of crafts encouraged the WAAC to persevere in their promotion.[36]

Like Mary Dignam, Alice Peck drew on her experience with a longer established group to offer helpful advice to the fledgling Winnipeg association. At an open meeting, where she described Montreal's overall program, she made several suggestions. These were to open a studio and form a sketch club for active members (i.e. practicing artists); to establish an adjoining handicraft shop, which would raise funds as well as advance appreciation of crafts; to enlarge members' knowledge by presenting art subjects, through talks at WAAC meetings and public lectures. The club began to act on these suggestions as expeditiously as possible. With help from several male supporters they acquired a studio immediately.[37]

Six weeks later the WAAC began a lecture series. The first speaker was A. Dickson Patterson (1854-1930), RCA, a student of Millais and an accomplished portrait painter originally from

Toronto. His subject was "Hints on Motive in Art and Some of the Joys and Sorrows of a Portrait Painter." Examples of his work, including some recent portraits done in Winnipeg, were on view. The WAAC also used the expertise of local faculty members. Professor Osborne (University of Manitoba) spoke on "The Value of Independence in the Appreciation of Art" urging his hearers to form their own opinions after studying works of art carefully and with good judgment, rather than adopting the views of others.[38] Professor Will (Manitoba College) contributed an illustrated talk, "The History of the Art of Manuscript Illumination", to a gratifying audience of about one hundred and fifty people, where a collection was taken to defray the cost of pictures and slides.[39] Also in the autumn, the Association decided to open a handicraft shop, hoping to attract the Christmas trade with moderately priced merchandise. As before, Montreal was to supply a large part of the stock. The WAAC secured the drawing room at the YWCA for ten dollars a month and appointed Hester Baird, a well-known china painter, to be the manager. Local items, all hand-made, were sent to her, priced and clearly marked by the maker. The WAAC was to retain ten per cent commission on all sales.[40] At a special opening on December 9 and 10, a large part of the stock was quickly purchased. After this initial success, however, the project settled down to a desultory pace, with the cream of the stock disposed of. Local demand for such things, still in its infancy, seemed to have been largely satisfied for the moment. Replenishing wares was also difficult. There were relatively few local sources, and the freight on Montreal crafts was high. By mid-January 1905 the WAAC decided to close the shop temporarily, re-opening it for a sale in May before disbanding for the summer.[41] The concept of a shop, requiring day-to-day attention even during periods of little activity, had been very ambitious for a group whose previous projects had been concentrated, short-term events.

The annual meeting in September brought new officers and the news that the bank balance had fallen to the sum of $27.73.[42] The craft shop remained problematic and was finally

dropped for the current year. Economic factors contributing to the decision included the heavy cost of bringing stock from far-away Montreal and the impossibility of securing a room and an attendant in a suitable location, at a price that the club could afford. Instead they decided to try to establish a depot for Manitoba crafts, using information gained from immigration authorities to get in touch with new settlers.[43] They also made contact with Galicians and Doukhobors in Yorkton, Saskatchewan and sent ten dollars worth of linen for them to embroider.[44] Not surprisingly, Mary Dignam's suggestion of another exhibition of handicrafts from the East was refused. The Winnipeg branch was still endeavouring to dispose of goods from the last show at marked-down prices in order to pay off the debt incurred through the shop.[45]

The area of self-education in art subjects, on the other hand, progressed well. It was enhanced by the formation of a reading circle in January 1906. Members contributed papers on artists of the Italian Renaissance such as Giotto, Botticelli, Andrea del Sarto, Michelangelo and Raphael. They met in private homes. Speakers brought prints and photographs as illustrations, and members brought additional material when possible. At the end of the Italian series Mrs. J.S. Aikins read two papers by Mr. Reasor, an American artist who lived at the site of the Barbizon School, who presented on one of its members, Charles Francois Daubigny and on "Dutch Art of Today."[46] The season closed with an extra meeting, which offered an interesting and instructive talk on old china accompanied by a collection of attractive pieces.[47] On this occasion the audience contributed a silver collection of twenty dollars in order to provide art prints for the new schoolhouse of the Children's Home. Clearly, the reading circle had been a great success. Average attendance was twenty-five.[48] It broke new ground at a time when any lecture on art was rare, and no course on art history was offered by the university or the colleges. Both speakers and listeners found it stimulating to learn more about the field.

Since the Winnipeg Fair of 1905 had been much criticized

for the way the women's sections had been handled, Dr. Bell, the manager, appealed to the WAAC to help rouse interest in that department.[49] They were also asked to arrange a new feature — a good selection of Doukhobor, Galician, and Icelandic work. This was surely a result of the WAAC handicraft exhibits. A committee was struck, which included Lilly Atchison, supervisor of drawing in the public schools; Adelaide Longford, who was organizing an art course for the Model School; Mary Campbell, an artist and teacher of decorative art and china painting, and Mrs. J.H. Bond, the recording secretary of the WAAC. They worked industriously and succeeded in revising the prize lists, obtaining extra prize monies and securing new and better display cases. Using the network that the WAAC was slowly building, they assembled a good selection of crafts and, through the Fair, introduced them to a wider public. In turn, the recognition given to crafts encouraged the craftspeople and interested them in future projects. Also at the Fair the WAAC pursued its goal of calling attention to Canadian art. They offered thirty dollars in prizes for the best papers on "What Canada Has Done in Art", but no submissions came in.

At this time the WAAC had well over one hundred members. Establishing a craft shop remained a prime consideration and the idea was discussed once again at the annual meeting. Women from various parts of the west had sent letters about their work and their need for a shop as an outlet. Much discussion ensued. After the experiences of the last few years, members realized that this was a demanding undertaking, which required concerted action from the WAAC as a group. Mrs. H.A. French, who had long been interested in a Women's Exchange, introduced someone who possessed useful and practical experience in the craft field. Mrs. Sherbinian, the wife of a professor at Manitoba College, was Swedish by birth. Acquainted with European arts and crafts, she had acquired many specimens while travelling in western Canada. She also had a list of women from whom work could be acquired. She made the point that a proper price must be obtained from crafts,

since a woman who receives only twenty-five or thirty cents for a day's labour on crafts may prefer to walk five miles to town and do laundry for a dollar and a quarter per day. Thus she runs the danger of losing her skill. It was also suggested that women in prison should be taught crafts, especially weaving linen from flax, which is ordinarily burned each year. After some discussion a handicraft committee was formed with Mrs. Hanson as chairman. Other members of the committee were Mmes Brydges, Cauchon, Hartshorne, French, Perry, Lindgren and Miss McArthur.

In early December the WAAC announced plans to open a Women's Exchange in 1907, which would encourage handicrafts of all kinds. It was also seen as a tourist attraction. As always, the expense of the project was a serious problem. A group was formed to collect a minimum of $200. Because of the importance of the undertaking, the original handicraft committee was enlarged to include five new members. The Association also voted to supply fifty dollars worth of materials to needlewomen to make into articles, which would be on hand when the shop opened.[50] Since they felt that much of the best work from the West was being sent to Toronto, the Winnipeg branch was eager to participate in the market.[51] Meanwhile, Mrs. French embarked on an interim project, soliciting handwork and needlework for display and sale at the Norman Lindsay Piano salesrooms on Portage Avenue.[52] When plans were still not complete in February, the WAAC decided to open in a small way at the Esperance, a millinery shop and tearoom on Portage Avenue. They hoped to sell work already in hand in order to underwrite other examples from various parts of the province.[53] Widening their list of artisans were the names of women who had exhibited crafts at the Fair in 1906. Clergymen whose congregations included immigrants were enthusiastic about the Exchange idea and added others.[54]

These locally-initiated and popular activities reflected a new energy and fostered a sense of success, which resulted in a growing spirit of independence among the members, who began to question the existing structure of the WAAC.

Winnipeg had joined the Montreal branch in asking for the charter to be amended so that all branches would be on an equal footing with Toronto, especially in governing their own finances.[55] If a branch were dissolved, for example, they wanted its assets to remain in the local community rather than to be allocated to the central association. They also felt that the WAAC organization did not understand the circumstances under which the branches operated. Manitoba was often pressed to undertake projects that were not feasible, because of heavy transportation expenses from central Canada, or suitable for the present development of the artistic community, which lacked many resources possessed by older centres. By the beginning of 1907, although leaving the parent organization was not their first choice, Winnipeg threatened to do so if the amendment was not passed.[56] The central WAAC countered that they too had reasons for dissatisfaction. Mary Dignam complained that Winnipeg had not pulled its own weight. It had not co-operated fully with other branches and had not participated in foreign exhibitions. She also questioned whether they were sufficiently encouraging of home industries. Nevertheless, she did not wish to break off the relationship because she had spent considerable time and energy in establishing this western branch of the WAAC. Thus she counselled the Winnipeg group not to make a premature judgment. In the end she persuaded them to continue with the relationship and to show and sell crafts at the Fair.[57] She also requested assistance with a second project — an exhibit of women's work in the fine arts and crafts scheduled for Melbourne, Australia for the autumn. It was designed to show women active in these fields and "the many avenues of employment which have opened up for them and [to] help them determine for themselves the occupations for which they are best qualified."[58] Manitoba was asked to collect First Nations and Doukhobor work, to judge it locally and send it to Ottawa for a final selection.

In contrast, a cordial relationship with the annual Fair continued, in recognition of the great improvement the WAAC had effected in the quality and quantity of exhibits in

the women's department in 1906. Mrs. Hugh Sutherland, Mrs. Munson and Mrs. Somerset Aikins became associate directors of the Board; Mrs. Bond, Mrs. Campbell, and Miss Acheson were appointed to make necessary changes in the prize list.[59] In accordance with Dignam's request, the association also mounted a separate display of handicrafts by Quebec habitants and western immigrants. Among the latter "Galician and Persian embroidery" and Irish lace were considered notable. Members of the local branch arranged the exhibit, explained the objects, and conducted sales. This was considered one of the most interesting sections of the Fair.[60]

In August Mary Dignam came to Winnipeg. She spent an hour at the Exchange, giving a critique of the stock. She found most of it pleasing, with special praise for the Irish lace, drawn work, and Swedish crafts. But she warned against continuing to include articles which followed fads in needlework, like realistic flowers embroidered in many-coloured silks. These perhaps were the saleable works originally recommended by the committee. Instead Dignam recommended designs adapted from nature and classical needlework like tatting and eyelet embroidery. She found most prices reasonable. The most important aspect, she felt, was to maintain a high standard of quality in all areas. This would inspire indifferent workers to raise their performances and encourage skilled needlewomen to submit their best work. She also alluded to WAAC plans of sending materials woven in eastern Canada to the West, so that they could be embroidered by Scandinavian and middle European immigrants and then distributed to the Association's depots in London and France and, in the future, in Rome.[61]

At the annual meeting in 1907 the association reported a substantial membership of 188 composed, interestingly, of 71 new names, while 63 had been dropped for non-payment of dues. This figure was the result of an active campaign in which members nominated likely recruits throughout the year.[62] Officers elected were Mrs. Coombes (president), Mrs. Hugh Sutherland, Mrs. J.H. Brydges, and Mme. Cauchon (vice presidents), Mrs. Fred Sharpe (treasurer), Mrs. Hay

Stead (corresponding secretary), Mrs. H.A. Bond (secretary). Members discussed the fact that Winnipeg had no public art gallery and suggested that the WAAC should work toward founding one.[63]

Meanwhile, the Reading Circle continued to be a drawing card. The current schedule started with a talk on Canadian handicrafts by Mrs. Hay Stead and then reverted to Old Masters: Joshua Reynolds by Mrs. W.S. Allan; Gainsborough by Mrs. H.D. Champion; Angelica Kauffmann by Mrs. Cawthra Richardson; another view of Titian by Miss Abel of the Chicago Art and Literary Club, presented by her sister, Mrs. J.D. Atchison; "Masters of Caricature" by Mrs. W.S. Grant; and "The Madonna in Art" by Mrs. G.B. Wilson. As she had done before, Mrs. W.H. Thompson finished the series with a paper on the minor arts titled "Some Old Lace". Members were asked to wear or bring a sample to the lecture. Mrs. Thompson used her pillow and bobbins to show how pillow lace was made.[64] Non-members who wished to attend sessions paid an admission fee, and a small charge for afternoon tea was levied for the benefit of the Exchange. To accommodate the large number of members attracted to the Circle, the WAAC rented the I.O.O.F. Eureka Hall, paying three dollars each for nine sessions. In order to utilize the space further, the Association's business meetings were scheduled there on the same day.[65]

The Handicraft Committee reported a steady increase in objects for the Exchange and a positive balance of $29.80.[66] Since Esperance was closing, a new site had been found at Miss Clarkson's Booklovers' Library, where the owner would look after the Exchange for a fee. More interest in the Exchange resulted from the talk at the Reading Circle by Berte Stead and Mrs. Sherbinian. Both women commented on the beauty and techniques of various pieces of needlework on display. They also stressed the social impact of the craft movement as an alternative to factory work in the United States.[67] In early December the Exchange advertised a large stock of articles for Christmas gifts, but sales were small and the shop did not cover operating costs.[68] It was necessary to raise special

funds in order to remain open but nothing much was done in spite of suggestions.[69] By the end of February the situation was serious and there was no money to pay Miss Clarkson's salary.[70] The crisis came at a bad time. One of the hard parts of the project had been to locate workers and to encourage them to send items. The Exchange was receiving many letters and articles from Saskatchewan and Alberta, in addition to work by local suppliers. The committee was anxious to support the workers, whom they had encouraged to participate and to benefit from shop sales. The WAAC urged Winnipeg women to rally to support the Exchange and to make it more widely known and appreciated, but the appeal was unsuccessful.[71] The Exchange was forced to close. The failure was a serious blow because the club had failed in implementing two major goals: promoting handwork in a machine age and helping women to become more self-supporting. Naturally the closing was very disheartening for the craftspeople involved. Unsold articles were returned to their owners with an explanatory letter.[72] Hopes for appreciation and support had been dashed and inquiries from new sources had to be turned away.

A more positive aspect of the Association's work was its mutually beneficial relation to the Fair. Associate Directors for 1908 were Miss Acheson, Mrs. Langford, and Mrs. Angus Sutherland. Another recognition of the WAAC's role in the community was a request from the University of Manitoba. On the eve of expansion, the university sought representations about its future scope and educational policy. Mrs. W.H. Thompson (convener), Mmes Stead and Langford, and Misses Johnston and Acheson undertook the task of commenting on art education, with particular reference to establishing a course in art history.[73]

While the Exchange was heading toward closure, Mary Dignam proposed an art exhibition similar to the ones in 1903 and 1904, and shown earlier in Australia and eastern Canada. It would consist of Dutch pictures, Italian lace and representative specimens of home industry. She asked the Winnipeg branch to make a special effort to display, insure, and protect the

works. Although the local club had less than two weeks lead time, they undertook the project with the understanding that external costs would not exceed $100. Their current bank balance was $45.[74] The exhibition of 50 watercolours, an equal number of proof etchings and some Canadian crafts opened in the ballroom of the new Royal Alexandra Hotel. Tickets were twenty-five cents, and for an additional fifteen cents tea was served by girls in Dutch costume. Through various WAAC shows, loan exhibitions at the Fair, the stock of travelling dealers, and experiences while travelling, many Winnipeg viewers had become acquainted with contemporary Dutch watercolours. They liked them very much, responding to the homely subjects, careful observation of nature, the accomplished portrayal of light and space, and the quiet, sometimes rich colouring. Attendance was excellent. Income came to $450.65, with a net balance of $304, a figure that would have been much smaller if the hotel had not waived the rental fee.[75] All in all the exhibition was considered an artistic, financial, and social success.

CHAPTER JIX

FOUNDATION OF THE
WEJTERN ART AJJOCIATION

The annual meeting marked the end of a varied year. The Association had experienced the success of the Dutch Exhibition and also the embarrassing failure of the Exchange. For some reason the profits from the show were not used to rescue the Exchange. Perhaps the group as a whole lacked the will to persevere with a difficult undertaking, despite the commitment of the handicraft committee. Also there seemed to be some feeling that funds should be set aside for an art gallery or school. Crafts were still being returned to women, who could not understand why the Exchange had not been supported, its display cases put into storage.[1]

Fifty-four new members had joined the WAAC in 1908. After an excellent year the Reading Circle looked forward to a full schedule. A strong new slate of officers was elected with Ada Chipman, wife of the Commissioner of the Hudson's Bay Company, as president. She was an experienced committee woman, active in the diocese of Rupertsland and in anti-tuberculosis campaigns. Others were Mary Elizabeth Coombes (past president); Mme Cauchon and Margaret Sutherland (vice presidents); Eva Jones, headmistress of

Rupertsland School (corresponding secretary); Allison Manning (recording secretary); and Mrs. R.M. McKenzie (treasurer).

The most important subject facing the Association was Winnipeg's relationship to the WAAC, a question which had been raised openly in 1907. Originally the connection had been invaluable, providing an impetus and focus for women interested in the visual arts. However, a feeling of alienation had begun to assert itself. The Winnipeg branch felt isolated because of physical distance and growing ideological differences. Winnipeg had a special interest in the local art community, which was struggling to develop art institutions and a supportive public. Progress in these areas was hindered by the Ontario-oriented program imposed by the parent organization. This situation was emphasized by the fact that the eastern milieu had developed a generation and more in advance of the West, resulting in different resources and capabilities in the two regions.[2] A specific complaint concerned the ready-made exhibitions offered on short notice and without regard for local conditions. The same was true of demands for the Winnipeg branch to participate in international shows. Failure to join in these projects brought the charge of non-cooperation and tensions.

The Montreal branch also desired some independence, wishing to specialize in the field of handicrafts, which they had developed successfully for some time. The branch withdrew from the WAAC in 1907. As well, the personality of Mary Dignam played a part. Enterprising, determined, and enthusiastic, she worked tirelessly to advance women's role in art. On the other hand, she dominated the WAAC, imposing her ideas inflexibly and often tactlessly. This style of governance was hard for active and able people, well-versed in their community, to accept. Relations had reached a stalemate. Although successful, the recent Dutch exhibition had reinforced dissatisfaction because of the short notice provided and the poor quality of the Italian lace section, which the local committee decided not to show.

Mary Dignam, undated.
Source: *Women's Art Association of Canada Archives*

After much consideration, the association authorized Ada Chipman and Mrs. Coombes to engage a lawyer. Mr. J.S. Hough was selected and it was his duty to find out whether the Winnipeg branch could break away from the central organization.[3] When he declared this feasible, the club grasped the opportunity and formed a new group at once. It chose to call itself "The Western Art Association of Canada" (WAA), an indication of its regional orientation but also the continuity with valued WAAC concepts such as the promotion of handicrafts and education in art history.

A new and independent association meant the loss of Mary Dignam's lively interventions and inspirations, but the members felt that much good work in Manitoba lay ahead. The words "vigorous", "independent" and "western" appeared in newspaper accounts.[4] The WAA also differed in its lack of feminist orientation typical of the WAAC. This was a result of local conditions. From the beginning, women artists in Winnipeg had not been excluded from the art groups, which established themselves in a pioneer society. Thus the WAA functioned as an association of women working to further the cause of art but its members did not feel the need to assert themselves aggressively. In fact they went one step further and established a male advisory committee, which could be consulted if necessary.

While no undue stress seems to have marked the birth of the WAA, the break ushered in a period of transition and adjustment. Not all WAAC members had wanted the split. Unfortunately the minutes, which covered this process, have not survived. According to the Free Press, however, "certain difficulties and obstacles in the path of the new group" responded well to "a combination of enthusiasm and tact." The two organizations functioned side by side and sometimes in joint meetings during the winter of 1908-09.[5] The Reading Circle remained part of the WAAC.

The WAA began by choosing a short list of officers: Mrs. Coombes (convenor), Miss Bury (treasurer), Mrs. Champion (secretary). By the end of February a constitution had been

drafted and adopted.[6] It provided for active, honorary, and life members. The aims were to direct and encourage public interest in the study of art in Western Canada and to maintain a permanent collection of art objects. These goals complemented those of the Manitoba Society of Artists and of a group of prominent citizens like James McDiarmid, who were connected with the art section of the Fair. Indeed these three groups stimulated interest in art to such an extent that in November the City Council submitted a by-law to establish a city art gallery.[7] Unfortunately, this proposal was rejected because art institutions were not yet a popular concern.

In 1908-09 the WAAC's Reading Circle studied the Pre-Raphelites: Romney (Mrs. Hough), Constable (Mrs. Champion), Turner (Miss Brunstermann), Millet (Mrs. Fortin), Holman Hunt and Christina Rossetti (Miss Hanson), G.F. Watts (Mrs. Fetherstonhaugh), and Edward Coley Burne-Jones (Mrs. R.C. Manning). Over seventy-five members also visited Flavia Holland's studio to view her china painting. In May they generously gave $150 to their sister society, the WAA, and disbanded.[8] The Reading Circle had been the most consistently popular and educational aspect of the WAAC. Careful planning had produced lectures, which attracted a large audience, while the effort to prepare and deliver papers had increased the capabilities of participating members.

At the annual meeting in November a full slate of officers, including those from the interim group, was elected.[9] Also a prestigious group of women had agreed to act as an Advisory Committee. Among them were Mrs. Hugh Sutherland, Mrs. W.F. Alloway, Mrs. William Whyte, Mrs. Robert Rogers, Mrs. A.W. Ross, Mrs. J.S. Aikins, Mrs. Moody, and Mrs. Fortin. The treasurer reported a bank balance of $204.35, which included a cheque of $100.00 from their lawyer J.S. Hough and $25.00 from the sale of the first life membership to Ada Chipman.[10]

The WAA announced as its first project a loan exhibition modelled on the format of several shows held in Winnipeg at the turn of the century. It was designed as a combined artistic event and a source of funds for establishing an art gallery.[11]

The Royal Alexandra Hotel was to house the exhibition from November 29 to December 2. The WAA appealed to members of the community for loans of family treasures in many categories: pictures, old china, jewellery, objects of historical interest, and antiques of various kinds. Lending was described as a public service, since opportunities to see such material were rare in Winnipeg.[12] The WAA promised to look after all objects with great care.[13]

A very busy time ensued. Instead of receiving a show which was sent as a unit and returned in the same way, the committee was responsible for all arrangements: choice of exhibits, cataloguing, display, and return of works, as well as many other details like public relations, finances, administration and security. Admission was set at twenty-five cents, and catalogues were to be sold by girls in fancy dress. Music was arranged for the entire run. It was suggested by some that the number of committees at work was almost large enough to run a world's fair![14] The WAA also had some outside assistance from Alexander S. Keszthelyi. Trained in Munich and Vienna, he had opened the Keszthelyi School of Fine Arts in Winnipeg in 1908. He naturally supported the WAA's desire to establish art in the city.[15]

People responded generously, with works continuing to arrive after space was exhausted and the catalogue had gone to press.[16] Owners were responsible for bringing in accepted pieces and supplying evaluation for insurance purposes. Each classification, such as painting, sculpture, etc. was looked after by a sub-committee who received the works, made duplicate listings for the owner and the WAA, and issued receipts. After the exhibition, lenders were asked to collect their possessions by tendering the original receipt. During the show a member of the pertinent sub-committee was on guard in each section.[17]

For some time the press had piqued Winnipeggers' interest with descriptions of various items on loan and the names of well-known lenders. Advance sale of tickets was reported as good. On opening night, as promised, visitors saw a cornucopia of exhibits. Paintings were displayed prominently

PROMINENT WESTERN WOMEN

MRS. ALAN C. EWART,
President of the Western Art Association.

MRS. F. G. CHAMPION,
Prominently Identified With the Association Since its Inception.

MRS. C. C. CHIPMAN,
First President and Honorary Life President of the Association.

"There is no art, or love of art, in the Canadian West," said a critic the other day. He had, of course, spent some three weeks on the great prairies, and was therefore in a position to indulge in generalities. Facts have such a hampering effect.

The editor of one of our largest Canadian magazines said not long ago, "The west has more real, eager, hungering love of art to the square inch than any other part of Canada. It loves art so much that it loves art's faults and all. For five dollars a throw to hear a faded prima donna sing stale arias with a jaded voice. The greatest tenor voice, headed now for Paris and the Opera Comique, comes from Winnipeg. With all its big hopes and big ideals, it is only natural that big ideas and big ideals should come out of the West. More big thoughts from the West rap at the magazine editor's door in a week than from the East in a month. The authors out there have room to think, and they use the room. The great Canadian novel, the greatest Canadian

drama, dwells unborn somewhere between Lake Superior and the Pacific Ocean."

The preamble is to announce that Winnipeg has a very much alive organization known as the Western Art association. For several years it was a branch of the Women's Art association of Canada, with headquarters in Toronto. In 1908 Winnipeg felt it was no longer compatible with its dignity to be a branch of anywhere, and accordingly the association was organized. Its success was assured from the beginning. Mrs. C. C. Chipman was the organizing president, Mrs. Coombes and Madam Cauchon occupied the vice-presidency, Mrs. J. G. Bury looked after the finances, while Mrs. Champion combined in herself the offices of both recording and corresponding secretary. The ideals of the association are revealed in its object as set forth in the constitution. "To direct and encourage the study of art in western Canada, and to create and maintain a permanent collection of objects of art, particularly Indian bead work and objects of interest peculiar to the North West." Already a collection

of Indian curios has been made, which is to form the nucleus of a museum to be started in the near future. If only as an attraction to tourists, apart from the fact of saving tangible history to future generations, this work is a worthy one.

As regards the association itself, the applications for membership have been so numerous that it has been decided next year to raise the subscription and to make it necessary for members to be balloted for.

The organization has a literary branch which this year arranged a series of lectures on art subjects. Four of these are by Hector L. Chalmers, the others by members of the association. The lectures have been held so far in the homes of the members, but next year a hall will be secured.

The association has applied to this session of the legislature for incorporation. This step was taken in order that the association might hold property, and as the members have a vision of an art gallery and an art building to be erected in the not too distant future, the initial step was necessary.

"Prominent Western Women: Mrs. Alan C. Ewart; Mrs F. G. Champion; Mrs C.C. Chipman." Manitoba Free Press, Women's Section, Saturday, March 11, 1911.

Source: Archives of Manitoba. Collection: Manitoba Free Press

with over one hundred watercolours on the north wall of the ballroom and a smaller number of oils on the west wall. The south wall had pewter and brass, First Nations beadwork and relics. East Indian and Japanese works were on the last aisle. Many other categories of arts, crafts and historical objects were shown in cabinets arranged around the room. Quality, of course, varied. Outstanding among the paintings were an oil of Venice by Turner, de Hoog's *Dutch Interior*, and contemporary works by McGillivray Knowles, Mary Riter Hamilton and Alex Keszthelyi. Viewers found something of interest on every side. First Nations artifacts appealed to many, including a bear claw necklace purported to have once belonged to Sitting Bull, a beaded costume and horse trapping made for Chief Little Fox, and numerous ornaments and weapons. Both men and women admired the large display of antiques, including china from English and German factories, and modern hand-painted work. Others were attracted by old silver, pewter and brass; jewelry, laces, and embroideries; a collection of Canadian stamps starting with pre-Confederation days; old books; and a miscellaneous group of armour and weapons.[18]

With such variety it was no wonder that visitors reacted favourably. Added to the pleasure of looking was a feeling of pride that so many beautiful and interesting things resided in Manitoba. This collection reinforced the often-voiced claim that the West had an aesthetic side despite its short history. The WAA was congratulated on making the exhibits accessible to the public at a time when there was no public art gallery to perform such a service. Of course, there were criticisms too, concerning the hanging, catalogue, and quality of some of the works. In the end, however, one of the sternest critics concluded:

> Taken all in all, the exhibition can be pronounced a success. The defects or mistakes in this, the initial attempt, can be remedied another year. It could do for the arts what the Industrial does for agriculture.[19]

The WAA could be pleased with their first big project.

They had involved many people outside the committee, both lenders and viewers, in a stimulating art event. People now looked forward to interesting WAA projects in the future. After the doors closed, the WAA ensured the safe return of the loans and concluded the administrative aspects of the large and complicated effort.

In early 1910 the WAA took a new step. It encouraged Miss Eleanor MacDonald of Fort Qu'Appelle to found a branch (WAAS) in the recently established province of Saskatchewan. Of outstanding pioneer heritage, MacDonald was the daughter of the Chief Factor of the HBC district of Swan River and the niece of Sheriff Inkster of Red River. The new club adopted the WAA constitution and agreed to pay an annual affiliation fee. Its officers were entitled to attend WAA meetings in Winnipeg and to vote on matters that concerned the entire organization.

Unlike the WAAC, however, Winnipeg did not attempt to impose its format on the Saskatchewan branch, which was free to use whatever means its members considered suitable for their community, to develop public interest in art.[20] One striking difference between the two groups was the fact that the WAAS was provincial in scope rather than located in one city. For example, Eleanor MacDonald became president, Mrs. G. Spring-Rice of Pense, vice-president with Alice Court (Mrs. J.S.) of Indian Head, treasurer and Miss Margaret Smith of Cupar, corresponding secretary. The executive and committee members came from Fort Qu'Appelle (2), Pense (1), Grenfell (1), Regina (3) and File Hills (1). Despite the distances meetings were well attended. In her annual report Eleanor MacDonald mentioned one executive member who travelled more than one hundred miles by road and rail to attend a meeting. R.S. Lake M.P. was the patron of the WAAS, his wife the honorary president. The Rt. Rev. Bishop Harding of the Anglican Church headed an advisory board of seven prominent men who also came from different places in the province.

The WAAS operated in a pragmatic way. It decided to specialize in the decorative arts and handicrafts, since examples

of these were more available than fine arts in their community. MacDonald also reported, "for the present we in Saskatchewan are content to leave the accumulation of pictures and statuary and the building of museums to the richer part of the Association."[21] They planned to concentrate on one or more areas each year instead of diffusing their efforts. In 1910 they chose the subject of so-called "Primitive Art" by circulating reference books on early ornamentation and concentrating on First Nations work. This study culminated in a successful exhibition of material originating from areas as far north as the Arctic Circle and as far west as British Columbia. Among the chief lenders were Ada Chipman; Mrs. Stanley (Kutawa); Mrs. Taylor (Moosomin), Mrs. MacIree (Regina); Mr. Robert Laing (Indian Head); and a group of Sioux " who kindly sent some beautiful Indian things, which were much appreciated by a good number of visitors."[22] As befitted the make-up of the organization and its aim of increasing public interest in art, the show was held in three locations: Fort Qu'Appelle (May), Pense (June) and Indian Head (July).[23] The first two showings were in private homes, the third in the Agricultural Hall at the Indian Head fair grounds, where there was an admission fee of twenty-five cents. The paid attendance in Indian Head was eighty-nine. After expenses for printing, express, and cartage, the project seems to have been successful from a financial as well as artistic point of view.

After its first season, the WAAS could feel that it had made a place for itself in Saskatchewan and that further opportunities lay ahead. Also the WAA could be proud of establishing a viable affiliate. Although there was some talk of founding other branches in Alberta and British Columbia, these did not materialize. The WAAS remained unique. A further account of its activities may be found in the Afterword of this book, where one can follow the story more easily.

In Winnipeg the association continued the WAAC practice of educating members through lectures and studio visits. Unlike the last years of the Reading Circle when a certain period or group of artists was chosen, the 1909-10 program

was miscellaneous in nature. Among the offerings was a paper on sculpture and a double program composed of an exhibition of pictures and miniatures, at the studio of Miss Farncomb and Mrs. Crawford, followed by a paper on architecture.[24] The Rev. Mr. Johnstone spoke on "Art and its Relation to Religion", Mrs. Curry on "The Wallace Collection", Mrs. J.S. Aikins on china, and Mrs. A.C. Ewart on Whistler.[25] Mary Ewart's talk was particularly interesting because she spoke from her experiences as a student of Whistler's. A comparatively new member of the WAA, Ewart came originally from Philadelphia, where she attended the Academy of Fine Arts for several years. She had enlarged her experience with studies in New York (William Chase), Britain (Frederick Mark Morries and Whistler), Paris (M. Colin) and Spain.[26] It was an impressive background, comparable, if not superior, to that of Mary Dignam. In 1907 she had come to Winnipeg as the bride of A.C. Ewart, a prominent lawyer and the son of J.S. Ewart, whose legal work had won a national reputation. Her participation in the WAA signalled that the local desire for autonomy had now been matched by a mature artistic knowledge. The Western Art Association could be confident in its ability to continue the mission first outlined by the Women's Art Association of Canada.

CHAPTER SEVEN

NEW DIRECTIONS WITH MARY EWART

In October 1910 Mary Ewart became the new president of the WAA. Other officers at the time were Mrs. B.E. Chaffey and Mrs. Coombes (vice presidents), Mrs Crotty (treasurer), Mrs. Alan Weagant (recording secretary), Mrs. Swindell (corresponding secretary), Mrs. G.D. Minty (literary convenor). The advisory board remained much as before.[1] It was this group that would offer leadership in new directions for the WAA.

The club's initial task was choosing a fundraising project, which would also be an interesting, publicized art event. They decided not to present a second loan exhibition. The interval of one year between shows was considered too short, because the supply of works of good quality had virtually been exhausted in 1909 and repetitions would diminish the freshness and appeal of a second show. Instead the WAA decided to implement what was termed "an excellent and original suggestion" made by Mrs. Ewart that the club stage a series of tableaux representing world famous paintings whose forms and colours would be followed as closely as possible.[2] The performances were arranged for December 9-11 at the ballroom of the Royal Alexandra Hotel. Tickets were one dollar for adults and fifty cents for children, who were allowed

to attend the Saturday matinee only. These were high prices compared to the usual admission of twenty-five cents, but then again this was something special, even novel.

Twelve committee members took on the major responsibility of choosing fifteen tableaux and staging them. With the exception of Fra Angelico, Jean Marc Nattier, Jean Baptiste Greuze, and Mme Vigée Le Brun, they selected the work of British artists. All but Sir Joshua Reynolds were from the nineteenth century. They included Dante Gabriel Rossetti, Edward Coley Burne-Jones, Frederic Leighton, and John Singer Sargent. While creating the scenes, several women worked singly, others in pairs. Some indefatigable workers, like the team of Mrs. Chaffey and Miss Bain, were responsible for as many as three tableaux. The number of men and women recruited as actors varied from one or two per painting to eleven for Yeames' *When Did You Last See Your Father?* These participants were drawn from the general membership, their family, and friends. All had to be fitted with carefully designed costumes, which reproduced those worn in the original paintings, and they had to rehearse their parts.

In the meantime, two colleagues from the professional art world painted backgrounds. Raymond Carey, a much admired architect, did the one for Christina Rossetti's *Dream of Dante*. Hector Chalmers, an artist and interior designer, assumed the large task of preparing the remaining fourteen. In addition to furnishing an acquaintance with the appearance of well-known paintings, "Living Pictures" was designed to give useful information about the works. The Rev. F.C.C. Heathcote of All Saints' Anglican Church agreed to give a short introduction to each tableau, remarking on the artist, the period, conditions surrounding the creation of the piece, and a description of what the audience was about to see. As the originator of the show, Mrs. Ewart was extremely active. She supervised all aspects of the production, including the services of a cosmetician and a dresser to help prepare the actors for the stage, and an orchestra to play throughout the evening. Mr. Carey was the stage manager, an arduous

job because of the many changes of scene.[3]

All these careful preparations ensured a successful event. Large audiences found to their delight that these were no ordinary tableaux. "Their deep admiration was tinged somewhat with astonishment at the artistic feast of color and the beautiful and faithful posing of those taking part" was the favourable assessment of the Winnipeg Free Press.[4] This element of surprise often marked Winnipeggers' reaction to art achievements in their city. The most popular scenes were Reynolds' *Tragic Muse*, Vigée Le Brun's *Marie Antionette*, Leighton's *Wedded*, and Sargent's *Carmencita*.[5] One can tell from this list the tendency toward the melodramatic in the taste of the audience.

The success of the "Living Pictures" resulted in a request for a repeat performance in a theatre with a larger seating capacity and tickets at popular prices, so that the general public could enjoy it, too. Mrs. Kirby, who had formed a team with Mrs. Coombes in preparing three scenes and was also a devoted member of the Humane Society, persuaded the WAA to repeat the show as a benefit for the Society.[6] This presentation on January 5 at the Winnipeg Theatre attracted a large, enthusiastic audience, who brought back actors in favourite scenes to take as many as four or five curtain calls.[7]

"Living Pictures" also achieved its goal as a fundraiser. The cost of such a finished performance had been heavy. From an income of over $600 the club had cleared an impressive $300. Even this figure was possible only because many of the scenes were paid for by members. Expenses had been incurred for advertising, rent, printing, hiring an orchestra, an honorarium to Mr. Chalmers for scene painting, services of a carpenter and an electrician, canvas, etc.[8] No dissatisfaction with this outlay, however, is found in the WAA minutes.

The new year began with a lecture series. For a fee of $100 the WAA engaged Mr. Chalmers to deliver four talks, one for each month, beginning in January. His topics were "Color and Taste", "Picturesque Treatment of Interiors", "The Function of Art", and "The Applied Arts". Alternating with them were

papers by members, meant to complement Chalmers' subjects: "Franz Hals" (Miss Brunstermann), "Interiors of Pompeii" (Mrs. Champion), "Leonardo da Vinci" (Mrs. Fortin), and "Ancient Art of Central America" (Mrs. Crotty). Popular as ever, the series was a welcome novelty in a community which still lacked an art gallery, a school of art, or a university department which could provide lectures on art and interior decoration. Non-members were allowed to attend on payment of twenty-five cents at the door; but they sometimes slipped through without payment when the membership list was not checked.[9] Because of the large audience, lectures took place in St. Luke's schoolhouse. A ten-minute question and discussion period was a welcome addition to the format.

A follower of Ruskin and Morris, Chalmers described true art as marked by simplicity and reverence, combining beauty and utility. He recommended a systematic study of colour and form in nature to develop the feeling and judgement, which produce taste. Drawing should be taught in all schools. Chalmers urged the WAA to educate the public by forming art and handicraft guilds and arranging exhibitions. The purpose of this public education, he reiterated, was "to show that art is not the plaything of the hour but demands respect and love."[10] More practically, he enrolled the WAA in the Burns Club project of erecting a statue of the poet in Winnipeg.[11]

Listeners enjoyed the history of the art of interior decoration and its various schools. Chalmers advocated comfort, truth of construction, utility, and appropriateness. Condemning "gilt mirror and blue satin principles", oddities and rococo deformities, he said that a room should echo the owner's personality, each part fitting into the general picture, with pretty things standing out against a quiet background.[12] This advice concerned the listeners directly, whether they accepted or rejected Chalmers' aesthetic dogma.

Two of the members' papers treated unusual topics. Mrs. Champion spoke on the interiors of Pompeii and the different styles in which they were decorated with mosaics and frescoes.[13] The season closed with "Ancient Art of Central America" by

Mrs. Crotty. Since she had visited Chichen Itza, her source was personal experience, as well as archaeological reports, and she had photographs for illustrations. Because of general interest in this topic, the *Winnipeg Saturday Post* published the entire article on May 27.[14]

In 1911 Winnipeg was enjoying good economic times, the culmination of several years of prosperity.[15] The city had become the third largest in Canada with a population of 136,035, triple the figure in 1901. There had been comparable increases in manufacturing activity and the accumulation of capital. Of special importance was Winnipeg's function as a great railway centre and entrepôt, providing both a gateway to the West for people and wholesale goods, and a means of distributing agricultural products to the East and abroad. Construction was booming. Among substantial public structures were banks, other commercial buildings, an imposing Carnegie Library, two large technical high schools, and government buildings; there were plans for new law courts and legislative buildings also. The housing market was active in all sectors. In the upper scale was the Ewarts' Italian villa in Crescentwood on a new street appropriately named Ruskin Row.

This expansion also affected education and the arts. The thriving city attracted artists, architects, teachers, and professors who were to make a contribution in the next few years. In tune with the times the WAA aimed to increase its already considerable membership and its influence. Members also wanted their own space for activities like the lecture series. Perhaps the fact that the WAAC had a house in Toronto encouraged this desire. The WAA decided to apply for incorporation so that the club could own property and a Building Fund Committee was formed to investigate ways and means for the project. They also sought the advice of the Men's Advisory Group, made up of the Lieutenant Governor and twenty-seven other community leaders. These were top members of the judiciary and major churches, prominent educators, politicians and businessmen. The arts were represented by Keszthelyi (who left Winnipeg in 1910) and Murray Morris, cousin of the artist Edmund Morris.

The latter was in touch with other eastern artists and helpful in many ways.[16] The fact that men of this status would ally themselves with the WAA illustrates both the respect in which the association was held and the useful social contacts enjoyed by the members. After due consideration they seem to have recommended that renting space would be more practical than building. No more is heard of this undertaking; but the WAA became very enterprising in the search for space.

At this time the Manitoba government was planning a new building for the legislature. As representatives of the WAA, Mrs. Chipman, Mrs. Ewart, and Mrs. Coombes met with the premier to ask what provision could be made for an art gallery and museum in that structure.[17] The meeting went well, with the premier promising temporary room in the present building, for the WAA collection of First Nations artifacts, in the meantime.[18] Housing these works had been a concern as the collection continued to grow.

At the annual meeting Mary Ewart was re-elected by acclamation. Other officers were Mrs. J.J. Bury and Mrs. T.H. Crotty (vice presidents), Mrs. J. Atchison and Mrs. M.E. Nickels (secretaries). It had been three years since its formation as an independent group and it was time for the WAA to assess its status. The original aims had been to encourage art in all its forms and to make a collection of western Canadian art, particularly First Nations material because it was felt to be an art form that was rapidly disappearing.[19] They certainly showed success in these areas. Lectures and exhibitions had attracted many people and had encouraged interest in a wide variety of arts; as we have seen, the collection of First Nations artifacts was progressing. As long-time collectors the committee maintained high standards. They were disappointed in the quality of much work coming on the market. However, they had just acquired several genuine pieces, which were not of outstanding quality, but could be sold if better works became available.[20] The WAA also had a comfortable bank balance.[21] Turning to the future and hopes of expansion, they doubled the membership fee to two dollars.[22] The WAA began negotiating with the

Architectural Association and the Arts and Crafts Club for the joint rental of club rooms, which could be used for night classes and children's classes in art as well as for meetings.[23]

Despite this initiative, the club still had to rent space in the writing room of the Royal Alexandra Hotel for the lecture series. The WAA made it clear that they welcomed the attendance of men as well as women at the talks. Admission for non-members remained at twenty-five cents per session. After a year of transition the format had ceased to resemble the WAAC Reading Circle. The 1911-12 series of seven lectures reached into the wider community for speakers who treated different aspects of art, many of which had some relationship to life in Winnipeg. This trend had emerged the previous year in Chalmers' lectures. Hay Stead led with a paper on cartoons. He described their evolution and, using illustrations, showed how characteristics differed from country to country. Also he told anecdotes about his own experience as a staff artist on the *Free Press*.[24]

On December 9 Edgar Ransom, president of Ransom's Engraving Company and a founder of the Manitoba Society of Artists, spoke on the art and science of engraving. After tracing its history he described modern processes of engraving.[25] As a long-time enthusiast, Berte Stead talked about First Nations art and showed a great variety of objects from her collection. In addition to the more familiar embroidery and beadwork, she had wood carvings, sculpture, baskets, peace pipes, metal work, and Inuit carvings made from walrus ivory.[26] A change of emphasis came with Professor Crawford of the University English Department, who lectured on poetry as a fine art – the finest of all arts, as far as he was concerned.[27] "Mediaeval Cathedrals" was the topic of Claude W. Gray, critic, artist and architectural draughtsman trained in London's South Kensington Schools.[28] The lecture was illustrated with Gray's drawings of famous cathedrals. He paid tribute to the enormous effort with which people worked, using local materials, to construct these romantic buildings. Mayor R.D. Waugh spoke on "The City Beautiful", a town-planning concept, which was

starting to gain popularity in North America. He pointed out the way in which Winnipeg's park system enhanced the city and praised the work of the Parks Board established in 1890. For further action along these lines, Waugh advocated the formation of a civic garden club.[29] The series closed with Capt. Gauthier's account of the various British orders and medals.

At the last meeting of the 1911-12 season, members voiced familiar plans for the future, which included two large entertainments to generate funds for a club room. Each member was asked to bring two new members to the fall meeting to enhance the membership numbers. A novel idea was also floated: that the WAA might start an art school in the near future "run on the lines of such institutions in older cities".[30] Mary Ewart, still a practising artist, had much to do with fostering the idea. In early May, as president of the WAA, she had presided at a meeting to consider the creation of a new group for artists and art lovers, an amenity then lacking in Winnipeg. The Manitoba Art Society was dormant; and the WAA filled only part of the gap since membership was restricted to women, and in general they acted as amateurs, activists and patrons rather than creators of art. She contributed information about similar clubs. Among other topics, the foundation of an art school was discussed. The result was the establishment of the Manitoba Arts and Crafts Club, whose mandate embraced

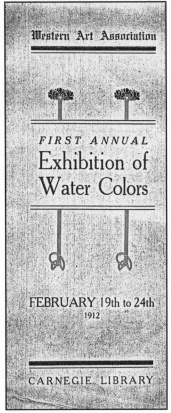

Western Art Association

FIRST ANNUAL
Exhibition of
Water Colors

FEBRUARY 19th to 24th
1912

CARNEGIE LIBRARY

workers in all arts and crafts. Architect J.D. Atchison became chairman. The club planned to have an annual exhibition program including both local artists and outside groups.[31] They proposed a show of summer sketches as a first project.

Exhibitions continued to be part of the WAA agenda. In the autumn of 1911 they undertook a loan exhibition of watercolours, to be shown early in 1912. Furthermore they hoped to hold three more shows before summer, one each of rare prints and etchings, black and white drawings, and oil paintings. This was a more sophisticated concept than the previous loan exhibition, which combined various media with articles of historical interest. Seen in separate exhibitions, each medium could be hung more advantageously rather than competing for attention with other types. Separate shows would allow viewers to appreciate the special characteristics of a form.

Once again the WAA needed to secure space for its projects. In late January, Mary Ewart, Berte Stead, and J.D. Atchison approached City Council. They asked permission for the WAA and MACA to use a large room in the Carnegie Library for several art exhibitions in the next few months. Because of the educational value attributed to the shows, they secured space recently vacated by the Power Construction Department.[32] In the meantime the watercolour exhibition was taking shape, as a committee made selections from works offered by individuals and commercial galleries. The exhibition ran from January 19 to 24, with generous hours of 10:00 a.m. to 9:30 p.m. On two days the admission charge of twenty-five cents was waived, since the event was in a public building.

On the opening night the Lieutenant Governor, D.C. Cameron, praised the show of about one hundred watercolours by European, Canadian, American and Japanese artists. After congratulating the WAA on its efforts to cultivate art and thus to refine and elevate the community, he expressed the wish that Winnipeg would soon have its own art gallery for occasions of this kind. He then added his voice to those who called on the WAA to work for such an institution.[33]

Perhaps because of the specialized nature of an all-watercolour show, the committee singled out for particular attention some paintings illustrating the variety of subjects and styles. The list also reveals what was being collected, the names of some of the owners, and the preferences of the organizers.[34] The contemporary Dutch school was represented by *At Katwyjk* (loaned by Mrs. Nares) and J. Zoetlief Trump's *The Little Mother* (loan of Dr. Moody). Consul J.E. Jones loaned J. Yamamoto's *In a Japanese Garden* and J. Naragi's *Grass Cutter*. The American example was Soyer's *Boy and Rabbit* (loan of Mrs. Donald Ross). Modern British painting included Maria Eaton's *Evening* (Richardson Gallery), W. Shaw's *Twilight – a Sussex Farm* and J.R. Bagshaw's *Early Dawn* (loan of J.D. Atchison), E.A. Walton's *A Bit of Upland* (loan of Mrs. Donald Ross), Lee Hankey's *The Merry-makers* (James McDiarmid). Canadian artists were Laura Muntz, represented by *Mother and Child* (E.P. Fetherstonhaugh), and Charles Collings' *In the Rockies* (James McDiarmid). More works by Collings were shown – about twenty pieces in all – than by any other artist, and they were loaned by several collectors. Other living Canadian artists in addition to those in the first list were W. McGillivray Knowles, C.M. Manly, C.W. Jefferys, F.M. Bell-Smith, and Lucius O'Brien. The Luscombe Carroll Gallery sent H. Caffieri's *The Little Bathers* and *Boulogne Fisher Maid*, as well as H. Henshall's *News from Afar*. The Cranston Art Company was represented by Dircks Anton's *Katwyck*.[35]

During the preparation and presentation of the watercolour exhibition, the WAA was working with the MSAC on a pioneer project: a fine art school with a varied curriculum. It aimed to encourage general interest in making art. Such training had not been available since Keszthelyi's departure in 1910. They hoped that the school would serve as a stepping stone to the establishment of an art institute. The ability to produce work for business purposes was promoted as very important for Winnipeg as a commercial centre. There was no charge for tuition. The instructors, who donated their services, were MSAC members with Mary Ewart as a liaison with the WAA.

Friends, including the WAA, gave lighting equipment, materials, and other necessities.[36]

The curriculum of the school was ambitious. Mary Ewart taught morning classes in portrait work and drawing and painting from draped models. She and Mrs. Verral offered a Saturday morning class for children. The night classes were the heart of the school. Drawing and painting from model, still life, and the antique were taught by Claude Gray, John Atchison, Mary Ewart, and Mrs. Verral, with design by Mr. Dolan, and black and white by Hay Stead.

A preliminary session attracted forty to fifty people. Regular instruction had to wait, however, until the watercolour exhibition closed, since the same space was required for both projects.[37] By the end of March seventy-five students were enrolled, with classes planned to continue through April.[38] After a few weeks the original plans had been adapted to fit current demands on the school. Because of the very large number of children who wished to attend, the committee had to abandon the Saturday morning classes because there wasn't enough room to accommodate the students. To give women equal opportunities for study, the spaces were made available to them on certain mornings and afternoons. Friday nights were reserved for men only.[39] A contemporary illustration gives an interesting first-hand glimpse of a night class in which two women in studio garb are concentrating on drawing a seated workman while supervised by a male instructor. After more than three months the session came to an end.[40]

From May 25-31 the WAA and MSAC continued the exhibition schedule at the Carnegie Library with a show of 300 works by local artists. Pieces by students at the school were displayed with those of professional artists and craftsmen. The committee sent out about a thousand invitations to the show, which was designed to demonstrate the good quality and large quantity of art being produced in Winnipeg. Thus they hoped to interest influential people in founding a permanent art school, which would be the basis for further art development in the city.[41] The newspapers gave good coverage, stressing

the surprising number of art objects created locally. Oils, watercolours, pastels, miniatures, china painting, black and white work, tapestry, pyrography, brass, leather work, wood carving, and enamels were on show. Among artists singled out were Mary Riter Hamilton, Valentine Fanshaw (recently arrived from training at South Kensington Art School and Christopher Dresser's studio) and two other new artists, Mr. and Mrs. Julius Zsoldos. Once again there were editorials calling for a building – described as "permanent, fireproof, not large or costly, but suitable for the housing of pictures and other art objects and as a site for future loan exhibitions".[42] This ran counter to the school committee's wish to use the show as a lever for establishing an art school. The art community seems to have been of two minds. While all wanted a building devoted to art, there was no consensus on whether it should be a gallery or a school. Though deeply felt in some cases, this difference of opinion did not hinder the desire for new facilities. Some indeed envisioned a combination of both, similar to Chicago's Art Institute or Pittsburg's Carnegie Institute.

CHAPTER EIGHT

CHALLENGES, ACHIEVEMENTS AND REBIRTH

An unexpected catalyst for a new art facility was the Industrial Bureau, a forerunner of the Chamber of Commerce, whose goal was the promotion of Winnipeg as a business centre. Their interest in the subject, however, stemmed from a variety of perspectives. From the beginning of the WAAC, art had been linked with business as a source of improved design for products and presentations. This had been emphasized recently in the Free School and was acknowledged by many businessmen as a laudable goal. A number of bureau members and their wives had the taste and the means to collect and enjoy art. Some had been involved in the Art Section of the Fair, the MSA, the WAA, and the MSAC. As well, the presence of art institutions was considered a desirable aspect of Winnipeg's image as an attractive and thriving place.

The Bureau did not decide immediately on a home for the arts; plans developed gradually from existing conditions. In 1912 the Bureau erected a building for permanent industrial displays, meeting rooms, offices, etc.[1] By early summer the work of some craftsmen in printing, engraving, and interior design was on view. Always on the alert for space, the WAA saw this as a new opportunity. With the collection of First

Nations artifacts deposited at the Legislative Building, the club addressed the handicraft portion of their mandate, which had been dormant for some time. On July 23 Mary Ewart and Berte Stead asked the Industrial Bureau to grant the WAA the use of a space of about one hundred and fifty square feet for a display of rugs, curtains, embroideries, lace, drawings, and enamel work done by immigrants. They requested the space free of charge for a period beginning in January 1913 and continuing until the WAA could afford to pay a reasonable rent. The Association justified the project as a drawing card for tourists, a way of helping workers earn an independent living, and a source of artistic products. These aims were consistent with the Bureau's, so the application was approved on condition that the space would be rent free for only six months and that no goods were to be sold on the site.[2] At about the same time, the Bureau became associated with the WAA and other groups in the common project of founding an art gallery. The defeat of the city by-law supporting such an institution had closed the door to civic funding and made other initiatives necessary. The art lobby, headed by the WAA and the MSAC, continued to exert pressure on the community. Eventually the Industrial Bureau responded.

As promoters of Winnipeg, the organization was aware of the value which such a cultural centre would confer on their city. Some leading figures—McDiarmid, Ransom, and Wilson—were art enthusiasts as well as being members of the bureau, and its president, W.J. Bulman, the head of a well-known printing firm and an art collector, was sympathetic to the project. Encouraged by the momentum generated by their successful new building and by a general feeling of prosperity, the bureau proposed a pragmatic solution: add a wing which would house an art gallery and finance it by subscriptions of $100 from leading citizens. The plan worked. It is interesting to note that Mary Ewart was the only woman to contribute. She acted as an individual rather than using WAAC funds. Some other WAAC members were represented by spousal donations. Although the group at the WAAC-MSAC free school had

favoured building an art school before a gallery, all agreed that this was a wonderful step forward. Using some of the new space for art instruction was a possibility, as was that of an art school in the near future. Plans went ahead rapidly, with an opening set for December. Although named the Museum of Fine Arts, it was referred to ordinarily as the art gallery.

Donald MacQuarrie, who had trained at the Glasgow School of Art, became the gallery's first curator. Before coming to Winnipeg in 1910 he had exhibited with the Royal Scottish Academy and art museums in Glasgow, Dundee, and Liverpool. A commercial artist in Manitoba, he showed successfully at the Fair and now shared a studio with the promising young Winnipegger, L. LeMoine FitzGerald. Macquarrie began to prepare the gallery space for the opening, which was to feature the annual RCA Exhibition. This was the first time it had been shown in the West, and it included a section of works by leading Manitoba artists.[3]

Although she was travelling in England at the time of the annual meeting, Mary Ewart was elected president once more. Berte Stead and Mrs. E.P. Fetherstonhaugh became vice-presidents, Mrs. J.D. Atchison and Miss Champion were elected secretaries, and Mrs. A.W. Crawford became the treasurer.[4] Together they were the executive committee. Mrs. Ewart wrote that she had been in touch with some English artists and hoped that arrangements could be made for an exhibit of English paintings next winter.[5]

Following the miscellaneous format of the past year, the lecture committee decided not to set the program in advance. They preferred to include visitors to Winnipeg and thus introduce a variety of subjects and attitudes. Rev. Father Nash, who had been head of the Jesuit College in Calcutta for thirteen years, gave the first lecture, discussing Hindu and Muslim art. He described colourful and contrasting pieces, characteristic of the varied land of India, with the Taj Mahal garnering his greatest admiration.[6]

After the business section of the annual meeting, Ivan Lindhe, a Swedish portrait painter, now working in London

and member of the Modern Society of Portrait Painters, spoke. Earlier in the month the association had issued invitations to a private viewing of his work at the Great West Life Building. He talked on artists as colorists with special reference to Rembrandt. Turning to the work of living painters, he showed great admiration for Sargent. On the same occasion Mrs. Colin Campbell gave a talk on cloisonné, referring to fine examples in Winnipeg.[7]

Two weeks later J. Henry Stanford spoke on "Art: Its Relation to Nature and Its Influence on Life". He attacked Canadian taste in art in a way that must have startled many in the audience. Stanford vigorously criticized the often praised portraits at the Legislative Buildings and City Hall, painted by local artist Victor Long. He termed them "miserable effigies masquerading under the name of portraits" and nothing more than imitations rather than true art, which he said is marked by emotion and skill.[8] Canada as a whole, he felt, didn't lack conditions for producing genius, but it had several grave drawbacks. People did not have sufficient opportunity to see good work, to purchase it and to honour the producers. As a first corrective step, Stanford asked the WAA to exert its influence so that the community would provide wider art experiences for all citizens.[9] Less controversially, Professor A.W. Crawford, a favourite lecturer, talked about Robert Browning's poems on art.[10] Later J. Pender West gave an illustrated address on Gothic architecture in England.[11]

The next three lectures described different aspects of the visual arts and their relationship to local conditions. Miss Clopath, who had taught in the Minneapolis school system, took a didactic approach with "The Educational Value of Art". A follower of Ruskin and Morris, she advocated the general need to study art, as opposed to the idea that it is only for people with special ability or the desire to become artists. She said that it develops the power of observation, increases the faculty of memory and joy in life, fosters the imagination and the pursuit of the ideal, and is related to everything in the home. The highest function of such training is to provide

aesthetic and moral training.[12]

A talk titled "Handicrafts in General and Enameling in Particular" addressed an area in which local interest was increasing, as shown by the WAA's sponsorship of handicrafts and the recent formation of the MSAC. The speaker, Mrs. Maeve O'Byrne Doggett, was a spirited advocate of crafts as the equal of painting and sculpture. A recent arrival in Winnipeg, she was a medallist at the Metropolitan School of Art in Dublin, a prizewinner at South Kensington, and a member of the Craft Society of Ireland. She described the dignity of crafts, which depends on the degree to which they express the artist's conception, understanding of a chosen form, and originality of concept. After giving a history of enamelling and its present day revival, she pointed out the merit of encouraging crafts in Winnipeg. "I foresee a great future for art in this vast and beautiful country, with its great surplus of many peoples", she said; but she felt some doubt about the immediate future. "Time will show if this city is yet 'cultured' enough to appreciate the value of having a handicraft shop."[13]

Valentine Fanshaw, the artist and art teacher at the new Kelvin Collegiate, spoke on "The Significance of Design in Everyday Life". His background included seven years of study at the Sheffield Technical School of Art, followed by two years each at the Royal College of Art in Kensington and the L'Académie des Beaux Arts in Antwerp, combined with a certificate in textile design from the London Board of Education. He came to Winnipeg in 1912.[14] He described design as the selection of the form, line and colour, suitable for specific objects. This can be seen in the most common things. Articles of dress, selection of stationery, arrangement of flowers, placement of furniture can all affect everyday life. Using pictures he showed how form and colour influence emotions and comfort; and he recommended that the audience use careful observation and study in order to master good design. He felt that this was especially important in Winnipeg, where beauty of surroundings would compensate for lack of natural beauty and make people proud of their place.[15]

In quite a different vein, Frank Allen, Professor of Physics at the University of Manitoba, described colour and the mechanics of how it is viewed from a scientific rather than aesthetic point of view. For example, he attributed many of the wonderful hues we notice in the sky and sea to the presence of dust in the atmosphere.[16]

The series closed with a report from Mrs. C.E Dafoe, who had attended a craft exhibition in Minneapolis as a representative of the WAA. She also gave a detailed history of Oriental rugs.[17] The lecture series had been a truly varied program, which had increased the knowledge of the audience and challenged them in various ways to work for greater acquaintance with art in their community. But it was the mandate of promoting handicrafts that brought a major competitor to the field.

The WAA had never completely abandoned the handicraft project, which had failed in 1908, but its efforts tended to be sporadic. The large number of European immigrants who continued to settle in Winnipeg and the West had become a noticeable segment of the population.[18] Their presence was a spur to those interested in ethnic crafts and cultures. Montreal's Handicrafts Guild continued to furnish an example, and it eventually looked westward for both objects to display and a venue in which to display them.

The Canadian Handicrafts Guild, hereafter known as the Guild, had originated with the Montreal branch of the WAAC, some of whose members had a long-established interest in Canadian handicrafts, predating their membership in the association. They withdrew from the WAAC in 1907 and as the Women's Art Society fostered the work of women artists and developed the Guild.[19] Mary Dignam had incorporated handicrafts into the WAAC program at the turn of the century and continued the interest. This caused some rivalry between the two organizations.

The Guild made its presence felt in the West both as a buyer for its shop and an exhibitor and retailer of crafts. In 1910, for example, Mary Phillips, the Guild's travelling secretary and former president, visited ethnic colonies in the West –

particularly German, Ukrainian and Doukhobor – encouraging women to make articles for sale. During her tour she came to Winnipeg and spoke at the Women's Canadian Club. She had found that many skilled wood carvers and metal workers had emigrated to the United States because they found no market in the West. With this in mind, the Guild hoped to establish bureaus in different cities to bring artists and purchasers together. In addition to the aesthetic and economic benefits inherent in fostering handicrafts, Mary Phillips struck a new, political note. She claimed that the knowledge and appreciation of the decorative arts, characteristic of the various nations now in Canada, would be important in forming a united country.[20] A bureau was founded in Edmonton in early 1911.[21] In July the Guild mounted an exhibit at the Winnipeg Fair. The First Nations baskets from British Columbia, pottery from the Grenfell Mission in Labrador, colourful embroideries created by recent European settlers, French-Canadian textiles, Irish lace and other home crafts attracted an appreciative audience. Despite much interest in the enterprise, a Winnipeg shop or bureau had not developed yet. Much time was spent in planning what such an enterprise should be like and how to support it. There was a strong feeling that the stock must be of high quality and that business and art should not be combined with philanthropy. Indifferent "fancy work" did not attract customers, and skilled craftsmen refused to be associated with work of doubtful merit.[22] Stress was to be put on Doukhobor and Ukrainian work and the finest First Nations embroidery and basketry. Supporters from the WAA welcomed the prospect of a shop similar to those in Montreal, Toronto, and Minneapolis as an amenity. It also would assuage a western sensitivity by furnishing a market for local goods which were now collected by eastern and American buyers, and sometimes sold under their auspices in Winnipeg.[23]

The process of gathering sufficient merchandise of the desired quality to stock an efficient shop continued for many months. The committee in charge was made up of Berte Stead, Mrs. W.C. Perry, Mrs. C.E. Dafoe, Mrs. A.W. Crawford,

and Mr. Valentine Fanshaw. They had to renew relationships with known craftspeople and search out new workers. Special areas addressed were the Francophone community of Saint Boniface and Winnipeg's North End where large groups of urban immigrants settled. Later Mrs. Stead said she tramped all over these districts, searching for attractive works.[24] They also placed advertisements in the ethnic press. Arrangements for selection and commission seem to have remained as before.

In late March 1913, the WAA decided to affiliate with the Handicrafts Guild of Montreal, thus implementing an exchange of metal and basketry, enamels, and lace. The shop, however, would remain under WAA supervision.[25] The memory of its relationship with the WAAC had made Winnipeg guard its independence. The Guild, which had also experienced the WAAC, did not wish to follow its example by dominating the bureaus, which now included Edmonton, Calgary, Ottawa, Vancouver and Hamilton. They were to be self-sufficient and to use any profits to benefit local work. By this time Montreal was entirely self-supporting, but it had taken years to achieve that status. Therefore branch shops would pay for consignments only when the goods had been sold.[26] In order to raise money for the shop, the WAA held a fancy dress ice carnival, which realized $547.05.[27]

The WAA had been publicizing the projected shop by displaying wares at the Industrial Bureau. In May they were permitted to hold a week-long sale there, with profits earmarked for the shop. Promotion material emphasized beauty of the objects, their practical use and reasonable prices.[28] Women looking for unique or beautiful objects for their homes or wardrobes were urged to lend their support. Much of the work, especially textiles, came from Quebec. Enthusiasts felt, however, that Winnipeg's large foreign population would be a growing source of crafts, particularly weaving and rug making, and that Manitoba might work up as extensive an industry as Quebec's in due time.[29] Although not large, the selection of goods was considered excellent. Many visitors came, including delegates attending the national I.O.D.E. convention. Sales

came to a healthy $329.89, but the net profit was only $71 after craftsmen were reimbursed and travel and various other expenses were deducted.[30] In order to be viable, the shop in its early stages would clearly need continuing funding from the WAA.

The next step was a larger exhibition at the Fair, showing women's work from all over Canada. The exhibition contained everything "from lacework and basketry to pottery and homespun."[31] As a new feature a handloom was set up, and people were invited to bring rags and have them woven into rugs.[32] Lace makers also demonstrated their work. First Nations crafts varied from birch bark and fern baskets (eastern), trinket boxes decorated with sweetgrass and porcupine quills (prairies), to beadwork (western reserves).[33] This exhibit proved to be an opportunity to attract the attention of the largest audience of the year, including potential buyers and suppliers of crafts. Another point of contact appeared in the prize lists, which the association still supervised: hand-made pottery, enamelling, jewellery, and weaving were included for the first time.[34]

Soon after these two experiences the WAA opened the permanent shop for which they had been preparing. As a result of the initiative of 1912 it was located in rent-free quarters at the Industrial Bureau. A woman weaver was in charge of daily operations. She was able to weave three rugs a day and attend to the shop. Using the purchaser's material, charges were as follows: eighty cents for rugs 30 by 36 inches; ninety for 36 by 36 inches; $1.25 for 30 by 108 inches; and $1.50 for 36 by 72 inches.[35] It would seem that rug weaving to order was becoming very popular.

The stock was made up of crafts, which had attracted buyers at the sale and the Fair. Novelties from the Doukhobor colony were chairs put together without nails, and French-Canadian homespun sold well.[36] In September Christine Steen, manager of the Guild's shop in Montreal, visited Winnipeg during a western tour and complimented the association on the progress of the shop. She also emphasized the Guild's goals of preserving First Nations and Quebec rural crafts,

encouraging new immigrants to retain theirs, and stimulating all citizens to respect and admire genuine handicraft, a true sign of a real culture. Looking ahead, Steen expressed the hope that Winnipeg citizens would foster and sustain the shop as a worthy cause.[37] This support was vital to success.

At the annual meeting the treasurer reported that the WAA had turned over to the handicraft committee some $800 including the shop assistant's salary for a year. Mrs. Stead, the chairperson, reviewed the committee's early struggles. She was sanguine about the shop's success, although it still had to be subsidized and required a larger number of craftsmen to make it succeed. The shop had had a red-letter day when the actress Margaret Illington purchased $85 worth of curtains, rugs, and couch covers for her summer home. Stead also answered criticisms of the project. "We are not in competition with any cottage industries...we do not sell lace or anything else brought from other countries." she explained, "We are a Canadian company to build up Canadian industries."[38]

CHAPTER NINE

GOOD TIMEƒ IN THE ART COMMUNITY

The autumn of 1913 saw the opening of a second public art institution in Winnipeg. The Winnipeg School of Art, like the Art Gallery, was founded under the aegis of the Industrial Bureau. It occupied space in the same building and was administered by the Bureau's art committee, chaired by James McDiarmid. Alexander Musgrove, who had been trained at the Glasgow School of Art and Glasgow University and had taught at the former, became the principal. With Donald MacQuarrie and Cyril Barraud., he began the systematic teaching of drawing, painting, modelling, design, and crafts.[1] Cyril Barraud stood out among the artists who had emigrated from Britain to Winnipeg. Descended from several generations of English painters and photographers, he had exhibited at the Royal Academy, and was associated with St. Martin's School of Art through active participation in the Gilbert-Garret Sketch Club.[2] Some of his work was on display at the Art Gallery. While a capable, all-round artist, his specialty was etching, which he was to popularize in Winnipeg.

This was the realization of more than a generation of hopes and struggles in which the WAA played a major part, together with the MSA, MSAC, the group connected with the

Fair, the Manitoba Society of Architects, and others interested in developing the presence of art in the city. Mary Ewart had been very active as a proponent and as a teacher at the Free School. At the WAA annual meeting Ewart was given a fourth term as president with Mrs. Stead and Mrs. Hugh Sutherland as vice-presidents, Mrs. W.G. Perry served as recording secretary, Mme. Bourgouin as corresponding secretary, and Mrs. A.W. Crawford as treasurer. The number of board members was increased to eighteen. Ewart, who travelled often, reported that Winnipeg had become known in the United States, Britain, and the continent because the Industrial Bureau had established the first civic art gallery in Canada.[3] After mentioning the role of the WAA in founding the Art Gallery and Art School, she suggested that the Association should establish a scholarship at the School.[4] They agreed to give annual scholarships of $125 and $75 to female students who made the most progress during the term, so as to encourage their studies.[5]

The 1913-14 lecture series illustrates the buoyant art developments in Winnipeg. New institutions and professionals were present as never before. An addition to the two art institutions and the technical high schools was the School of Architecture, newly founded by the University of Manitoba. Ambitious murals for the Royal Alexandra Hotel were commissioned, and the CNR had opened the imposing Fort Garry Hotel. After an empire-wide contest, won by the experienced British architect Frank Simon, the construction of the legislative building had begun. Drawing on the skills of many newcomers connected with these enterprises, the WAA was able to present an attractive series and to furnish a platform for a variety of causes. The lectures took place at the Industrial Bureau, the Fort Garry Hotel, and the homes of Mrs. Nanton and Mrs. Ewart.

The first speaker was Dr. James McLean, the first president of the recently reorganized University of Manitoba.[6] A classics scholar who had studied at the University of Toronto and Cornell, he formerly had been the president of the University of Idaho. McLean's topic was the importance of art in public

schools. Following Ruskin's views, he felt that industry and art need to be united. In Winnipeg, he argued, it was more important to foster the School of Art than to amass a collection of art works for the civic gallery. By its influence during the next ten years, the School would cause artwork in the public schools to advance from its present linear style to more three-dimensional presentations. He concluded on an encouraging note, saying that he noticed "a movement of the people towards art and a movement of those who interpret art towards the people."[7]

On the same occasion Professor Arthur A. Stoughton, the first professor of the School of Architecture, also spoke. An architect from New York, he had studied at Columbia and at the École des Beaux Arts in Paris for three years. After giving a historical survey of his field, Stoughton turned to the everyday aspects of architecture in Winnipeg homes and the city's public buildings. In both "beauty is a necessity and not a luxury" was his message.[8] Then he suggested that a new civic enterprise for WAA members would be educating public taste on the standards of beauty.

Alexander Musgrove, the principal of the Art School, described the make-up and aims of the fledgling institution, which had eighty pupils and was continuing to grow. It had been established to provide a place near at hand where students could get complete and thorough training. Instruction was given on the studio plan in order to encourage individuality. Musgrove also addressed the topic of public taste. While he did not expect that all his students would become working artists, the school would offer an artistic and aesthetic education and would cultivate discrimination and taste for the beautiful. This education would also have an impact on the community. By influencing choices of objects in daily use, it would help to raise general standards. In turn, the educated community would produce artists and perhaps a distinctive school of Canadian art.[9]

Mrs. Bergman, the wife of the manager of the Fort Garry Hotel, entertained the WAA in the hotel's chateau-style premises. Mrs. Hay Stead spoke on the WAA's handicraft

shop as one in a chain of such institutions stretching across Canada. Standing before a screen hung with samples from the shop, she called attention to their attractive features. Among them were Ukrainian rugs, and lace, woodcarving, and pottery made by Russians. Her highest praise was for First Nations basketry that had been developed to fill all domestic needs. "Into their art," she said, using the language of the day, "they wove history, poetry, and the spiritual aspirations of their race."[10] Stead emphasized, however, that although the stock was attractive, in the end the survival of the shop depended on citizens' support.

Cyril Barraud lectured on the medium of etching in some detail, with reference to the different processes the etcher used to obtain a variety of effects, and he illustrated points by showing the tools, materials, and methods involved, and finally some finished works. Compared to painting and drawing, the artist's print was an unfamiliar concept for many of his audience. They were surprised at the complicated process and careful techniques needed to make an apparently simple etching.[11]

In a return to art history, the Rev. G.F. Salton of Fort Rouge Methodist Church lectured on British art in the National Gallery and the Tate in London. Dr. Salton had a long-time interest in the field. In addition to his church duties he conducted educational tours to Great Britain, which featured gallery visits. And he extended this art education by giving lectures at home. His slides were considered superior to those usually seen. In relation to continental work, Salton presented British art as marked by the desire to convey a lesson. His slides also showed the fine artistry of such painters as Reynolds, Gainsborough, Lawrence, Turner, Constable, Millais, Wilkie and others. Much modern art he discarded, however, as impressionistic slapdash. At the end of the hour the audience wished that the popular speaker had continued for twice as long.[12]

A presentation titled "An Artist's Life" by F.M. Bell-Smith, an established Ontario painter who was well-known through his connection with RCA and OSA exhibitions and visits to

Winnipeg while en route to sketching in the Rockies, was considered very interesting and characteristic of his genial temperament. He did, however, have a message for his audience. Trained at the South Kensington schools, Bell-Smith had emigrated to Canada in 1866, where he found an artist's life very hard because most Canadians distrusted their own judgement of art without the European stamp of approval. So they did not purchase Canadian paintings. When living in England, he reported, he was able to sell works in Canada. After emigrating he had to spend twelve years as a photographer's assistant before managing as an independent artist. This experience, which was representative of the Canadian market, was told by Bell-Smith in order to encourage members of the WAA to appreciate and foster the artists of their own country.[13]

Mr. C. Quinn's topic was "Historical English Furniture and Decoration". He described the decorative art of different periods including the present, with special attention to the relationships among the separate media and to the general phases of colour schemes. As illustrations, Quinn brought samples of period furniture, old prints, and china together with contemporary tapestries and chintzes.[14]

Walter J. Phillips, who was in charge of art training at St. John's Technical High School, talked on "The Practice of Watercolor Painting." Phillips had had a varied career before arriving in Winnipeg in 1913. After study at the Birmingham School of Art he lived in South Africa and then, on his return to England, worked as a commercial artist and art master in Salisbury. Like Cyril Barraud, he had exhibited at the Royal Academy.[15] Phillips gave a detailed description of watercolour technique, too technical for the layman, some thought, but valuable for art students.[16] As foremost contemporary watercolourists he mentioned Ernest Waterlow, Alfred East, Helen Allingham and others, pointing out the characteristic style of each with the aid of prints. As further illustrations of the medium he had brought some of his own works, which were greatly admired.[17]

The season concluded with an appeal different from

those usually directed to the WAA. Mrs. Mary T.S. Schaefer of Philadelphia spoke enthusiastically about her recent tour on horseback in the Canadian Rockies and particularly the hitherto unexplored Maligne Lake region. She showed slides she had made en route. Moved by the nature of the country, Schaefer was eager to press the Dominion Government to deed the land to British Columbia as a national park and thus to bring it to the attention of Canadians. At present, she felt, American tourists outnumbered Canadians nine to one.[18]

All these speakers contributed to a new sense of urbane sophistication felt in the city. Community art education was an integral part of the cultural scene, along with the art gallery and the school of art. A critical mass seemed to be building that would establish a sensitivity toward art in a variety of forms, if not in the general public, then among the elite. The role of the WAA in creating this cultural dynamic was fundamental.

As an acknowledgement of their pioneering efforts, two members of the WAA were appointed to the Art Committee of the Industrial Bureau. This body supervised the Gallery and School under the chairmanship of James McDiarmid. On December 5, 1913 the WAA and the Art Committee held a reception for the opening of an exhibition of modern Scottish oils, watercolours and graphics. Also featured was a display of Canadian handicrafts, presided over by a Swedish woman in full native costume. Tea was served, and an orchestra played throughout.[19] The following June the Art Committee looked after an occasion to mark the simultaneous opening of several exhibitions of interest to the group: work of Western Canadian artists; a juried show of photographs submitted by international artists and arranged by the Winnipeg Camera Club; a generous sampling of students' work done at the School in its first year; and a varied exhibit in the Handicraft Shop area. The WAA's interest in the Western Artists Exhibition was heightened by the inclusion of three fine portraits by Mary Ewart and works by such artists as Barraud and Musgrove, who had participated in the lecture series.[20]

Despite its Montreal affiliation the Handicraft Shop

continued to be a major part of the WAA program, but its finances remained uncertain. The relatively small volume of sales, when combined with the minimal commission charged on articles, was insufficient to generate a profit. Therefore, the Association embarked on a money raiser, a program of folk dances and songs to be presented by Winnipeg's ethnic groups. Such a project had not been seen in the city before. It evolved quite naturally from the Shop's connection with immigrant groups; and a craft sale complemented the performance. Advance publicity described it as "a glimpse of the possibilities of the Canada of tomorrow."[21] Like "Living Pictures" the "Songs and Dances" show required much preparation on the part of the committee and the participants. Mrs. F.H. Brydges was the chairman, with Mrs. W.R. Allen supervising the French component. Louis Kon arranged the large section comprised of Swedish, Norwegian, Ukrainian, and Polish groups, while Mrs. Malcolm and Mrs. Chalmers looked after the Scottish ones. Great care was taken with the costumes, the form of the dances, and the rehearsals. Patronesses for the event represented the cream of Winnipeg society. This international presentation was held on three successive evenings in the banquet hall of the Fort Garry Hotel from February 17 to 19, 1914. Tickets were one dollar. After the various groups had performed, all the choirs united in singing "The Maple Leaf", a hopeful symbol of the union of all groups in their new country.[22]

Accompanying the performance were five booths of handicrafts, arranged according to nationality. For each, a background of draperies and rugs created the atmosphere of the country involved. Stepping into any, one visitor thought, was like stepping into Europe.[23] In one booth three women from France and Austria, now living in St. Boniface, demonstrated the arts of making bobbin lace and applying beadwork to net. Examples of many kinds of lace, from wedding veils to heavily bordered tablecloths, hung on the walls. The Scandinavian area featured a girl in Norwegian holiday garb weaving linen. Displays included crocheted bedspreads, patchwork quilts, tablecloths edged with tatting and Hardanger lace, wool and

linen homespun. Quebec furnished the popular habitant work, which had formed the backbone of craft exhibits for several years, together with First Nations bead and leather work. Many visitors were attracted to the First Nations display because it was supervised by mocassin-shod Native women and featured basketry, sweetgrass, quillwork, and embroidery.

The Ukrainians had the most elaborate section of all, adorned with antique and modern Oriental rugs, and garments featuring geometrical embroideries similar to cross-stitch but different from those of other nationalities. There was also a display of wrought metal and woodcarving, which indicated the recent growth of these crafts locally. All in all it was a novel and enjoyable event. The presentation not only revealed the variety of crafts available in Winnipeg but in many cases it introduced them to a new audience.[24] Alison Perry, a *Winnipeg Post* columnist, directed the public's attention to the WAA's permanent installation in the Industrial Bureau for further purchases and emphasized the Shop's need for active patronage.[25]

As a fund-raiser the project was moderately successful. The WAA cleared $181 from receipts of $652. Like the earlier "Living Pictures" there had been heavy expenses for music, costumes, rehearsals, etc. To these were added transport, installation of booths, and payment to artisans for objects sold. However, "Folk Songs and Dances" had intangible educational value, in addition to the presentation and sale of crafts. Alison Craig of the *Free Press* summed up the result:

> The gospel of getting together, of understanding one another, is one Canadians need to learn, and, therefore, the WAA is due a vote of thanks for its recent presentation to artistic Winnipeg of so many of the new Canadians.[26]

The work of publicizing the Handicraft Shop in the Industrial Bureau continued, partly by such means as an informative talk delivered by Mrs. Dafoe, a member of the committee, to the Ladies Aid in the Congregational Christian Church. She was accompanied by Miss Westlind, a Norwegian

weaver in costume, who demonstrated her skill at weaving linen. After describing the various wares available in the shop, Mrs. Dafoe termed the enterprise a link between the craftsman and the public because it operated to secure a fair price and ensured that durable materials were used, while not interfering in the design or colour.[27] She also mentioned that the demand for handwoven articles was increasing.

In March, hand-made pottery was added to the stock as the result of a demonstration arranged by a business interested in the potential of local clay. Using a wheel and Winnipeg clay, a man from Bukovina (a Ukrainian province of the Austro-Hungarian Empire) worked the treadle bare-footed and shaped pots with what seemed marvelous quickness. Coloured dull brown and green, they were received with interest. People were surprised that often-slandered Winnipeg mud could be used in such a way.[28] In April the WAA adjourned its meetings until fall. Mrs. Ewart expressed the hope that all members would take an active interest in the shop during the intervening months. The handicraft display held at the Art Gallery in June featured tempting stock: beadwork and moccasins from the Peace River district, "pioneer rugs", richly coloured Ukrainian rugs, artistic brasses from Montreal, and local pottery.[29] It had been a successful winter and spring season for the WAA. How developments in Europe that coming fall would change the overall situation were not foreseen by anyone.

CHAPTER TEN

THE GENERAL EXCHANGE

When the WAA began the 1914-15 season World War One had broken out, and Canada was deeply involved. Even at this early stage the war brought new concerns and responsibilities to the Association. As well, Winnipeg's economic boom had been over for some months and the expansive times of the last few years had come to an end. Because of her splendid leadership Mrs. Ewart was acclaimed again as president. Other officers were Mrs. Hugh Sutherland, Mrs. Desjardins, Mrs. Frank Drummond, Mrs. Stoughton, Mme. Bourguin, and Mrs. Bale.

The WAA suffered a great loss when Berte Stead, who had worked with such enthusiasm for the crafts shop from the beginning, left Winnipeg to live in British Columbia. The shop, still not self-supporting, had received a subsidy of $1,100 from the association's income of $1,489. With this help it had succeeded in gaining greater recognition for crafts than they had had before. For example, one hundred and twenty rugs woven on the shop looms had been sold. With the idea of further widening its scope, the committee was considering a move downtown and to larger quarters.[1]

The war and the new economic climate were to change

the nature of the shop. With men in the army or unemployed, many families had inadequate incomes. Aware of the financial stringency, the WAA planned to set up a general exchange, similar to those in other cities. "We hope to provide a market for house industry," said Mary Ewart. "The prices will be kept at market rates…To pay, such a project must have the patronage of the general public. It may not pay at first, but it should in time."[2] Sewing and cookery were to be combined with such men's work as toys and carvings. A ten percent commission was to be charged on sales to cover running expenses.

The WAA was encouraged about the feasibility of the exchange by a group of influential business leaders who attended an executive meeting to express their support. Among them were Mayor Deacon, ex-mayor Waugh, George Galt, Mr. W. Allan, C.F. Roland, and A.M. Nanton. The last was particularly enthusiastic after seeing a similar project in Toronto.[3] Both for patriotic reasons and to raise funds for the Exchange, the WAA planned another "Living Pictures" entertainment. This time the tableaux would represent patriotic subjects. It was a joint venture with the Industrial Bureau, the local Council of Women, the Women's Musical Club, and various other groups. Proceeds were to be divided as follows: half to the Patriotic Fund, which raised money to support soldiers' families; a quarter to the establishment of the General Exchange; and a quarter to the Art Gallery.[4] Mary Ewart was in charge of the production, which ran for four nights at the Walker Theatre in mid-November. The twelve subjects, "posed by some of the most prominent ladies and gentlemen of Winnipeg" were accompanied with music by a well-known band.[5] The tableaux were interspersed with vocal numbers and a women's chorus. The capacity audiences included theatre parties arranged by several hostesses. Like the WAA's earlier tableaux shows, these patriotic evenings were a great success.

The association received $397 from the project, a very helpful sum.[6] By December 1 the WAA's General Exchange had opened its doors at 270 Carlton Street near Portage Avenue. This was a more visible location than the space in the

Industrial Bureau. One window displayed home cooking such as breads, pies, cakes, and pickles; the other showed wood-carving, quill baskets, hammered brass, and fancy work. Quilts, spreads, rugs and other crafts were inside the shop, and orders could be placed for moccasins made by First Nations women from Selkirk, Manitoba. Prices were considered reasonable, which made the wares attractive to Christmas shoppers. In a small room, members of the WAA served tea for twenty-five cents. They hoped to expand this feature to a larger space if all went well.[7]

The press continued its friendly attitude to the WAA with generous coverage of the Exchange. The committee was active in gaining additional support. Charles Roland, manager of the Industrial Bureau, gave a public talk on "The General Exchange from the Industrial Point of View."[8] Another avenue was explored when members of the Patriotic Committee, who visited soldiers' families, were asked to tell their clients about the Exchange as a resource.[9] In a few days the WAA entertained members of the Press Club in the tearoom. While familiarizing them with the premises, Mrs. Ewart indicated that the tearoom would soon be moved to an adjoining space in order to provide an area where weavers, lace makers, and other craftspeople could demonstrate their skills.[10] At least one reporter felt that the Exchange had been inspired and implemented by Mary Ewart despite some opposition encountered because of hard times.[11]

A further constructive step was the appointment of a manager. Miss Agnes Spackman had been in charge of the dining and dormitory areas at Manitoba Agricultural College for five years and was an experienced judge of cooking and handicraft.[12] Soon the tearoom was able to extend its services by offering a light lunch, an amenity that many people had requested.[13] Business in the tearoom had been flourishing for several weeks before Lady Cameron, wife of the Lt. Governor of Manitoba, presided at the official opening of the Exchange. She described it as the WAA's most ambitious and practical undertaking and congratulated the members on the artistic and

successful way they were carrying out the project.[14] On view was a fine collection of handwork. The tearoom featured some pieces of willow furniture, which had been made locally. Tea tables were set with attractive linen and willow pattern china with willow baskets of flowers as centrepieces.

Once more it was time to raise funds. Starting the Exchange had required a substantial outlay, and experience with the Handicraft Shop had taught the WAA that such projects need consistent support in their early years. The association decided on a practical, non-artistic approach to raise funds. This was a break with the combination of artistic and educational elements with financial ones, found in hosting exhibitions and mounting tableaux. Perhaps it was a reflection of the times and the war's increasing demands or it may very well have arisen from the more limited energies of the group. Less than two months had passed since the WAA had played the leading part in organizing the "Patriotic Tableaux" and just over a year since the production of "Folk Songs and Dances." Both had consumed enormous amounts of planning, effort and time. Financial return had been moderate.

Consequently the WAA decided to sponsor a series of benefit bridge parties held by well-known hostesses. Preparations for them would be comparatively easy, and there would be few deductions from the income. Prizes were given and afternoon tea served. As president, and perhaps originator of the project, Mary Ewart had the first party, which attracted about twenty-five tables of players. China lilies "in a real treasure of a Chinese vase" adorned the tea table. Mrs. Stoughton and Mrs. George Allan poured the tea, and there was a bevy of assistants. The sum raised that afternoon was $90.[15] Using a similar format, Mrs. A.M. Nanton at "Kilmorie" and Mrs. John Galt at "Greenock House" gave twin parties which realized $140.[16]

The Exchange was off to a great start. By mid-February over $700 had been distributed to clients for work sold. The lunch and tearoom was popular, with an income of $304.20.[17] In March the treasurer reported that the WAA's income was

$937, with $664 in disbursements, much of which was to the Exchange.[18] Future fund raisers included a bridge party hosted by Lady Cameron at Government House, Margaret Bemister's second lecture "Indian Lore", and Mrs. W.C. Perry's lecture "London and Paris in War Times", accompanied by recruiting posters by well-known English artists. For the last occasion any receipts over $100 were to be given to the All Saints' inter-denominational working group, who were preparing hospital supplies for base hospitals.[19]

The Exchange was praised for furthering handicrafts and helping people to maintain themselves in hard times, but the operation was not always problem-free. There were issues that concerned both suppliers and buyers. Buyers thought some articles were over-priced. On occasion it was necessary to remind suppliers to make allowance for the fact that the 10% commission charged by the Exchange had to be added to the selling price. Other articles were not attractive to customers for a variety of reasons. Work aprons and towels were in demand, as were Irish crochet and work of real artistic merit, but painted cushion tops were not. There was a good market for eggs, butter, preserves, pickles, and home cooking, if fresh, of good quality, and reasonably priced. To avoid misunderstanding, prospective purchasers were asked to write and inquire about items and prices before placing orders.

The rug department had expanded. In addition to hit and miss carpets it was now possible to have woven or stenciled designs made for an extra charge. One rug, for example, had figures of Dutch women at each end. Workers asked that the rags supplied by purchasers should be clean. Dyeing also presented some difficulties. White material could be dyed to order at 15 cents per pound, but dark colours could not be tinted in lighter shades. To expedite the process, people wishing to have carpets woven were asked to write to the Exchange and make arrangements.[20] In time, relationships between buyers and sellers were clarified and resolved satisfactorily as the Exchange developed.

Although the WAA spent much time and energy on fund-

raising and establishing the General Exchange in the 1914-15 season, they did not abandon the lecture series, which was such a stimulating part of their program. Indeed, they presented an especially varied group of speakers and topics. Professor Arthur Stoughton addressed the Association on "City Planning", a subject harmonious with the group's interest in extending art influences into everyday life. The Planning Movement, which had existed in the United States for fifteen years and had made great strides, was just beginning in Canada. Recently, Winnipeg had established a three-man commission, headed by J.D. Atchison, to work in this area. In its short existence and during periods of rapid growth, the city had developed haphazardly to meet needs as they arose. Stoughton felt that civic beauty is the result of effective and scientific design. Now was the time to improve conditions in such areas as traffic management, transit, installation of utilities, the regulation of height of buildings, and recreation areas. In addition to correcting faults already present, it was necessary to plan for new contingencies and lay out new sections correctly. In closing Stoughton asked the Association and its individual members to support the work of the Commission in implementing a functional and aesthetic plan for Winnipeg.[21]

Some favourite speakers returned. Professor A.W. Crawford discussed "Tennyson's Conception of Art and Life". Citing passages on painting, sculpture and architecture he described the poet as a champion of the social values of art and of the social responsibility of artists. This concept was set in opposition to art for art's sake, which he termed spiritual stagnation.[22] In a similar vein Rev. G.F. Salton discussed "Masterpieces of Art" and their characteristics as shown in slides of paintings, to which he devoted two minutes each. Salton felt that masterpieces must portray some of the artist's personality and make a personal appeal to all viewers. Also they must unite thought and goodness. For him the latter meant truth, righteousness, and wholesomeness.[23]

Raymond Carey gave a lecture on "The Meaning of Architecture". He described true architecture as the artistic

development of forms dictated by practical necessity at various historic times. Buildings should have strength, restraint in ornaments, purity of form and detail, and the repose that comes from a harmony of elements. Carey illustrated his points with blackboard drawings of Greek, Roman, and medieval structures. These were the work of artisans who were artists also. His description of them as not hampered by trade unions or constant reference to the dollar completes an idealized situation, which one infers is quite different from Carey's own experience as the architect for some of Winnipeg's most attractive houses. Turning to contemporary work and the new materials of steel and concrete, he felt that no architecture using these materials had emerged as yet to express the present age.[24]

Miss Margaret Bemister's lecture "Indian Lore" complemented the WAA's interest in First Nations crafts and their makers. She had started collecting North American Indian myths as stories for children. This research deepened as she discovered that many tribes shared religious concepts in which the forces of nature were personified and the Great Being was life itself. Bemister gave examples about the origins of different animals, such as how the chipmunk got its stripes. When transcribed, these myths became literary. According to Bemister the beliefs described in them were comparable with other systems of mythology. The stories also provided information about First Nations crafts and customs. Miss Bemister thought, as was typical of the Euro-Canadian racial stereotyping of the times, that the stories showed a child-like mind, which should not be judged by the standards used by white people.[25] The popularity of this lecture inspired the WAA to sponsor a repeat performance for a wider audience of children and adults, with the proceeds earmarked for the Exchange.[26]

Variety continued to be the hallmark of the series. In March George Halford described the history of gardens.[27] Elizabeth Farrow talked on "The Craft of Woodcarving." One of the English artists who had come to Winnipeg, Farrow's career

began with her early experiences in her father's workshop. Eventually she spent three stimulating and successful years at the London School of Art, working alongside students from seven different countries. She had an independent studio before coming to Winnipeg to teach manual training at Laura Secord School. Four hundred boys attended her ordinary classes each week, and others came to two classes held after school hours. Farrow had a great belief in the value of her work as a means of building character as well as learning skills. She felt that carving trains students "to do common things uncommonly well" thereby learning to express their own ideas in craft and appreciating other people's.[28]

Frederick H. Brigden, the manager of Brigden's graphic art firm and himself an experienced artist, addressed the WAA on "The Advent of a National Canadian Art."[29] He had come to Winnipeg at the request of the T. Eaton Co. to found a branch of the firm and to produce Eaton's western catalogue. They had done the eastern one since 1893. Brigden's interest in his subject had developed during association with artists in business, as a fellow artist in the Art Students League, and as an exhibitor with the OSA and the RCA. He felt that progress towards a Canadian art as distinct from European styles had been particularly marked in the last decade, when landscape painting showed wild woodlands, lakes, and prairies, and the use of colour was vivid. These artists, he pointed out, deserved far more support than they received. They had to combat the habit of many wealthy people, who preferred buying "any sort of daubs from Europe to a bit of real achievement by a Canadian."[30]

Brigden commended Canada for establishing a national gallery of art in Ottawa and sending exhibits to civic galleries. These included two fine paintings by C.W. Jeffreys and Lloyd Harrison on view in Winnipeg's gallery. In this connection he praised the local art community for its success in founding a public gallery, accessible all the year round. The audience listened attentively when Brigden gave biographical sketches of Canadian artists and was described as "feeling proud that

Canada had such a worthy list."[31]

The series took an international turn with "Japanese Prints", a topic introduced to the WAA by Professor Stoughton, who brought along several examples. At first glance these works, so different from European art, might be considered a combination of old tapestry and comic strip art. Originally borrowed from the Chinese, the prints evolved over the centuries into conventionalized portrayals of Japanese society, which Stoughton described as being "full of intense palpitating life and redolent of movement."[32] Unusual combinations of colour and detailed attention to costume were strong features. They were created for a decorative purpose rather than resembling the European pictorial tradition. The process of producing these prints demanded such skill that the artist, the engraver, and the printer all signed the finished work.

It would seem that, in spite of the demands of the war effort, the WAA was able to carry on its activities and even expand into new ones such as The General Exchange, which contributed to the economic and social needs of a society at war. Organizations like the WAA, which had already proven their worth in the pre-war era, responded admirably to the needs of the times. Of course at this point few foresaw the devastation a lengthy conflict would cause, and the impact this would have even on those societies which did not experience the horrors of battle directly, the way the European countries did. Winnipeg was far from the killing fields but it still felt their consequences.

CHAPTER ELEVEN

THE END OF AN ERA

The false sense of normality continued in the 1915-16 season with the implementation of a program similar to the one established the year before. A bridge party netted $72 for the Exchange.[1] The annual meeting was announced for the fall with Mrs. Hugh Sutherland, the vice-president, presiding, since Mrs. Ewart was away, as she often was at this time of year. It was a shock, therefore, when a letter of resignation arrived from Ewart. She explained that she planned to make her home in Philadelphia in the future, although she would always be interested in the art progress of the west.[2] No public mention was made of the fact that she had separated from her husband. She returned to Winnipeg the following May to stay several weeks with friends, and presumably to wind up her affairs in Winnipeg. The fall of 1915 proved to be the end of her involvement with the WAA. She did maintain contact with some Winnipeggers, however. FitzGerald's Cash Book, for instance, notes Ewart's changes of address through 1918.[3]

The WAA had lost a dynamic and innovative leader, a working chairperson, who had guided the newly independent organization through five years of growth and development. In addition to the regular program, Ewart had initiated and

closely supervised a series of "Living Pictures" productions. She had been an enthusiastic advocate of and a teacher at the free art school, as well as a consistent supporter of the Handicraft Shop and of the project of forming a collection of First Nations artifacts. She had played a major role in establishing the General Exchange and tearoom, as a means of alleviating the difficult social and economic conditions of wartime. To finance these enterprises she introduced the use of bridge parties as fund-raisers.

Mary Ewart had also been a prominent figure in the wider art community. In 1911, for example, she presided at the founding meeting of the Manitoba Society of Artists and Craftsmen.[4] The next year she was one of the judges for the Camera Club's international jury show.[5] On addressing the local Council of Women on the desirability of having art institutions in Winnipeg, Ewart suggested that the founding of an art gallery in the centennial year of the Selkirk settlement would be a fitting memorial to Lord Selkirk.[6] Later she was the only woman contributor to the fund for building the gallery.

Ewart's stature was enhanced by the fact that she was a practicing artist with international training. She specialized in portrait subjects. She also taught some advanced students. The Winnipeg Art Club, a small group of Winnipeg's best artists, including Barraud, Phillips, Fanshaw, and FitzGerald, met at her studio on Saturday nights to do studies from life. By the standards of Canadian art of the day she was considered worthy, though not innovative.

In late 1912 Ewart was one of the Winnipeg artists chosen to participate in the RCA Exhibition mounted for the opening of the Winnipeg Art Gallery.[7] Her *Portrait of a Boy* was praised for the close observation displayed and certainty of handling.[8] This show was followed by an active period of painting and exhibiting. Her works appeared at the Philadelphia Academy's jury show (portrait of Mrs. Howard Buell Wilcox);[9] a group show of western artists at the Winnipeg Art Gallery, which included the paintings *Mrs. Wilcox*, *Alan C. Ewart*, *Lady with a Fan*, *A Venetian Scene*, *Nude*, *Reveries*, and *Reading*;[10] the Art

Section of the Winnipeg Fair;[11] the RCA exhibition in Toronto with the portrait titled *Alan C. Ewart*;[12] and the Art Union Show in Winnipeg *The Ballet Girl*.[13] Ewart's paintings were described as vigorous, bold, and vivacious. Noted also was her ability to express the personality of the sitters as well as their appearance.[14]

Obviously the sudden departure of someone of Mary Ewart's stature and leadership abilities was a blow. The WAA was forced to regroup in a short time. The annual meeting took place as scheduled, but without a president. Officers elected included vice-presidents Mrs. H. Sutherland and Mrs. A. de Jardin, with Mrs. Drummond as treasurer. New board members were Mmes. D. N. J. Hagerty, F.H. Brydges, A.M. Nanton, W.W. McMillan, H.T. Champion and Lady Aikins. During the past year the Exchange and the Tea Room had done so well that they had become a separate organization with an independent board. The WAA, however, still mounted a handicraft exhibit in the Industrial Bureau. At the annual meeting they also agreed to contribute $25 for the purchase of a collection of South African material, presumably for the Gallery collection.[15]

Mrs. A.H. Stoughton became the new president. She had accompanied her husband from New York City to Winnipeg in 1913 when he became Head of the School of Architecture. Immediately they had both become involved in local art circles. Stoughton showed some courage in becoming president. It was not only hard to follow a person like Mary Ewart, who had served for such a long term, but the optimism and expansion in the arts, so marked a few years before, had gradually been eroded by a falling economy and the progress of the war. The seriousness of the situation had been underlined by the very heavy Canadian casualties at Ypres and the Prime Minister's call for 150,000 troops, triple the original force.

The main financial responsibility of the WAA continued to be the Exchange, even though its day-to-day operations were managed independently. In December the Association held an exhibition and sale of work at the home of Mrs. J.D. Atchison with proceeds earmarked for needy handicraft workers.[16]

They also raised funds with a "White Elephant" party in late February and an Easter tea.[17] The Exchange itself held a sale of Easter wares, which netted $321.20.[18] The WAA also maintained its connection with the School of Art, giving $50 for the tuition of two women students for the coming year. The recipients were to be selected by Musgrove.[19]

Like other programs, the lecture series was curtailed both as to the number of talks and the variety of speakers. It began with a return performance by Dr. Salton. He described his choice of the world's greatest paintings, ranging from Byzantine to modern times. Of topical interest was a slide of a painting, which had recently been destroyed when a Venetian church was bombed. The *Free Press* noted that the audience was not as big as the subject deserved.[20] Perhaps this was indicative of the extent to which wartime activities were absorbing women's attention.

A.D.F. Hamelin, Professor of Architecture at Columbia University, called his field an art, a science, a business, and a profession, which influenced life at many points. He illustrated how, at various times, buildings were formed by social, religious, commercial, political, and intellectual conditions. Anyone looking for a liberal culture and an appreciation of the arts, he suggested, should study architecture; thus they would develop mental discipline and critical ability while appreciating beauty. This sort of education did not have to depend on travel to visit architectural monuments or laborious technical study. It was available to anyone who had access to books and photographs in a public library. Hamelin also pointed out that all masterpieces are not old. Although there was more uniformity in present-day building than ever before, many structures were being created which would be admired in the future.[21]

In "Browning as an Art Critic" Professor Crawford indicated that Browning showed an understanding of the great art periods equal to that of any critic. His poems depict the history of art from the objective perfection of the Greeks to the harmony of great painters like Leonardo and Raphael.[22]

In March Professor Stoughton's topic was interior decorating

and the value harmonious surroundings contribute to the development of a person. He gave helpful suggestions for the treatment of walls, floors, ceilings, draperies, and furnishings, using slides of period decoration from French, English, early American, and modern homes. At this meeting the WAA undertook a practical application of interior decoration: the project of improving the appearance of Immigration Hall.[23]

H. Valentine Fanshaw, the art master at the Kelvin Technical High School since its opening three years earlier, spoke on "Art and the Public Schools." While acknowledging that Winnipeg had made a start in the field, he advocated a greater emphasis on art in the curriculum in the future. His ideal was a specialist institution costing $500,000, a stunning figure for those times. In most cases he felt that art training enables students to develop aesthetic pleasure and broaden their experience rather than making professional artists of them. Money spent in this way enhances the well-being of the community and helps Canada to take its place among the cultured nations. Contrary to public opinion, it is not wasted. Fanshaw mentioned that he had many energetic and enthusiastic students. Also he showed some interesting designs made by his classes. These were said to have "provoked some discussion", whether pro or con is not indicated.[24]

By autumn 1916 it was clear that the war was absorbing the attention, time, and resources of Winnipeg women. The battles of the last few months, ending with the Somme, had caused even heavier casualties than before and resulted in relatively small gains. Art enterprises paled before the anxiety and sorrow felt by many, and a strong desire to support the war effort. At the opening meeting of the fall season, therefore, the WAA decided to discontinue meetings for 1916-17.[25]

The Exchange, however, continued its independent course. It was a helpful source of income for soldiers' families, among others, paying out about $300 a month to consignors. In fact more space was required for the expanding stock and the popular tearoom, whose "wholesome meals" were popular with women and girls working downtown. After closing briefly

for a move, the Exchange re-opened with a special tea and sale.[26] In the last years the nature of the shop had undergone a change. In addition to the new emphasis on a philanthropic Exchange, the focus on handicrafts was different. Originally, much work had come from communities now considered as "enemies" or "aliens." The enthusiastic promotion of "Folk Songs and Dances" had also vanished in the atmosphere of the war. Besides, many workers were occupied by knitting and sewing for the troops.

In October, at the beginning of what would have been the WAA's 1917-1918 season, the group again decided to suspend activities, this time for an indefinite period. Conditions had worsened during the year. The army, which continued to suffer huge casualties, especially at Vimy Ridge, needed ever-increasing numbers. When a call for 500,000 volunteers brought only 330,000, despite frantic recruiting, the divisive conscription law had to be enacted. The war seemed endless.

Eventually the armistice came. The great relief and rejoicing which followed were soon diminished by the universal flu epidemic, which claimed about as many lives as had been lost in the war. Also there were many problems connected with the re-integration of soldiers into a civilian life. In Winnipeg a General Strike erupted because of workers' dissatisfaction with their low wages in an inflationary period. When it was forcibly put down, the gulf between labour and capital had widened substantially.

Almost a year after the armistice, the WAA reconvened. It began where it had left off, re-electing the former officers with Mrs. Stoughton as president. There were no specific plans, however, about what direction the club should take. They resumed their long-time interest in art lectures, but did not arrange a program for the season. Instead they decided to attend Professor Stoughton's lectures at the University and to consider the assigned reading as part of the winter's work.[27] The year seems to have slipped by without other plans.

After this quiet period the WAA brought in a new slate of officers, with Mrs. H.T. Champion (president) and Mrs. G.F.

Coombes (first vice-president), members of long standing, providing continuity with the past. Florida Champion was the daughter of Dr. J.H. O'Donnell (1838-1912), a pioneer physician and political figure in Manitoba. Arriving with her family in 1864, she had studied art at St. Mary's Academy in Winnipeg and in 1882 was married to Henry T. Champion (1847-1916), a veteran of the Red River Expedition who became a partner in the banking house of Alloway and Champion. Other executive members were Mrs. W.W. McMillan (second vice-president), Miss Margaret Johnson (recording secretary), Miss Winnifred Telford (corresponding secretary) and Mrs. F. Drummond (treasurer).

No more was mentioned about art lectures. The WAA chose support for the Winnipeg School of Art (WSA) as its main goal for the year.[28] The school had survived the depression and the war with difficulty. Enrolment had plummeted; the staff was weakened; and funding was cut. While the end of the war and the re-establishment of grants were cause for optimism, the WAA's interest was most welcome.[29] The association held a reception for art students and members of the Sketch Club in December, probably at the opening of an exhibition of Sketch Club work in the Gallery.[30] They also raised money for scholarships, $100 for the commercial course and $50 for any branch chosen by the WSA board. In addition they hoped to set up a scholarship endowment as a regular resource for "ex-soldiers and others striving for an art training which will mean a livelihood."[31]

It was becoming evident that the great days of the club had not returned. Florida Champion described the situation in a frank and depressing letter to Alison Craig of the *Free Press*. She wrote about the wearing struggle to sustain art interest in Winnipeg and Manitoba because of a discouraging atmosphere. Failure to arouse sufficient public interest in projects had caused the WAA to narrow its activities, which now consisted of furnishing scholarship money for the WSA. Membership in the club had dropped and Champion complained that people lacked the public spirit to devote themselves to fund-raising

without receiving some benefit. She also blamed Winnipeg's climate for driving away residents who, had they stayed, would have fostered the arts. These were people who were financially able to support artists and purchase pictures, and as charter members of the club worked hard for art causes. Moreover, she pointed out that some former undertakings were redundant, just as the WAA lecture series had been superseded by the one given at the university. This reasoning could have been applied to the fact that the Gallery now took care of art exhibitions, the WSA of art training, and the Exchange of handicrafts. Thus the Association appears to be the victim of the very progress for which members had worked devotedly. With many goals realized, they tended to look back to the good old days rather than seek new directions. It may be that Mary Ewart's central role for five years had encouraged a passive nature, with no strong group to carry on. More probably, the WAA could not adapt to the changes caused by the war, when reserves of energy and vigour had been sapped and many attitudes had been altered by new economic and social conditions. At this time there did seem to be an indifference to art in Winnipeg, which caused the Gallery and the WSA to struggle, too. The WAA, however, did not recover its vitality; it had run its course.

CHAPTER TWELVE

CONCLUSION

Originally, Mary Dignam's WAAC was a feminist group designed to increase women's opportunities in an art field dominated by men. Over the years its goals changed somewhat. In Winnipeg, where art organizations were less developed than in the East and artists of both genders fewer in number, they became more inclusive. The club, however, remained an association of privileged women with the time and means to pursue their interests in art and also to promote the concept of making art accessible to the general community.

These ideas attracted women of ability as general members, officers, and patrons. After Mary Dignam and Maud Moore, the Association was led by other competent and inspiring figures. Isabel McArthur, Ada Chipman, Berte Stead, Florida Champion, Mrs. Coombes, Mary Ewart, and Mrs. Stoughton were the most prominent. Coming from Canadian, British, and American backgrounds and acquainted in differing degrees with European traditions, they represented the major influences found in other parts of the art establishment of early twentieth century Winnipeg, a city of very recent birth and lacking in the refined traditions of central Canadian cities.

In order to encourage art education and institutions the

WAA mounted a varied program. Their list of major achievements is impressive: those of the early group who banded together to improve their art skills and to mount public exhibitions of work by local and national WAAC members; later major shows of Scottish and Dutch watercolours, selections from Winnipeg collections, and contemporary Canadian art; self-education through study groups on art subjects; public lectures presenting a combination of useful, challenging, and inspiring material; a handicraft shop which pioneered an interest in Canadian handicrafts in Manitoba; the presentation of "Living Pictures" tableaux to increase acquaintance with painting and "Folk Songs and Dances" to promote ethnic arts; improvement of the Women's Section of the Fair over a number of years; support for the free art school which preceded the WSA and promotion for the founding of an art gallery; contribution of scholarships to the WSA; the establishment of the General Exchange to market handwork and home cooking during hard times.

It is truly remarkable that the association implemented such an extensive, varied and many-sided program in the short time between 1894 and 1896 and again from 1903 to 1916. As Winnipeg grew from the eighth to the third largest city in Canada the WAA took a major part in promoting art in the rapidly changing community. Although the WAA did not continue as an entity, the legacy of these women was an enhanced appreciation of the visual arts in Manitoba. Without them it would have been slower in coming. After the WAA disbanded, the capacity remained. It is this legacy that underlies the achievements of later years, when Winnipeg developed a reputation as a cultural centre with its own, much lauded contribution to the arts in Canada.

AFTERWORD

WOMEN'S ART ASSOCIATION: SASKATCHEWAN BRANCH 1911-1915

By 1911 the WAAS had increased its membership to 65, a number which Eleanor MacDonald felt "assures us that the formation of an Art Association in Saskatchewan was not in any way premature and gives every reason that there is a future of great activity in store when the aims of the Society are more widely known."[1] During the year members studied Christian art, which they acknowledged to be a big subject covering various art forms and symbols developed over many centuries. Their studies led to another pioneering exhibition: ecclesiastical embroideries and church ornaments loaned by Anglican clergy and church wardens from various locations. The exhibition took place June 8 and 9 during the synod week of the Anglican Church. The mayor and corporation of Regina allowed the WAAS to use the City Hall as the venue. Visitors were impressed by the large number of beautiful ecclesiastical objects found in their province. Outstanding altar frontals were those in violet (St. Peter's, Qu'Appelle), white (Kutawa and St. John's, Fort Qu'Appelle) and sarum blue (St. Chad's Hostel, Regina). These were complemented by altar panels (St. Andrew's, Wild Hills), a banner (St. Peter's) and Margaret

Smith's stencilled hangings. Finest among the many stoles were red ones from Bishop Harding and Rev. W.B. Parrott and a white one from T.W. Cunliffe. Burses and veils from Grenfell and Pense also attracted attention, as did an enamel icon and cross of Russian work loaned by Bishop Grisdale.[2]

In addition to furnishing aesthetic pleasure, the show had a didactic motive. The WAAS hoped that the works on display would encourage needle-women to beautify their churches and also inspire people in new parishes to look for objects of the best workmanship and design when equipping churches. About two hundred people attended. Because of its nature, the exhibit could not be circulated to other points as the 1910 one had been. This, of course, limited the desired exposure.

At the same time the WAAS was expanding its activities. Alice Court had established a popular class in carving at Indian Head, which was hoped might be an inspiration to other groups. Also Eleanor MacDonald suggested that the WAAS should begin a permanent collection of Indian work. She thought that a gift of $5 to the Association from Gerald Spring-Rice could be put towards this and would probably attract donations from other public-spirited men. Rejecting the criticism that it was no longer possible to acquire good examples, she also opposed the current situation in which outside collectors took excellent work away from the province.

On August 30 "a small but interesting" display of First Nations work took place at Mrs. Barnet Harvey's house in South Qu'Appelle. Twenty-six members heard Gerald Spring-Rice read "a very interesting paper", which is not described. Likely, however, it was connected with a new project, which was to absorb much time and interest in the future. This was the erection of a memorial to mark the signing of the Treaty at Fort Qu'Appelle in 1874. Although this heritage undertaking departed from the club's usual program, it is related to their interest in Native culture, previously expressed by studying, exhibiting, and collecting First Nations handicrafts. A special sub-committee was struck which was responsible for acquiring a site, planning a monument, and financing the project. Its

members were Eleanor MacDonald and Mrs. Gwynne from the WAAS; Barnet Harvey, William Graham, J.S. Court, Edmund Morris, and Gerald Spring-Rice from the advisory group with Spring-Rice serving as the secretary-treasurer.

Edmund Morris was an active figure on the committee and may have instigated the enterprise.[3] His interest was two-fold. The treaty was part of his family history, since his father, Alexander Morris, had been the negotiator when he was Lieutenant Governor of Manitoba and the Northwest Territories. At that time he had established a good relationship with the First Nations people of the region, who were impressed by his fairness. The treaty was also part of Eleanor MacDonald's background. Her father, Archibald, the long-time Hudson's Bay Company Factor in that area, had rendered valuable assistance to Morris because of his comprehensive acquaintance with the First Nations and his knowledge of the Cree language. MacDonald was still living in 1912.

Edmund Morris' second point of interest was his own association with the First Nations. This began when he was a small child at Fort Garry (1872-77), where he saw them on a daily basis, and this was reinforced by occasional visits from them after the Morris family returned to the east.[4] Edmund was an artist trained in North America and Europe, and was an active figure in the Canadian art community at the turn of the century. His acquaintance with aboriginal people revived when the government of Ontario commissioned him to paint the Ojibwe in that province in 1906. This was followed by a second commission to depict the First Nations of the prairie region. For the next four summers Morris travelled in the prairie provinces sketching portraits and landscape. He spent the most time in Saskatchewan. One result was the completion of fifteen portraits delivered to the new legislature in Regina in 1911. While working on the reservations, Morris saw how native life had deteriorated. His portraits recorded a culture with which he sympathized. A treaty memorial would serve to commemorate the First Nations' often overlooked contribution to the country as well as that of the Europeans. This was a

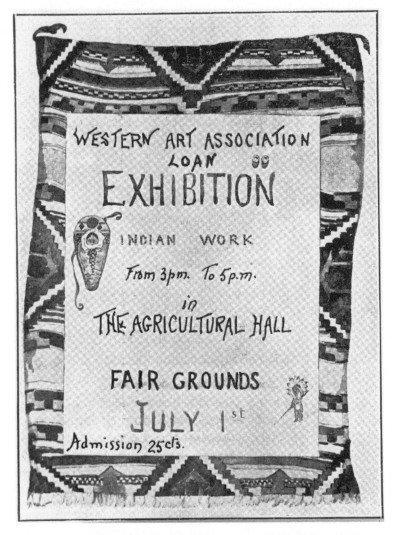

Poster for the Western Art Association Loan Exhibition, Indian Work
First Annual Report, 1911

very progressive idea for the time, which implied an equality between the two peoples that had tragically come to an end with the systematic institution of the reserve system.

The WAAS program for 1912 focussed on home arts and crafts. Members felt this was an important way to help women who were setting up homes in the countryside. "People coming to live in this country do not bring much with them as a rule, and have to rely more on their own ingenuity and natural taste for the internal beauty of their homes", said Mary Spring-Rice in her president's report.[5] The long winters were considered an opportunity for working on domestic crafts. The juried Home Arts and Crafts Exhibition, featuring work by members and their friends, took place in Regina on July 21 at the Parish Hall of St. Paul's Church, but was not shown in other places. In addition to a large group of embroideries, there were carvings from the Indian Head class, a font cover carved by Gerald Spring-Rice for the Moose Jaw church, leather and metal work made by Miss Andrews and sketches by Mary Spring-Rice and Mr. Lloyd. The Vancouver School of Embroidery sent some fine examples. It was agreed, however, that much of the amateur work was of the same calibre.[6]

Unfortunately the event was not popular. Despite publicity from posters in shop windows and newspaper advertisements, attendance consisted mostly of WAAS members. They had not attracted the homemakers whom they had targeted. One can think of various reasons for this: the many demands on time and energy caused by the busy summer season; the struggle to establish even basic conditions in a pioneer setting; slender resources for "extras"; and a lack of public rapport with WAAS interests. When evaluating the situation, the branch suggested a return to the original plan of showing small exhibitions at different sites in order to reach more people. They did not wish, however, to relinquish the idea of encouraging home crafts. Using a grassroots approach, Mary Spring-Rice asked members to learn skills, like basketry, which would be inexpensive to practice and useful for everyday life. Such a skill could be developed as a specialty. Once the products "were

known for their practical good taste" a centre would be formed where fellow members and others in the district could come for instruction.[7]

The WAAS considered that the most important undertaking of the year had been the work on the Treaty Memorial.[8] Despite the fact that the secretary-treasurer, Gerald Spring-Rice, reported that only one meeting had been held, much work had been done. At that time they had decided to leave the design of the monument to Edmund Morris, subject to the final approval of the WAAS. He in turn asked the Canadian sculptor Walter Allward to carry out a plan, which used as a centrepiece a large stone, sacred to the First Nations, which had already been transported to the Fort from the Red Deer Valley as a contribution from the Morris family. It was to be flanked by two great stone shafts, representing the two parties to the treaty, connected at the top by a granite slab symbolizing brotherhood. The Toronto architects Darling and Pearson had agreed to furnish these stone shafts and to design the lettering on two bronze plaques, where the names of all participants in the ceremony were to appear. Morris was preparing to submit a sketch of the concept for the WAAS.

The important matter of selecting the site was more difficult than anticipated. At first there was some disagreement about the actual location of the event. When this was resolved, they found that the place belonged to a man who demanded too high a price for their budget. The most suitable alternative was a site in the Hudson's Bay Reserve, which was in the purview of the Governors of the Company in London to gift. Despite much work by the committee, led by Eleanor MacDonald, the negotiations dragged on.

Fund-raising was progressing. By October 1912 Spring-Rice reported that the committee had some promises and slightly over one thousand dollars in hand. The WAAS had contributed $50 and the Imperial Order of the Daughters of the Empire, whose individual sections had been canvassed vigorously by Mrs. Gwynne, had given generously. The Hon. James Calder, acting premier of Saskatchewan, had secured a grant of $500

from the Legislature. In addition to Saskatchewan donors, Toronto friends like Sir E.B. Osler and Sir Byron Walker and "oldtimers" in Winnipeg had sent contributions. There were disappointments, too. The federal Department of Indian Affairs had not responded to appeals. There had been no results from reports in the press, and the direct mail campaign to selected people had had very mixed results. Some, like Mr. Brock of Winnipeg, had promptly sent a cheque for $50 "with the kindest expressions towards the scheme", Spring-Rice reported. "Others have not even condescended to expend the two cents necessary to convey the expression of their inability to contribute."[9] He felt that a new brochure incorporating the design for the monument would help future efforts.

The committee also had introduced part of the Treaty Memorial to a public gathering. They had hoped that the Governor General, the Duke of Connaught, could visit the site when touring the West and would give his official sanction to their enterprise. When a crowded schedule made this impossible, they persevered with an event at the site, where the sacred stone had been placed on a cairn. The interest shown by the audience raised anticipation of wider attention when the entire memorial was finished.[10]

This proved to be Spring-Rice's final report. The WAAS suffered a substantial loss when he and his wife Mary, the president of the branch, returned to England. The key positions, which they held, were filled by another active couple, Alice and J.S. Court. In recognition of their outstanding contribution, the Saskatchewan branch presented the Spring-Rices with a First Nations jacket and leggings, a very fitting memento of their life in Saskatchewan.

By 1913 WAAS membership had increased to 81, a sign of growing influence. Lace and embroidery were the chosen subjects for the year, with successful exhibitions in Regina and Indian Head. At both places Mrs. T.B. Patton, the convenor, read a paper on the history of lace making, described as "most comprehensive, interesting, and instructive."[11] Lace was a popular medium. Both members and non-members loaned a

wealth of beautiful examples, which they had made, acquired, or inherited. These came from many different countries and periods, including: handsome shawls, Hindu embroidery, antique Mechlin lace, wedding veils, a Mexican collar, infants' robes, Honiton lace used for four generations, old Flemish lace, a Maltese shawl, Chinese embroidery, Maori and Turkish lace, Irish Carrickmacross and crochet. An interesting exhibit displayed a pillow showing unfinished Honiton lace. In the same vein Mrs. Halls of St. Chad's added to the interest of the occasion by giving a demonstration of lace working. Paid admissions in Regina came to 214. Unfortunately, after Indian Head it was not possible to send the show to Fort Qu'Appelle, South Qu'Appelle and Pense as planned, because of the value of the works and the difficulty of securing the glass cases necessary for security. Otherwise the exhibition was considered a great success.

Another indication of the influence of the WAAS was a request for help from the Provincial Fair Board in Regina, which asked the group to organize art and needlework sections and to provide judges for these classes. Alice Court, the president, and three others did so. This relationship was like that between the Winnipeg Fair and the WAA. A similar request came from Moose Jaw. In addition the Regina and Winnipeg Fairs asked the WAAS to send an exhibit to their events. When this was impossible to implement, it was left to individual members to exhibit at Regina if they wished.[12]

The Treaty Memorial was progressing slowly. In addition to Spring-Rice, several other members had either left Saskatchewan or resigned for other reasons. The most serious blow was the death of Edmund Morris, whose enthusiasm and vision had been central to the project. Nonetheless Court, the secretary, was able to report several advances. When negotiations with the Hudson's Bay Company promised to drag on indefinitely, a new site was found in the village park at Fort Qu'Appelle. This was offered as a gift from the village and accompanied by a promise of future maintenance. Recommended by Court and Eleanor MacDonald as preferable to the original choice,

it secured the immediate approval of the WAAS. Details were then sent to both Allward and Pearson, who were to develop the design of the monument to suit the location.

Fund-raising continued. In addition to $1,100 in the bank there were pledges of $500 each from the Minister of the Interior and the Saskatchewan Legislature, probably $300 from the village of Qu'Appelle and $250 from various individuals. This left around $400 of their projected budget of $3,000 to be collected during the winter. Court felt that this would not be too difficult, particularly after a brochure containing a sketch of the proposed monument and a list of contributors was printed. The committee intended to keep costs within their budget. Because the campaign had now lasted for two years, they felt pressure to complete the Memorial as soon as possible. They hoped to unveil it the following year, the fortieth anniversary of the signing.[13]

Work on the Memorial did not progress as quickly as anticipated, but the circumstances are not clear. The annual reports held by the Saskatchewan Archives, which have been the chief sources of information about the Association, stop with the one for 1913. Presumably the WAAS went ahead with the exhibition of enamel and metal work projected for 1914.[14] This was to be held in Regina and also travel to some of the centres along the railroad. Mr. J.S. Court continued as the secretary-treasurer of the Memorial Committee. Then the declaration of war in August introduced a period marked by new duties and concerns.

In June 1915, however, the WAAS returned to its first interest when it showed "a splendid collection of Indian work" at Balcarres. Pieces of all kinds, many loaned from the Saskatchewan Museum, featured fine beaded dancing waists, leggings, coats, fire bags, and moccasins. The exhibit, described as the third in a series, probably was shown at two other locations. As befitted the times, the proceeds of $40 were given to the Red Cross.[15]

News of the Treaty Memorial came in November when the Regina Leader-Post announced the unveiling.[16] This

must have been a triumphant occasion for the WAAS, the Treaty Committee, and the many donors. Their perseverance had insured that a formative part of western history was commemorated in a fitting and permanent way. It is interesting to note, though, that the form of the monument had changed substantially. According to a WAAS brochure it was now a thirty-four foot high obelisk of Manitoba tyndall stone set on an eleven foot square base.[17] Granite panels on the four sides recorded the names of the commissioners, chiefs, and witnesses; dates where several treaties were signed; and the coats of arms of the governments under which the land had been administered: the Hudson's Bay Company, Great Britain, Canada, and Saskatchewan. Morris' vision of the sacred stone between two tall shafts which were linked at the top had given way to a more conventional but still impressive concept. It is not clear whether this change was due to the budget, difficulty with the original design, or problems which surfaced as the war progressed. Perhaps Morris' vision was too egalitarian for his more conventional compatriots, who preferred to do something clearly in the Euro-Canadian style. With his passing the concept could not be sustained.

From current information it would seem that the WAAS, like the WAA, was not able to continue during the war. Nor does it seem to have been revived afterward. In the short space of six years, however, the members had made an impact on art and heritage matters in Saskatchewan. Originally inspired and encouraged by their parent group, the WAAS operated in a pragmatic way suited to their environment. The association did much to increase the knowledge and appreciation of First Nations arts and crafts. They also promoted interest in ecclesiastical art, embroidery, lace, metal work and enamels. In addition to providing knowledge and aesthetic pleasure, they worked to improve the taste of those who made or purchased domestic and church objects. At the same time they sponsored the Treaty Memorial and saw it to fruition. This was an ambitious and prolonged project for a women's art group in the early twentieth century. While the Saskatchewan Branch

went off in its own direction, the spirit of the WAAC's original mandate was honoured and augmented as had happened in Winnipeg.

APPENDIX I

FEMALE MEMBERS OF THE ROYAL CANADIAN ACADEMY OF ARTS 1880-1920

There were two categories of members: Academicians and Associates.

- Of the 25 Academicians, Charlotte Mount Brock Schreiber (1880-1886) was the only female throughout the entire period.
- There were 50 Associate members at all times. The women Associates, chosen from time to time, were:

1880's
Richards, Frances Elwood (1882-1885)
Jones, Frances M. (1882-1888)
Windeat, Emma S. (1887-1908)

1890's
Tully, Sydney Strickland (1890)
Eastlake, Mary Alexander Bell (1893-1897)
Reid, Mary Augusta Hiester (1893)
Lyall, Laura Adeline Muntz (1895)
Cutts, Gertrude E. Spurr (1895)
Ford, Harriet Mary (1895-1899)
Holden, Sarah (1895-1904)
Houghton, Margaret (1897-1902)

1900's
Hagarty, Clara Sophie (1903)
Pemberton, Sophie Theresa (1906-1908)
Knowles, Elizabeth Annie Beach (1908)

1910's
Carlyle, Florence (1912)
DesClayes, Gertrude (1914)
May, Henrietta Mabel (1915)
Reid, Mary Evelyn Wrinch (1917)

Source: As listed in Rebecca, Sisler, *Passionate Spirits: A History of the Royal Canadian Academy of Arts (1880-1980)*. (Toronto: Clarke, Irwin and Company, 1980).

COMPARISON OF MEMBERS OF THE
ONTARIO SOCIETY OF ARTISTS, 1872-1910

1870's

Members joining – male: 64
female: 7

Blackwell, Anne (1875-1889)
Forges, Elizabeth Adela Armstrong (1876)
Hamilton, Jane (1876-1877)
Hamilton, Mrs. S. (1876-1886)
Schreiber, Charlotte (1876-1889)
Sinclair, Mrs. (1875-1877)
Westmacott, E.K. (1874-1889)

1880's

Members joining – male: 31
female: 6

Martin, Emma May (1889-1956)
Payne, Frances Emily Travers (1889-1893)
Peel, Mildred (1889)
Reid, Mary Hiester (1887-1921)
Tully, Sydney Strickland (1888-1911)
Windeat, Emma S. (1884-1888)

1890's

Members joining – male: 28
female: 5

Cutts, Gertrude Spurr (1891-1941)
Ford, Harriet M. (1896-1899; 1911-1939)
Hagarty, Clara S. (1899-1958)
Hawley, Wilhelmina D. (1899-1905)
Lyall, Laura Muntz (1891-1908; 1924-1930)

1900's

Members joining – male: 16

female: 7

Carlyle, Florence (1900-1906)
Farncomb, Caroline (1908-1912)
Hillyard, Carrie Learoyd (1904-1924)
Hooker, Marion Nelson (1905-1912)
Knowles, Elizabeth McGillivray (1906-1908)
Shore, Henrietta Mary (1909-1915)
Wrinch, Mary E. (1901-??)

Source: As listed in Joan Murray, *Ontario Society of Artists: 100 Years*. (Toronto: Art Gallery of Ontario, 1972).

APPENDIX II

POPULATION OF SELECTED CANADIAN CITIES AND RANK BY SIZE 1871-1921

City	1871	1881	1891	1901	1911	1921
Montreal	115,000 (1)	155,238 (1)	214,616 (1)	328,172 (1)	490,504 (1)	618,506 (1)
Toronto	59,000 (3)	96,916 (2)	181,215 (2)	209,982 (2)	381,833 (2)	521,893 (2)
Winnipeg	241 (62)	7,985 (17)	25,639 (8)	42,340 (6)	136,035 (3)	179,087 (3)
Hamilton	26,880 (5)	36,661 (4)	48,959 (4)	52,634 (5)	81,969 (6)	114,151 (5)
London	18,000 (8)	26,266 (8)	31,977 (8)	37,976 (9)	46,300 (9)	60,959 (9)

Source: Adapted from Alan Artibise, *Winnipeg: A Social History of Urban Growth: 1874-1914.* Montreal: McGill-Queen's University Press, 1975.

NOTE/

CHAPTER ONE: MARY DIGNAM AND THE FOUNDING OF THE WOMAN'/
ART A//OCIATION OF CANADA

[1] *Daily Norwester* (Winnipeg), Feb. 5, 1894, 6 and Feb. 19, 8 (hereafter *Norwester*); *Winnipeg Tribune*, Feb. 23, 8 (hereafter, *Tribune*). The WAAC began in 1886 in Toronto as an art society, which became the Women's Art Club in 1890 and in 1892 the Woman's Art Association of Canada.

[2] See Allison Thompson, *A Worthy Place in the Art of our Country: The Women's Art Association of Canada 1887-1987*. Unpublished thesis, Institute of Canadian Studies, Carleton University, Ottawa 1989. Information about Dignam's life varies from one account to another. For example, the date of her birth is given as 1857, 1858, 1860. For more information see Jarret Bonelie, "Mrs. Dignam's Pursuit" *The Beaver* June-July 2000, 35-38 and Ellen Easton McLeod, *In Good Hands: The Women of the Canadian Handicrafts Guild* (Kingston and Montreal: McGill-Queens University Press, 1999).

[3] J. Russell Harper, *Early Painters and Engravers in Canada* (Toronto: University of Toronto Press, 1976), 63.

[4] Colin MacDonald, *A Dictionary of Canadian Artists* (Ottawa: Canadian Paperbacks Publishing, 1988 reprint). Vol. 5, 1560.

[5] Elizabeth Collard, *Nineteenth Century Pottery and Porcelain in Canada* (Montreal: McGill University Press, 1967), 315-16.

[6] Harper, *Early Painters and Engravers*, 176.

[7] MacDonald, *Dictionary of Canadian Artists,* Vol. 5, 1561-4.

[8] Dickins, " My first art lessons…." *Christian Science Monitor* Mar. 18, 1936.

[9] Brock, Daniel and Muriel Moon, *History of the County of Middlesex, Canada* (facsimile of the 1889 ed) (Belleville ON: Mika Studio, 1972), 66.

[10] Thompson, *A Worthy Place in the Art of Our Country,* 53-54.

[11] *Quarterly Illustrator* Vol. 1 No. 4 (Oct-Dec) 1893, 304. While Dignam has also mentioned Kenyon Cox (1856-1919), this was apparently later since he began teaching at the NYASL in 1884.

[12] Brock, *History of the County of Middlesex, Canada*, 66.

[13] *Quarterly Illustrator*, op.cit., p.304.

[14] Marie Fleming and John R. Taylor, *100 Years Evolution of the Ontario College of Art* (Toronto: Art Gallery of Ontario, 1976), 11-14.

[15] William Colgate, "The Toronto Arts Students League: 1886-1904" *Ontario Historical Society Papers and Records,* vol. 37, 1945, 5-8.

[16] Compiled from lists of members in Joan Murray, *Ontario Society of Artists: 100 Years 1872-1972* (Toronto: Art Gallery of Ontario, 1972). See Appendix I for tabulation of these figures.

[17] Newton MacTavish, *The Fine Arts in Canada* (Toronto: Macmillan, 1925) Facsimile Edition (Toronto: Coles, 1973), 25-26. Much of this material is also recorded in Dorothy Farr and Natalie Luckyj, *From Women's Eyes: Women Painters in Canada* (Kingston: Agnes Etherington Arts Centre, Queen's University, 1975), 3.

[18] Compiled from membership list in Rebecca Sisler, *Passionate Spirits: A History of the Royal Canadian Academy of Arts 1880-1980* (Toronto: Clarke, Irwin, 1980), 280-89.

[19] National Gallery of Canada artist's form c. 1912 (hereafter NGC).

[20] Harper, *Early Painters,* 327.

[21] McLeod, *In Good Hands,* p.74, quoted from M.E. Dignam, "Art, Handicrafts, Music, and Drama" in *Women of Canada* (Ottawa: National Council of Women of Canada,1900), Reprint (NCWC 1975), 218-220. For Female School of Design see Anthea Callen, *Women in the Arts and Crafts Movement* (London: Astragal Books, 1980), 27ff.

[22] Moulton Ladies' College was formerly the women's section of Woodstock College. McMaster had been formed from a merger of Woodstock and Toronto Baptist College. Alfred Hall, *Per Ardua: The Story of Moulton College Toronto 1888-1954* (Toronto: Moulton College Alumnae Association, 1987), 12-13.

[23] Jessie Dryburgh, "Mary E. Dignam and the Women's Art Association" *Lyceum Club and Women's Art Association of Canada 82nd Annual Report* (Toronto, 1969), 18. Also Women's Art Association of Canada "Objects, Constitution, and Rules" (Toronto: Oxford Press, 1895), 2.

[24] McLeod, *In Good Hands,* 36.

CHAPTER TWO: ART IN WINNIPEG BEFORE 1894

[1] Alan Artibise, *Winnipeg: A Social History of Urban Growth 1874-1914* (Montreal: McGill-Queens University Press, 1975) Table 7, 132 records Winnipeg in 1891 as 8th and in 1901 as 6th. Appendix II compares the population of selected Canadian cities 1871-1921.

[2] *Manitoba Free Press and Standard* October 7, 1876, 1(hereafter *FP*).

[3] *FP,* July 8, 1881.

[4] *FP,* Jan. 27, 1882, 2.

[5] *FP,* Oct.11, 1883, 9. Shown at the 1883 Exhibition. The Protestant section showed map drawing, penmanship, freehand and industrial drawing.

[6] For more information on Lucille McArthur, see Virginia Berry, "Lucille C. Casey" *Dictionary of Canadian Biography* vol. 13 (1901-1910) (Toronto: University of Toronto Press, 1994), 176-77.

[7] *FP*, March 5, 1886, 4; March 11, 4; March 19, 4.

[8] *FP*, May 10, 1886 and *Winnipeg Sun*, May 6 and 10, 4 (hereafter *Sun*).

[9] *FP*, August 4, 1886, 4; August 7, 4.

[10] *FP*, September 30, 1886, 4.

[11] Ibid.

[12] *FP*, Nov. 13, 1880, 3.

[13] *Tribune*, May 14, 4, 1891 and May 20, 1. Also May 18, 6 and May 28, 4

[14] Virginia G. Berry, *Vistas of Promise: Manitoba 1874-1919* (Winnipeg: Winnipeg Art Gallery, 1987), 34-37.

[15] *Tribune*, May 23, 1892, 3; *FP*, June 27, 6.

[16] *Tribune*, Sept.9, 1893, 4; Nov. 20, 4.

[17] Thompson and Bryce eds. *The City of Winnipeg 1886*, 167. Known as Dobier and Soper 1881-82; Soper and Le Capellaine, 1883, Soper's 1884-1905.

[18] Thompson and Bryce, *The City of Winnipeg 1886*, 167.

[19] *Winnipeg Siftings,* Oct. 3, 1885, 3.

[20] *FP,* June 6, 1890, 8.

[21] *Siftings,* Nov. 27, 1886, 1.

[22] *FP*, Jan. 31, 1887, 4; Feb.3, 4; Oct.24, 4.

[23] *FP*, Oct. 3, 1888, 4; *The Winnipeg Sun*, Oct. 2, 4 (hereafter *Sun*).

[24] Winnipeg Art Gallery Collection. Reproduced in Berry, *Vistas of Promise*, 34 and on the cover of this book.

CHAPTER THREE: THE WINNIPEG BRANCH OF THE WAAC 1894-96

[1] *Nor'wester* Feb. 19, 1894 and Feb. 5, 6.

[2] Ibid.

[3] Listed in the catalogue of the Columbia Exposition (Chicago, 1892). Although McArthur was in Europe, her paintings continued to be exhibited through the efforts of her husband.

[4] Virginia G. Berry, *Vistas of Promise* (Winnipeg: Winnipeg Art Gallery, 1987), 35.

[5] *FP,* Jan. 30, 1893, 4.

[6] *FP,* June 2, 1893, 2.

[7] *FP,* Jan. 30, 1893, 4.

[8] *FP*, Feb. 5, 1895 and Feb. 6, 1.

[9] *Nor'wester,* Feb. 19, 1894, 8.

[10] *Annual Report 1894* Woman's Art Association files, Toronto (hereafter WAAC), and *FP,* Jan. 26, 1895, 5.

[11] Angela Davis, "No Man's Land: The Battlefield Paintings of Mary Riter Hamilton" exhibition catalogue (Winnipeg: University of Winnipeg, 1998), 7.

[12] For Mary's vision see Florence R. Deacon, "The Art of Mary Riter Hamilton" *Canadian Magazine,* vol. 39, no. 6 Oct. 1912, 53.

[13] Ibid. Although dated 1896 by Deacon it is also linked with her arrival in Winnipeg, misdated 1896.

[14] *Nor' Wester,* July 25, 1894, 4.

[15] *FP,* Sept. 15, 1894, 2.

[16] For Bready's years in Europe see: *FP,* Sept. 21, 1891, 8 (departure for Paris); *Tribune* Feb. 15, 1892, 4 (Algeria); *FP,* Dec. 27, 1892, 8. (Algeria, Paris and northern France); *FP,* Feb. 10, 1892, 7 (Germany); *FP,* Aug. 26, 1893, 5 (Wisconsin); *FP,* April 3, 1894, 6 (Italy and Switzerland).

[17] *FP,* Jan. 26, 1895, 5 summarizes the 1894 season.

[18] *FP,* Jan. 26, 1895, 2.

[19] *Tribune,* Feb. 6, 1895, 5 and *FP,* Feb. 6, 1895, 1 describe the work of the committee. For information about the different sections see *Catalogue of the First Annual Exhibition of the WAAC-WB* (Winnipeg, Dolsen and Palmer, 1895) PAM.

[20] *Tribune,* Feb. 9, 1895, 6.

[21] *FP,* Feb. 5, 1895 and Feb. 6, 1.

[22] *Tribune,* Feb. 6, 1895, 5.

[23] Exhibitors and works: *FP,* Feb. 5, 1895, 8; *Tribune,* Feb. 6, 1895, 5; *FP,* Feb. 6, 1895, 1 and the catalogue; *The First Annual Exhibition, WAAC-WB,* 1895.

[24] *FP,* Feb. 8, 1895, 8.

[25] *FP,* March 14, 1895, 8; Mar. 25, 8; *Tribune,* April 1, 8.

[26] *Tribune,* May 22, 8.

[27] *FP,* July 16, 1895, 1, 6.

[28] WAAC minute book, Oct. 11 1896. PAM.

[29] *FP,* Nov. 4, 1895, 8.

[30] WAAC minute book, Nov. 6, 1895.

[31] *FP,* Dec. 3, 1895, 4.

[32] *FP,* Dec. 5, 1895, 5.

[33] For information about artists and works see catalogue *Second Annual Exhibition of the WAAC* Winnipeg Dec. 2-4, 1895, *FP,* Dec.5, 1895, 5.

[34] Other local contributors were Agnes Culver, Mrs. Fisher, Mrs. Anderson, Mrs. Chambers,

Miss Dennistonn, Mrs. Morse, Miss Hargrave, Miss Byrnis, Mrs. Corbet, Mrs. Armstrong, Miss Agur, Mrs. Paterson. *FP,* Dec. 5, 1895, 5.

[35] *FP,* Dec. 5, 1895, 5.

[36] *Nor' Wester,* Dec.5, 1895.

[37] *Tribune,* Dec, 5, 1895, 5.

[38] On Lady Aberdeen and her career, see her reminiscences, *We Two* and Marjorie Pentland, *A Bonnie Fechter: The Life of Ishbel Marjoribanks, Marchioness of Aberdeen and Temar* (London: B.T.Botsford Ltd., 1952).

[39] Minutes WAAC-WB, Jan. 9, 1896.

[40] MCW Minutes, Nov. 2, 1896. PAM.

[41] MCW Minutes, Feb.6, 1897. PAM.

[42] MCW Minutes, Nov. 30, 1895. PAM.

[43] WB Minutes, Feb. 8, 1896.

[44] The following classified ad appeared in the Feb.29, 1895 issue of *The Free Press* (7): "Miss May Corbet, teaching of all kinds of china painting. 352 Edmonton Street, Winnipeg."

[45] *FP,* Feb. 17, 1896, 5.

[46] *FP,* Feb. 24, 1896, 4.

[47] These students were Mrs. Agur, Mrs. Paterson, Miss Ponton, Miss Forrest, Mrs. Hargrave, Miss Taylor, Mrs. Brown, Mrs. Anderson, Mrs. Christie, Mrs. Fisher. *FP,* Feb. 24, 1896, 4.

[48] WB Minutes, Mar. 3, 1896.

[49] Ibid.

[50] *Tribune,* Mar.25, 1896, 5. Unidentified clipping in WB minute book, PAM.

[51] WB Minutes, March (undated) and April 16 and 24.

[52] See Appendix II for a comparison of Winnipeg's population with other cities, 1874-1921.

CHAPTER FOUR: ART DEVELOPMENTS IN WINNIPEG 1896-1903

[1] Artibise, *Winnipeg,* 130-139.

[2] *FP,* Mar.28, 1902, 7.

[3] *Tribune,* May 9, 1905, p.3; *MT,* May 10, 8.

[4] Ibid.

[5] *Telegram,* April 13, 1900, 8 and Sept.1, 1900, 8.

[6] *FP,* Nov.16, 1901, 2 and *Town Topics,* Nov.2, *Town Topics* is unpaginated. (hereafter*TT*).

[7] Marta H. Hurdelek, *The Hague School: Collecting in Canada at the Turn of the Century* (Toronto: Art Gallery of Ontario, 1893), 18.

[8] *Tribune,* Nov. 18, 1899, 2.

[9] *TT*, April 25 and May 3, 1902 and *FP*, April 28, 1902, 3.

[10] Ibid.

[11] *TT*, May 3, 1902.

[12] *FP*, Sept.18, 1906, Magazine section, 6.

[13] *Tribune*, Oct. 8, 1902, 3.

[14] *Telegram*, Feb. 16, 1903, 10; *Tribune*, Feb. 16, 10.

[15] *FP*, Feb. 21, 1903, 5; Feb. 23, 5; Mar.9, 10; Mar.30, 10; April 29, 12.

[16] *FP*, Oct.10, 1896, 6.

[17] *Telegram*, May 12, 1900, 2.

[18] William James Wilson, "Daniel McIntyre and Education in Winnipeg" Unpublished MA thesis, University of Manitoba [Education], 1978.

[19] *Tribune*, Nov. 21, 1900, 3 and Feb. 22, 1901, 3; *Telegram*, Nov.26, 1900, 8.

[20] *Telegram*, Jan. 14, 1902, 7.

[21] *Tribune*, Sept. 27, 1897, 5.

[22] *Tribune*, Oct. 5, 1899, 5.

[23] *Telegram*, Aug. 5, 1901, 4.

[24] Caroline Armington's Diary. This diary consists of two or three entries per year summarizing large blocks of time. Location undetermined.

[25] Ibid. March 19, 1902 and Dec, 2?, 1903.

CHAPTER FIVE: THE RETURN OF THE WOMEN'S ART ASSOCIATION

[1] *TT*, Jan. 3, 1903.

[2] *Tribune*, April 20, 1903, 3 and May 19, 6.

[3] *Telegram*, Feb. 14, 1903; *TT*, Feb.21, 1903, 7.

[4] *TT*, Feb.21, 1903, 8.

[5] *Tribune*, Feb. 14, 1903, 4 and Feb. 25, 2.

[6] *FP*, Feb. 28, 1903, 11.

[7] For accounts see *Telegram*, Feb. 24, 5 and Feb. 25, 7; *TT*, Feb. 28, 7.

[8] *FP*, Feb. 28, 1903, 11; *Telegram* March 3, 1903, 10.

[9] *Tribune*, May 17, 1903, 6.

[10] *FP*, Feb. 27, 1903, 12.

[11] Ibid.

[12] *Tribune*, Feb. 26, 1903, 2.

[13] *Telegram,* Mar.3, 1903, 6.

[14] *TT*, Mar.4, 1903, 13.

[15] *Tribune*, April 23, 1903, 11; *TT* April 25, 13.

[16] *FP*, Nov. 25, 1903, 10.

[17] *Tribune*, Nov. 24, 1903, 5; *FP,* Nov. 25, 1903, 10.

[18] *Telegram*, Feb.24, 1904, 5; *FP,* Feb.22, 1904, 6.

[19] *Telegram*, Feb. 25, 1904, 5; *Tribune,* Feb.24.1904, 9.

[20] *Telegram*, Feb. 25, 1904, 2.

[21] *FP*, Mar.2, 1904, 6.

[22] *Telegram*, Mar.2, 1904, 3.

[23] *TT*, Feb. 27, 1904, p.14.

[24] *Telegram*, Nov. 13, 1903, 8.

[25] *FP,* Jan.27, 1904, 8.

[26] *Tribune*, Dec. 17, 1903, 3; *TT*, Dec.19, 1903, 12-13.

[27] WAAC Minutes, Feb. 26, 1904.

[28] *FP*, Feb.27, 1904, 10 and Mar.2, 5; *Telegram,* Mar.2, 1904, 3.

[29] Minutes, Mar.26, 1904.

[30] *TT*, April 9, 1904.

[31] Minutes, June 22, 1904.

[32] *Tribune,* Sept.24, 1904, 12.

[33] *FP,* Sept.19, 1904, 9.

[34] *FP,* Sept.22, 1904, 6.

[35] *FP,* Sept.23, 1904, 8.

[36] *Telegram*, Sept.27, 1904, 5 and Sept.29, 5; *TT*, Oct.1, 1904, 11.

[37] *FP*, Sept.28, 1904, 9 and Sept.29, 8; *TT*, Oct.1, 1904.

[38] *FP,* Jan.12, 1905, 8.

[39] *FP,* Mar.4, 1905, 7 and Mar.8, 16.

[40] *Telegram*, Oct.19, 1904, 14 and Dec. 2, 10; Minutes Nov.24, 1904.

[41] Minutes, Jan. 16, 1905; *Telegram*, May 3, 1905, 3.

[42] *Tribune*, Sept.26, 1905, 5.

[43] Minutes, Nov.6, 1905.

[44] Minutes, Jan.5, 1906.

[45] Minutes, Mar. 5, 1906.

[46] *FP*, April 6, 1906, 9; *Telegram,* Mar.24, 7.

[47] *FP*, Ibid, p.10.

[48] *FP*, Sept.25, 1905, 7.

[49] *FP*, Aug.2, 1905, 4.

[50] Minutes, Dec.3, 1906.

[51] *FP*, Dec.4, 1906, 13; *Tribune*, Dec.4, 5.

[52] *FP*, Dec.15,1906, 8.

[53] *Tribune*, Feb.4, 1907, 7; *FP*, Feb.5, 9.

[54] Minutes May 4, 1907.

[55] *Telegram*, Sept.24, 1906, 16.

[56] Minutes, Jan.1907.

[57] *FP*, April 2, 1907, 12 and April 4, 13.

[58] Ibid.

[59] Ibid.

[60] *FP*, July 16, 1907, 12.

[61] *FP*, Aug.6, 1907, 9.

[62] *Telegram*, Oct.1, 1907, 8.

[63] Minutes, Oct.1, 1907.

[64] *FP*, Sept.27, 1907, 7 and April 9, 1908, 8.

[65] *Tribune*, Oct.25, 12.

[66] *Telegram*, Oct.1, 1907, 8.

[67] *FP*, Oct.26, 1907, 8.

[68] *FP*, Dec.5, 1907, 8.

[69] Minutes, Jan.20 and Jan.24, 1908.

[70] Minutes, Feb. 28, 1908.

[71] *FP*, Feb. 29, 1908, 5.

[72] *FP*, Mar.28, 1908, 8.

[73] Minutes, Nov.22, 1907.

[74] Minutes, Feb.28, 1908.

[75] FP, Mar.28, 1908, 8 and May 4, 5.

CHAPTER SIX: FOUNDATION OF THE WESTERN ART ASSOCIATION

[1] WAAC minutes, Oct. 5, 1908; *FP*, Oct. 6, 11.

[2] See for example *FP*, Nov. 9, 1909, 8 as indication of attitudes.

[3] WAAC minutes, Nov. 29, 1908.

[4] *FP*, Nov. 9, 1909, 8.

[5] *FP*, Jan. 16, 1909, 5.

[6] *FP*, Feb. 1, 1909, 8.

[7] *FP*, Nov. 9, 1909, 8; *Tribune*, Nov. 24, 1909, 2.

[8] *Wpg. Sat. Post*, May 29, 1909, 7.

[9] The newspapers of the time listed Mrs. D. C. Cameron elected president, Mrs. Coombes, first vice-president, Mrs. Chipman, second vice-president, Mrs. Campion, recording secretary, Mrs. MacKenzie, corresponding secretary, Mrs. Bury, treasurer, and Mrs. Chaffey, literary

convenor. *FP*, Nov. 9, 1909, 8; Nov. 13, 10.

[10] *FP*, Nov. 13, 1909, p. 10.

[11] *Telegram*, Nov. 24, 1909, 6.

[12] *FP*, Nov. 9, 1909, 8.

[13] For the period before the exhibit: *FP*, Nov.22, 6; Nov. 25, 9; Nov. 26, 9,18; Nov. 27, 6. *Telegram*, Nov. 24, 6; Nov. 26, 6; Nov. 27, 18. *TT*, Nov 27, 2, 7. *Tribune*, Nov. 26, 3. All dates are from 1909.

[14] *TT*, Dec.4, 1909, 4.

[15] Berry, *Vistas of Promise,* 50.

[16] *Telegram*, Nov.26, 1909, 6.

[17] *Tribune*, Nov.24, 1909, 2; *Telegram,* Nov.24, 6.

[18] Reports of the show: *FP* Nov.29, 16; Nov. 30, 18; *TT*, Dec.4, 4.

[19] *TT*, Dec.4, 1909, 4.

[20] According to Eleanor MacDonald the WAA also hoped to establish more branches in Alberta and British Columbia. Annual Report, Sask. Branch of the Western Art Association of Canada, 1911. This covered the 1910 season. Archives of Saskatchewan; *FP*, July 7, 1910, 9. For more on the branch see Afterword.

[21] Ibid.

[22] *FP*, July 7, 1910, 9.

[23] Ibid.

[24] *FP*, Jan. 28, 1910, 9; Feb.9, 9.

[25] *Telegram*, Feb.25, 1910, 7; *FP* Mar.11, 13; *FP* May 6, 9; *FP* June 3, 9.

[26] C.W. Parker ed., *Biographical Dictionary of Canada and Newfoundland* Vol.5 (Winnipeg: International Press Ltd., 1914); F.H. Brigden letter to Gagen, Winnipeg Mar.3, 1913 in NGC, FitzGerald Papers.

CHAPTER SEVEN: NEW DIRECTIONS WITH MARY EWART

[1] *FP*, Oct 17, 1910, 9; WAA Minutes, November 2, 1910.

[2] Minutes Ibid.

[3] On preparations for "Living Pictures", WAA Minutes, Nov. 2,5,8,25,29,Dec. 5. *FP*, Dec. 3, 1910, 19; Dec. 10, 8.

[4] *FP*, Dec. 12, 1910, 24.

[5] *TT*, Dec. 17, 26.

[6] WAA Minutes, Dec. 13, 1910.

[7] *TT*, Dec. 31, 1910; *Telegram,* Jan.6, 1911, 5.

[8] WAA Minutes, Dec.13, 27, 1910.

9 WAA Minutes, Jan. 28, 1911.

10 *FP*, Mar.13, 1911, 9.

11 *FP*, Feb. 13, 1911, 9.

12 *FP*, Feb. 13, 1911, 9.

13 *FP*, Feb. 25, 1911, 9.

14 *FP*, May 6, 1991, 9. *Telegram*, May 6, 8. *Sat.Post*, May 27, 7.

15 On the economic situation, see Artibise, *Winnipeg*, 123, 130-138; Ruben Bellan, *Winnipeg First Century*, (Winnipeg: Queenston House Publishing,1978), 99-113.

16 WAA Minutes, March 22, 1911.

17 WAA Minutes, Feb. 15, 1911.

18 WAA Minutes, Mar.8, 1911.

19 *Telegram*, Oct. 28, 1911, 9.

20 WAA Minutes, Mar.8, 1911.

21 Ibid. The amount was $637.

22 *Telegram*, Oct. 28, 1911, 7.

23 *FP*, Oct. 14, 1991, 11.

24 *FP*, Nov. 11, 1911, 48.

25 *FP*, Dec. 9, 1911, 5.

26 *FP*, Jan. 13, 1912, 4.

27 *FP*, Jan.27, 1912, 44.

28 *FP*, Feb. 16, 1912, 18.

29 *FP*, Feb. 24, 1912, 34.

30 *Telegram*, May 6, 1911, 8.

31 *FP*, May 11, 1911, 18; June 14, 24.

32 *FP*, Jan. 25, 1912, 22; *Sat.Post*, Feb. 10, 4.

33 *FP*, Feb. 20. 1912, 24.

34 *Tribune*, Feb.21, 1912, 9. See also catalogue *WAA First Annual Exhibition of Water Colors*, Feb. 19th to 24th, 1912. PAM.

35 *FP*, Feb. 20, 1912, 12; *Telegram*, Feb. 20, 3; exhibition catalogue, PAM.

36 *FP*, April 6, 1912, Lit. Sect., 4.

37 *FP*, Feb. 16, 1912, 18; Feb. 17, Lit.Sect., 3; *Sat. Post*, Feb. 10, 4.

38 Mrs. Ewart, "An Appeal for Art Development in Winnipeg", *Winnipeg Saturday Post,* April 20, 1912, 7 (hereafter *SP*).

39 *Telegram*, Mar. 6, 1912, 13.

40 *FP* Mar.30, 1912, 6.

41 *Tribune*, May 17, 1912, 9.

42 *TT*, May 25, 1912, 2.

[1] *FP*, April 6, 1912, Lit. Sect., 4.

[2] Industrial Bureau Minutes, July 23 and Sept.5, 1912, PAM.

[3] Berry, *Vistas of Promise,* 61.

[4] *Telegram*, Oct.12, 1912, 6.

[5] *FP*, Oct. 26, 1912, 9.

[6] *Telegram*, Oct.12, 1912, 6.

[7] *TT*, Oct. 5, 1912, p.4; *Telegram*, Oct. 3, p.6 and Oct. 5, p.6. *FP,* Oct. 26,1912, p.9.

[8] *FP* Nov. 9, 1912, p.21; *SP*, Nov. 16, p.4.

[9] Ibid.

[10] *FP*, Nov. 23, 1912, 21.

[11] *FP*, Jan. 11, 1913, 44.

[12] *Telegram*, Jan. 25, 1913, 7.

[13] *Telegram*, Feb. 15, 1913, 2nd section, 15.

[14] Patricia E. Bovey, *H. Valentine Fanshaw*, exhibition catalogue (Winnipeg: Winnipeg Art Gallery, 1973) and Marilyn Baker, *The Winnipeg School of Art: The Early Years* (Winnipeg: University of Manitoba Press, 1984) and Berry, *Vistas.*

[15] *Telegram*, March 1, 1913, 6; *FP*, March 1, 9.

[16] *FP*, Mar. 15, 1913, 6.

[17] *Telegram*, Mar. 29, 1913.

[18] For specific details, see Artibise, *Winnipeg*, op. cit. 142, Table 12, Origins of Winnipeg's Population.

[19] *FP*, Sept. 8, 1909, 9. *In Good Hands*, Helen Easton McLeod, pp. 114-34.

[20] *FP*, Nov. 4, 1910, 10, Dec. 7, 10, Dec. 10, 52.

[21] *FP*, Mar. 21, 1911, 9.

[22] *Telegram*, Oct. 12, 1912, mag. sect., 6; Oct. 12, 6.

[23] *Telegram*, Oct. 5, 1912, mag. sect., 6.

[24] *FP*, Oct. 25, 1913, 9.

[25] *Telegram*, Mar. 29, 1913, 7.

[26] *Telegram*, Mar. 29, 1913, 7; *SP*, May 3, 1913, 8 and Sept. 20, 1913, 8.

[27] *Telegram*, Oct. 11, 1913, 2.

[28] *FP*, May 6, 1913, 9.

[29] *SP*, May 3, 1913, 8.

[30] *FP*, May 14, 1913, 9; May 24, Lit. Sect., 1.

[31] *FP*, July 8, 1913, 28.

[32] *FP*, July 9, 1913, 3.

[33] Ibid.

[34] *Telegram*, Mar.25, 1913, 13.

[35] *Telegram*, Oct.11, 1913, 2.

[36] *FP*, Oct.5, 1913, 9; *Telegram* Oct.11, 2.

[37] *SP*, Sept.20, 1913, 8.

[38] *FP* Oct. 3, 1913, 9; Oct. 11, 9; Oct.20, 9; *Telegram* Oct.11, 2; Oct.25, 2.

CHAPTER NINE: GOOD TIMEſ IN THE ART COMMUNITY

[1] Baker, *The Winnipeg School of Art*, 26-34.

[2] Rosemarie L. Tovell, *A New Class of Art: The Artist's Print in Canadian Art 1877-1920.* (Ottawa: National Gallery of Canada, 1996.) Especially 139-42.

[3] *FP*, Oct.11, 1913, 9.

[4] *FP*, Nov. 17, 1913, 9.

[5] Ibid and *Telegram*, Dec. 18, 7.

[6] It had developed from a quasi-voluntary administration to one more capable of educating the increasing number of students and the variety of courses called for. W.L. Morton, *Our University* (Toronto: McClelland and Stewart, 1957) 91-98.

[7] *Telegram*, Nov. 15, 1913, 7.

[8] *SP*, Nov. 22, 8.

[9] *FP*, Nov.29, 9.

[10] *FP*, Dec. 13, 1913, 9.

[11] *Telegram*, Jan. 17, 1914, 7; *SP*, Jan, 24, 2.

[12] *FP*, Jan.29, 1914, 9; Jan.31, 7; *SP*, Feb.7, 2.

[13] *SP*, Feb. 21, 1914, 10.

[14] *FP*, Feb. 28, 1914, 32; *SP*, Mar.7, 1914, 2.

[15] Berry, *Vistas* and Roger Boulet, *The Tranquillity and the Turbulence* (Markham, ON: MB Loates Publishing, 1981).

[16] *FP*, Mar. 10, 1914, 18.

[17] *Telegram*, Mar.14, 1914, 7.

[18] *SP*, April 11, 1914, 2. Mary Schaefer had published a book on her travels in the Rockies.

[19] *FP*, Dec.4, 1913, 8; *Sat. Post*, Dec.6, 3; *Telegram*, Dec.6, 6; *TT* Dec.13, 6.

[20] *FP*, June 19, 1914, 11; *Telegram*, June 20, 7.

[21] *FP*, Feb. 13, 1914, 9.

[22] *FP*, Jan.26, 1914, 9; Feb.11, 9; Feb.13, 9; Feb.17, 8 & 9; Feb. 18, 9; *Tribune*, Feb.18, 9; *Sat. Post*, Feb.14, 2.

[23] *Tribune*, Feb. 21, 2nd section, 5.

[24] *SP,* Feb. 21, 1914, 2; *Tribune,* Feb. 21, 2nd section, 5.

[25] Ibid.

[26] *FP,* March 14, 1914, Women's Section, 1.

[27] *FP,* Mar.26, 1914; *Tribune,* Mar. 27, 8.

[28] *SP,* Mar.28, 1914, p.2.

[29] *Telegram,* June 20, 1914, p.7.

CHAPTER TEN: THE GENERAL EXCHANGE

[1] *FP,* Oct.10, 1914, 9; *Telegram,* Oct.10, 6 and Oct.24, 2; *Sat.Post,* Oct.17, 4.

[2] *FP,* Nov.7, 1914, Women's Section, 1.

[3] *Telegram,* Nov.23, 1914, 5.

[4] *FP,* Oct.10, 1914, 9.

[5] *Telegram,* Oct.20, 1914, 8. See also *FP,* Nov.13, 8.

[6] *FP,* Mar.13, 1915, 10.

[7] *FP,* Dec. 1, 1914, 9; *Telegram,* Dec. 1, 3.

[8] *Telegram,* Dec. 1, 1914, 6.

[9] *FP,* Dec.1, *loc.cit.*

[10] FP, Dec.9, 1914, 9.

[11] *Telegram,* Dec. 12, 3rd section, 3.

[12] *FP,* Dec.12, 1914, Women's Section, p.1.

[13] *Telegram ,* Dec. 12, 1914, 3rd sect., 3; *Tribune,* Dec. 21, 6.

[14] *FP,* Jan. 18, 1915, 7.

[15] *FP,* Jan.22, 1915, 22; *Telegram,* Jan.22, 4.

[16] *Telegram,* Feb.20, 1915, 4.

[17] *Telegram,* Jan.30, 1915, 5 and Feb. 13, 22.

[18] *FP,* Mar.15, 1915, 10.

[19] *Telegram,* June 12, 1915, 4 and June 15, 6.

[20] *FP,* Mar.6, 1915, Women's Section, 3.

[21] *FP,* Oct. 24, 1914, 6; *Telegram ,* Oct.24, 2; *Tribune,* Oct. 24, 6.

[22] *FP,* Jan. 9, 1915, 9.

[23] *Telegram,* Jan. 30, 1915, 5,

[24] *FP,* Feb. 13, 1915, 9.

[25] *FP,* Feb.27, 1915, 9.

[26] *FP,* Apr.8, 1915, 6.

[27] *FP,* Mar. 13, 1915, 10.

[28] *Telegram ,* Mar.27, 1915, 4.

[29] *FP*, Apr.2, 1915, 5. Full text, Brigden Collection, Metro Toronto Library. On Fred Brigden see Berry, *Vistas of Promise*, 69, 74 and Angela Davis, "Brigden's and the Brigden Family" in Baker, *School*, 91-93; J.E. Middleton, *Canadian Landscape as Pictured by F.H. Brigden* (Toronto: Ryerson Press, 1944).

[30] *FP*, Apr. 12, 1915, 5.

[31] Ibid.

[32] *FP*, Apr. 24, 1915,.5.

CHAPTER ELEVEN: THE END OF AN ERA

[1] *FP*, Sept.30, 1915, 3.

[2] *FP*, Oct.9, 1915, 14.

[3] FitzGerald Study Collection, University of Manitoba Archives.

[4] *FP*, May 11, 1911, 18.

[5] *FP*, May 1, 1912, 9.

[6] *FP*, Mar. 1, 1912, 9.

[7] *FP* ,Dec.12, 1912, 20.

[8] *FP*, Dec. 14, 1912, 20.

[9] *SP*, Feb. 15, 1913, 1.

[10] *SP*, June 20, 1914, 8 and catalogue.

[11] *FP*, Nov.21, 1914, 9.

[12] Royal Canadian Academy catalogue, 1914.

[13] Catalogue, Jan. 1915.

[14] *SP*, June 20, 1914, 8

[15] *FP*, Oct 9, 1915, 14.

[16] *FP*, Dec.9, 1915, 6.

[17] *FP*, Feb.26, 1916, 5.

[18] *FP*, Apr.6, 1916, 7; Apr.8, 4.

[19] *FP*, Feb.26, 1916, 5.

[20] Jan. 21, 1916, 3.

[21] *FP*, Feb. 9, 1916, 3; *Telegram*, Feb. 9, 12.

[22] *Telegram*, Feb. 26, 1916, 14.

[23] *FP*, Mar.11, 1916, 5.

[24] *FP*, Apr.8, 1916, 4.

[25] *FP*, Oct.14, 1916, 5.

[26] *FP*, Nov.20, 1916, 6; Nov.28, 7.

[27] *FP*, Oct.4, 1919, 7.

[28] *FP*, Oct.30, 1920, 16.

[29] On the WSA 1913-1920 see Baker, *Winnipeg School of Art*, 36-42.

[30] *FP*, Nov. 27, 1920, 8.

[31] Winnipeg Art Gallery clipping book dated *FP*, June 11, 1921.

AFTERWORD: WOMEN'S ART ASSOCIATION: SASKATCHEWAN BRANCH 1911-15

[1] Second Annual Report, Sask. Archives, 7.

[2] *Regina Morning Leader*, May 9, 1911, 14; June 6, 1911, 9.

[3] Jean McGill, "Edmund Morris among the Saskatchewan Indians" *Saskatchewan History* Vol. Xxxv, No.2, 1982, 103.

[4] On Morris see Geoffrey Simmins and Michael Parke-Taylor, *Edmund Morris "Kyaiyii" 1871-1913* exhibition catalogue, (Regina, Saskatchewan: Norman Mackenzie Art Gallery, University of Regina, 1984).

[5] Third Annual Report, 1913. Saskatchewan Archives, 6.

[6] Helen M. Harrison, Corresponding Secretary, Report, 3.

[7] Ibid.

[8] For an account of work leading to the memorial see McGill, "Edmund Morris", 103-107.

[9] Third Annual Report, 10.

[10] Ibid, 9.

[11] Alice Court, "President's Report", Fourth Annual Report, 6.

[12] Fourth Annual Report, 3.

[13] Ibid, 9 -11.

[14] Ibid, 6.

[15] *FP*, June 28, 1915, 7.

[16] Nov. 9, 1915.

[17] The Western Art Association, Saskatchewan Branch. Souvenir of the Treaty Memorial Monument erected at Fort Qu'Appelle, A.D. 1915, 33pp.

BIBLIOGRAPHY

PRIMARY SOURCES

Columbian Exposition catalogue. Chicago, 1892.

Daily Norwester. Winnipeg

FitzGerald Papers. National Gallery of Canada.

FitzGerald Study Collection. University of Manitoba Archives.

Industrial Bureau Minutes. Archives of Manitoba (PAM).

London Free Press.

Manitoba Free Press and Standard.

Nor'wester.

Royal Canadian Academy catalogue, 1914.

Regina Morning Leader.

Souvenir of the Treaty Memorial Monument erected at Fort Qu'Appelle, A.D. 1915. Western Art Association, Saskatchewan Branch. Saskatchewan Archives.

Western Art Association of Canada, Saskatchewan Branch. Annual Reports. Saskatchewan Archives.

Winnipeg Art Gallery clipping book.

Winnipeg Morning Telegram.

Winnipeg Saturday Post.

Winnipeg Siftings.

Winnipeg Sun.

Winnipeg Tribune.

Women's Art Association. *First Annual Exhibition of Water Colors,* exhibition catalogue. PAM.

Women's Art Association of Canada minute book, 1896, PAM.

Women's Art Association. *Annual Report* 1894. Toronto.

Women's Art Association. Catalogue of the Second Annual Exhibition of the WAA at their studio, Manitoba Hotel, Winnipeg, 1895, PAM.

SECONDARY SOURCES

Artibise, Alan. *Winnipeg: A Social History of Urban Growth 1874-1914.* Montreal: McGill-Queen's University Press, 1975.

Baker, Marilyn. *The Winnipeg School of Art: The Early Years.* Winnipeg: University of Manitoba Press, 1984.

Bellan, Ruben. *Winnipeg First Century.* Winnipeg: Queenston House Publishing, 1978.

Berry, Virginia G. *Vistas of Promise*. Winnipeg: Winnipeg Art Gallery, 1987.

Bonellie, Jarrett. "Mrs. Dignam's Pursuit" *The Beaver* June –July 2000.

Boulet, Roger. *The Tranquillity and the Turbulence*. Markham, ON: MB Loates Publishing, 1981.

Bovey, Patricia E. H. *Valentine Fanshaw*, exhibition catalogue. Winnipeg: Winnipeg Art Gallery, 1973.

Brock, Daniel and Muriel Moon. *History of the County of Middlesex, Canada* (facsimile of the 1889 edition). Belleville ON: Mika Studio, 1972.

Colgate, William. "The Toronto Art Students' League: 1886-1904" *Ontario Historical Society Papers and Records*, xxxvii, 1945.

Davis, Angela. "Brigden's and the Brigden Family" in Baker, *The Winnipeg School of Art*.

Dickens, Violet. "My first art lessons were shared with Paul Peel in London", Interview with Mary Dignam, *Christian Science Monitor* March 18, 1936.

Dryburgh, Jessie. "Mary E. Dignam and the Women's Art Association" *Lyceum Club and Women's Art Association of Canada 82nd Annual Report*.Toronto,1969.

Farr, Dorothy and Natalie Luckyj. *From Women's Eyes: Women Painters in Canada*. Kingston: Agnes Etherington Arts Centre, Queen's University,1975.

Fleming, Marie and John R. Taylor. *100 Years Evolution of the Ontario College of Art*. Toronto: Art Galley of Ontario, 1976.

Hall, Alfred. *Per Ardua: The Story of Moulton College Toronto 1888-1954*. Toronto: Moulton College Alumnae Association, 1987.

Harper, J. Russell. *Early Painters and Engravers in Canada*. Toronto: University of Toronto Press, 1970.

MacTavish, Nelson. *The Fine Arts in Canada* (1925) Facsimile Edition. Toronto: Coles,1973.

McGill, Jean. "Edmund Morris among the Saskatchewan Indians" *Saskatchewan History*, Vol. xxxv, No.2, 1982.

McLeod, Ellen Easton. *In Good Hands*. Kingston and Montreal: McGill-Queens University Press, 1999.

Middleton, J.E. *Canadian Landscape as Pictured by F.H. Brigden*. Toronto: Ryerson Press, 1944.

Morton, W.L. *Our University*. Toronto: McClelland and Stewart, 1957.

Murray, Joan. *Ontario Society of Artists: 100 Years 1872-1972*. Toronto: Art Gallery of Ontario, 1972.

Parker, C.W. ed., *Biographical Dictionary of Canada and Newfoundland* Vol.5. Winnipeg: International Press Ltd.,1914.

Rosser, Frederick T. *London Township Pioneers*. Belleville, ON: Mika Publishing, 1975.

Simmins, Geoffrey and Michael Parke-Taylor. *Edmund Morris "Kyaiyii" 1871-1913* exhibition catalogue, Norman Mackenzie Art Gallery, University of Regina, Regina, Saskatchewan, 1984.

Sisler, Rebecca. *Passionate Spirits: A History of the Royal Canadian Academy of Arts 1880-1980*.

Toronto: Clarke, Irwin, 1980.

Thompson and Bryce eds. *The City of Winnipeg*. 1886.

Tovell, Rosemarie L. *A New Class of Art: The Artist's Print in Canadian Art 1877-1920*. Ottawa: National Gallery of Canada, 1996.

Wilson, William James. "Daniel McIntyre and Education in Winnipeg" Unpublished MA thesis, University of Manitoba [Education], 1978.

Women's Art Association of Canada. "Objects, Constitution, and Rules". Toronto: Oxford Press, 1895.

INDEX

A

Chapman, Charles, 3.

Chase, William Merritt, 5, 79

Chesterton, Walter, 44

Chicago Art and Literary Club, 66

Chicago's Art Institute, 92

Chipman, Ada (Mrs. C.C.), 34, 69, 72-73, 75, 78, 86, 131

Chown, Dr. H.H, 44

Clarendon Hotel (Winnipeg), 44

Clarkson, Miss, 66-67

Clopath, Miss, 96

Colleu, Louis-Joseph, 5

Collings, Charles, 90

Columbia University, 78, 99, 105, 126

Congregational Christian Church, 110

Conn, Miss, 34

Constable, John, 73, 106

Constant, J.J. Benjamin, 49

Cook, J. H., 16

Coombes, Mary Elizabeth (Mrs. G. F.), 65, 69, 72, 81, 83, 86, 129, 131

Copeland and Garrett, 14

Corbet, May, 33, 38-39

Council of Women, 35, 47, 51, 53-54, 114, 124

Court, Alice (Mrs. J. S.), 59, 77, 134, 139, 140

Court, Mr. J. S., 135, 139, 141

Coven, Miss, 38

Cranston, George W., 45

Cranston's Art Company, 45-47, 90

Crawford, Mrs. A.W., 79, 95, 99, 104

Crawford, Professor A. W., 87, 96, 118, 126

Crotty, Mrs. T. H., 81, 84-85, 86

Culver, Agnes (Mrs. W. H.), 27, 31, 33, 38-39, 48, 57

Culver, Jean, 48

Cunliffe, T.W., 134

Cupar, SK, 77

Curry, Mrs., 79

D

E

French method of teaching art, 4
Frith, William P., 44

G

Gagen, Robert F, 43-44
Galician art and artifacts, 54, 61-62, 65 See also Ukrainian handicrafts
Galt, George, 114
Gauthier, Capt., 88
General Exchange, 113-115, 124, 132 See also Exchange
Gilbert-Garret Sketch Club, 103
Glasgow School of Art, 95, 103
Glasgow University, 103
Gordon, John, Earl of Aberdeen, 35
Graham, William, 135
Grant, Mrs. W.S., 66
Gray, Claude W., 87, 91
Great West Life Building, 96
Grenfell Mission, 99
Grenfell, SK, 77, 134
Greuze, Jean Baptiste, 82
Grier, E. Wyly, 48
Griffiths, James, 2-3
Griffiths, John Howard, 2-4
Grisdale, Bishop, 134
Groenewegen, Pieter, 52-53
Gwynne, Mrs., 135, 138

H

Hagerty, Mrs. D.N.J., 125
Hague School, 45
Halford, George, 119
Halls, Mrs., 140
Hamelin, Professor A.D.F., 126

Kutawa, SK, 78, 133

L

Lady Aberdeen, 35-36, 55
Lady Aberdeen Society, 36
Laing, Mr. Robert, 78
Lake, R. S., 77
Lampert, Emma, 28
Landseer, Sir Edwin, 44
Langford, Mrs., 67
Laura Secord School, 120
Laurens, Jean-Paul, 49
Lawrence, Sir Thomas, 106
Lefebvre, Jules, 3
Legislative Buildings (Manitoba), 94, 96
Lindgren, Mrs., 63
Lindhe, Ivan, 95
"Living Pictures", 82-83, 109-110, 114, 124, 132
Lloyd, Mr., 137
London School of Art, 120
Long, Marion, 7
Long, Victor, 15, 96
Longford, Adelaide, 62
Luscombe Carroll Gallery, 90
Lycett, Edward, 14
Lynn, W. Frank, 45

M

MacDonald Lloyd system of manual training, 47
MacDonald, Archibald, 135
Macdonald, D., 45
MacDonald, Miss Eleanor, 77, 132, 134-135, 138, 140
MacDonald, Sir William, 47

T

U

V

W